Deeds/ Abstracts

Deeds/Abstracts

the history of a London lot

Greg Curnoe

1 January 1991 – 6 October 1992

edited by Frank Davey

London, Brick Books, 1995

CANADIAN CATALOGUING IN PUBLICATION DATA

Curnoe, Gregory Richard, 1936–1992
 Deeds/abstracts : the history of a London lot

ISBN 0-919626-78-5

1. Number 38 Weston Street (London, Ont.) –
History. 2. London (Ont.) – History. I. Davey,
Frank, 1940- . II. Title.

FC3099.L65Z56 1995 971.32´6 C95-932845-9
F1059.5.L6C8 1995

The support of the Canada Council and the Ontario Arts Council is grate-
fully acknowledged. The support of the Government of Ontario through
the Ministry of Culture, Tourism and Recreation is also gratefully acknowl-
edged.

Cover is after a painting by Greg Curnoe, 'Deeds no. 2.' January 5, 7, 1991.
(106 x 168 cm.) Stamp pad ink, pencil, gouache, blueprint pencil. Back
cover is after a painting by Greg Curnoe, 'Self Portrait no. 17', August 8, 13,
1992. (26 x 18 cm.) Watercolour, pencil, stamp pad ink. All photographs of
paintings are courtesy of Sheila Curnoe.

Second printing - August 2004. Typeset in Ehrhardt. Printed and bound
by Coach House Printing. The stock is acid-free Zephyr Antique laid.

Brick Books
431 Boler Road, Box 20081
London, Ontario
N6K 4G6

Contents

Lot Description

38 Weston Street, sub-lot 7, Registered Plan #312, except the westerly 86.54 feet, part of Lot 25 in the broken front concession of Westminster Township, now in the City Of London, and which may be known and described as follows: that is to say commencing on the north side of Weston Street at the western limit of the original allowance for road between lots 24 and 25 thence westerly 66.84 feet on a course of north 84° 39′ east, then northerly on a course of north 10° 15′ 40″ west, 232.33 feet, then easterly on a course of north 63° 58′ 25″ east, 69.31 feet, then southerly on a course of south 10° 15′ 40″ west, 285.41 feet to the place of beginning.

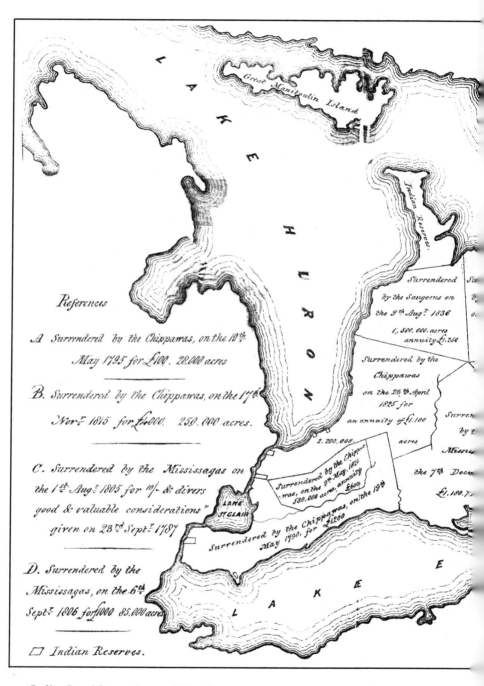

Indian Land Surrenders and Treaties

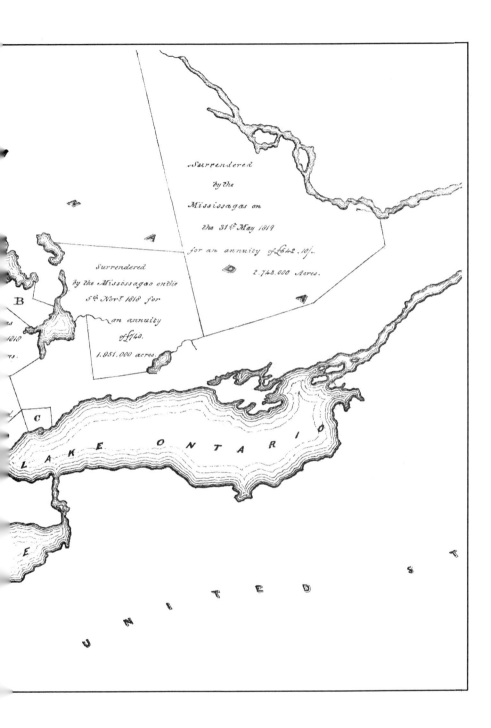

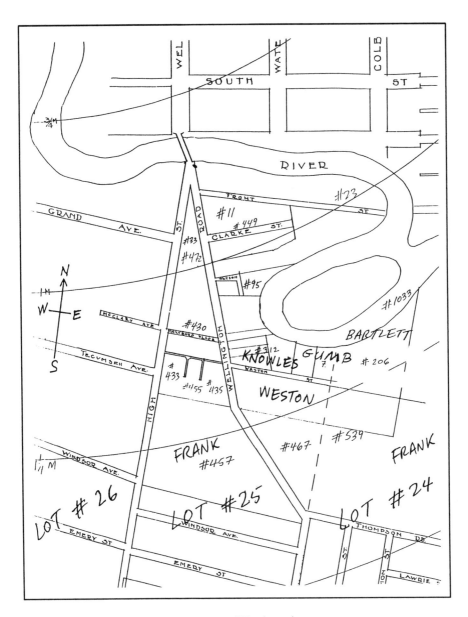

Weston Street and Environs in 1915

List of Illustrations

Editor's Note

In the fall of 1990, the Canadian painter Greg Curnoe became concerned with various legal questions concerning the boundaries of the lot, 38 Weston Street, on which his London, Ontario, home and studio were located. While he was able fairly quickly to resolve these, his research into them awakened further questions. How had a printing plant and factory come in the late nineteenth century to occupy this piece of land on a quiet rural side street? More seriously, how had it become possible in the eighteenth and nineteenth centuries to 'own' land that had for thousands of years been First Nations corn fields and hunting grounds? And why was it that present-day London knew so little about both its working-class and pre-European-settlement histories? Curnoe punningly began to imagine his research – much of it done in London-area land registry offices – as research into 'deeds' – into the pieces of paper that magically could confer status and ownership, and into the actions by which land had been taken away from its First Nations inhabitants and those people forgotten.

The first version of the book which he began to write from this research looked very much like this edition of *Deeds/Abstracts* – but with one large difference. Among the eight appendices to this version were short histories not only of the settler families that had once cleared and farmed land on or near 38 Weston Street (the Westons, Gumbs, Bartletts, and Knowles) but also histories of various eighteeth- and nineteenth-century First Nations people whose actions had in some way influenced the London area. In early 1992, Curnoe's interest in the European settlement history of his lot was sharply eclipsed by his interest in those First Nations people. He dramatically slowed his writing of his Weston Road history and began expanding its 'First Nations' appendix. That appendix then swelled into a 250-page listing and short biography of virtually every First Nations person whom Curnoe could identify as having lived in the lower Great Lakes region between 1700 and 1850, together with quotations from their speeches, wherever

possible, and a long cross-index of alternate spellings of their names. In the fall of the year, shortly before his strange death in a truck-bicycle collision while riding with his London Centennial Wheelers cycling club, Curnoe decided to divide the manuscript into two sections, one that would now focus only on the Weston Street land history, and another, to be titled *Deeds/Nations*, that would be an annotated 'directory' to Southwestern Ontario First Nations individuals of 1700-1850. He had, however, only briefly sketched this separation before he died.

In *Deeds/Abstracts*, one of his main goals had been to challenge the Canadian sense of history that sees important Canadian events beginning with white settlement, and which traces land ownership only back to European possession. He felt strongly that as a white individual he had benefited directly from the injustices First Nations people had suffered and that a major part of that benefit was hidden in the Canadian 'forgetting' of thousands of years of First Nations social development and inhabiting of the land. His own good fortune in being able to become a painter, writer, and land owner in London had been partly founded, he believed, on earlier exploitation and repression of First Nations voices and records. As I wrote in my foreword to *Deeds/Nations*, Curnoe had been born in London, and grown up in a society whose prosperity, sense of geography, and local culture were all founded on land and rivers that had been taken or 'purchased' from native peoples. His own studio on Weston Road overlooked Thames River lands that had once been Mohawk cornfields and that in the sixteenth century had been part of a First Nations settlement of five thousand inhabitants. The river where his two dogs loved to romp had been to First Nations peoples the Askunessippi River, but this name had been 'extinguished' by settlers as thoroughly as had been all memory of an earlier First Nations 'city'.

Another of his goals had been to counter what he saw as London's dismissing of its working-class history. The historic buildings that the city sought to preserve or remember, he would often complain, were almost always the elaborate houses of the wealthy and the churches and public buildings of official life. The small unpretentious buildings on a street like Weston, built by farmers, small tradesmen, and workers, were rarely awarded the city's blue historic plaque. Ironically, less than a year after his death, the City of London designated 38 Weston Street as a building that had been made 'historic' both by its industrial history and Curnoe's own

work there, and in a formal ceremony attended by about a hundred people placed a blue plaque upon it.

Curnoe's own plaque for his house would likely have been heart-shaped. The heart symbol (♥) that appears so frequently in this book and *Deeds/Nations* marks each person or event that directly touched the fate of 38 Weston.

I have restricted my own work in preparing *Deeds/Abstracts* for publication to introducing some consistency to the punctuation and to making the sources Curnoe acknowledged in parentheses at ends of each entry more recognizable. Curnoe intended this book as a personal statement rather than a work of scholarship. He listed the sources of his information primarily to be able to return to them himself, and to acknowledge his indebtedness to others. Rather than convert these acknowledgements into academic citations, I have kept many of their idiosyncrasies and redundancies, and provided a bibliography at end the book of the sources Curnoe appears to be referring to. I have also edited his essay, '*Deeds/Abstracts*, February 1/20, 1992,' which he wrote for the *Deeds Abstracts* booklet that accompanied his 1992 Forest City Gallery show of that title, so that it can serve, as he intended, as his introduction to this book.

Frank Davey
January 1995

Introduction

Today, Sunday, February 9, I was skiing down the back with our dogs. By skiing along the old river bed I have been able to get around the huge piles of snow dumped by the city. While going this way I am able to look up at the old river bank that forms the north boundary for all the lots on Weston Street. I realize that I am looking at a landscape not very different from that seen by Augustus Jones when he surveyed the river in January and February 1793. Probably the view from the flats is not that different in some respects to what it was when there was an Iroquoian camp some hundreds of years ago at the intersection of Foxbar Creek and the old river bed. In the woods at the foot of the old river bed there are the mounds of incinerator ash from Victoria Hospital medical waste that May Abrams walked through when she was a child in the 1920's. She has told me how frightening it was walking through the still smouldering piles at night. As I skiied further east I tried to visualize the fields of vegetables and flowers that the Bartlett family grew on the flats in the 1860's. I passed the old road that is still used as a path from Weston Street to the river. This is the road that Ernie Potter talks about that was used by the gardeners to get their produce up the hill. On the top of the hill they had orchards. I thought about the Moravians rafting back to Moraviantown along here, as they headed back to their ruined village in 1814. It had been burned by the Americans in the aftermath of the Battle of Moraviantown. As I look around my mind is filled with images of people and things who have occupied this area and I can see the landscape which consists of willows, frozen ponds and a steep hillside with backyards along the top. The earth moves enough to disrupt surveyors stakes, that is it moves in detail but stays the same in its over-all appearance.

Because the area behind us is wild and overgrown, it is timeless. But there is the story of the retired British Army engineer, General William Renwick, who owned in the 1870's what was called the tongue of land that extended south from what is now Nelson Street. At that time the river still

curved south so that the water's edge formed the north boundary of our lot. What remains now is a series of long ponds, actually they are identical to the coves only smaller, because the General caused the river to change its course. Apparently he dug a ditch across the tongue of land, about where the river flows now. When the great flood of July 1883 struck it gouged out a new channel where the General's ditch was. In doing so it did a lot of damage to Henry Winnett's house (which was on high land at the east end of Front Street) in addition to destroying four new cottages and washing away six acres of land on the river flats. General Renwick lost an expensive law suit for damages to Winnett's property.

Yesterday, February 8, the dogs were barking at a man and a boy who were getting water from an open spot in the old river in a blue plastic drum. They were using it to flood the frozen section east of us. They are doing what generations of residents of Weston Street have done, exploring the woods down the back, skating on the frozen river bed, making dug outs and shacks and so on. The street and its goings-on are probably typical of areas of the city near the river. My sons Owen and Galen and Mark Favro made a terrific video tape of an explosion of fireworks in one of the four-foot-high concrete storm sewer pipes down the back. There is this brilliant rolling ball of fire with smoke coming out of the pipe. Owen was talked out of shooting it from the inside. A few years ago someone built a birdwatching blind on a small island in the old river bed just east of us. My kids saw the bird watcher occasionally.

I can remember when they were digging the foundation for the Harper's house next door last summer, seeing the layers of rubble then the sandy topsoil profile of the original river bank and the light grey clay below that. That was my first realization of what we actually live on.

*

Today, Wednesday, February 12, I examined the flats more carefully and realized that the river seems to have curved south about 200 metres west of the L & PS Railway bridge before the flood of 1883, and the old river bank is at its highest directly behind our place where the river began to curve north again. It's possible General Renwick dug an irrigation ditch for the fertile river flats that he owned. It can be very dry along the river in the summer.

Around 1500 the population within the present city limits of London,

Ontario was 5,000. Three years before John Cabot saw Newfoundland the Neutral Nation lived in four towns around what is now London. They lived here for about 100 years. The term *Attawandaron* which has been used to describe this nation is a word the Hurons used to describe the Neutrals after they had left this area and moved to the west end of Lake Ontario around 1550. It was there that they came into contact with Europeans: French couriers de bois and priests. The priests compiled a dictionary of the Neutral language which has been lost. As a result we do not know what they called themselves. Recently a convent in Montréal which had been closed for many years has been opened to scholars. Huron girls were educated here and consequently it is a repository for early records of French/Indian contact in New France. An inventory is being made of its holdings and the hope is being held out that the dictionary of Neutral terms may be found there. Darryl Stonefish, Moraviantown historian, told me on February 7 that descendants of the Neutral Nation survive on the Six Nations Reserve to this day.

*

Human occupation of this area goes back much earlier to the paleo-indian sites of Pond Mills on the Ingersoll moraine. Tonight, Saturday, February 15, Neal Ferris told me more about Bob Calvert's discovery around 1947 of pottery fragments and other artifacts from a Middle Ontario Iroquois site (c.1400) where Foxbar Creek joins the old bed of the river. The site is about 300 metres from our house, behind the Moose Lodge at 6 Weston Street. Other Nations occupied this area after the Neutrals with the present Ojibwa occupants arriving about 1690. On June 22, 1790 at L'Assomption (now Windsor), in the District of Hesse, seven Ojibwa, thirteen Wyandot, eight Odawa and six Pottawatomie chiefs drew their totems on Surrender #2. They received £1,200 worth of goods in Québec currency for surrendering all of South-Western Ontario, south of the Askunessippi (Thames River or Rivière à La Tranchée) to the Crown, King George III. Surrender #2 had as its eastern limit a line drawn from near Dorchester on the Askunessippi, south to Catfish Creek (Rivière au Chaudière) at Port Bruce on Lake Erie. When I read a copy of that document I began to be aware of spheres of influence that operated in this area in 1790. They survive today: it is a long distance call from London to Putnam (25km). It is not a long distance call from London to Glencoe (50km). Our telephone areas

have something to do with our county system, which itself is related to the boundaries of the various surrenders, they are related to the areas of occupation of the various First Nations in Southern Ontario from around 1783 to 1820. In 1784 a tract of land was purchased from the Mississauga Ojibwa by the Crown. Its western limit was a line drawn north from Catfish Creek at Port Bruce to the Thames River near Dorchester.

On December 7, 1792 at Navy Hall (Niagara-on-the-Lake) in Lincoln County, Surrender #3 formalized the sale of 1784 with the drawn totems of five Mississauga Ojibwa chiefs, who lived near Lake Ontario. Much of this transaction was to secure lands for several Iroquois Nations who had supported the British during the American Revolution. They emigrated to Canada as a result of their allegiance to the Crown. The two Delaware divisions (Munsee and Oonami) who arrived around the same time seem to exist outside of these boundaries. They move freely between the Delaware communities on the Grand River, on the Thames River at Muncey and on the lower Thames at Moraviantown.

In talking to local historians about the period prior to European settlement it is common to be told 'I know nothing about this'. We live in a culture where pre-existing cultures lived and live. They have survived in isolation from the culture of the City of London, both within the city and in areas of original settlement that date back to around 1690, fifteen miles away. They have been omitted from most books of local history. The usual practice is to include a summary of 10,000 years of human occupation on the first couple of pages as a prelude to the arrival of European explorers and settlers.

*

I am discovering incidents of a co-incidental or personal nature that are really astonishing. John Simon [1900-1965], horse-shoe champion from the Muncey Ojibwa reserve, played at the Weston Street Horse Shoe Club. According to Ernie Potter he could throw ringers when the pit was covered with a blanket. Their field, lit with rows of electric lights, was located on the east side of our place on Weston Street until about 1940. It was a member of that club who discovered the big fire that destroyed the second floor of our building in August 1937. John Simon Senior signed Surrender #126 which gave a right of way to the Canada Southern Railway in 1872. His father or grandfather Old Simon fought alongside Tecumseh at the Battle of

Moraviantown in 1813. The Simon family seems to have been on the St. Clair River before that.

John Askin (clerk of the district court and clerk of the peace in London in the 1830's and after) was the son of John Askin junior and a woman from the Indian country west of Detroit. Some sources state that she was an Indian woman, others state that she was a white captive. His grandmother was Manette or Monette, an Indian slave. John Askin was 1/4 Euro-Canadian. Askin Street is named after him. Cynthia Street and Teresa Street are named after his daughters.

Poet Colleen Thibaudeau's great-great grandmother Margaret Middaugh [c.1803-c.1870] lived on a farm near Moraviantown. Family history says that she met Tecumseh as a child. On October 5, 1813, the Battle of Moraviantown took place beside her parents' farm. American soldiers showed her what they said was Tecumseh's head on a split rail after the battle. Margaret's future husband Pierre Thibaudeau [c.1785-c.1850] was a prisoner of war and guide with the US forces who escaped and fought on the British side at the Battle of Moraviantown. A member of the Kettle Point Ojibwa community has in his possession a George III medal that is said to have been Tecumseh's. Labatt Park used to be called Tecumseh Park.

South Central London, where we live, was developed as a residential and light industrial area where proprietors could live close to their plants. Our building was built in 1891 by Thomas Knowles senior [1841-1926], an immigrant from England (who had lived on Weston Street since 1873) as a lithography shop for his sons Thomas [1866-1933] and Joseph Knowles [1868-1954]. London artist Albert Templar apprenticed here in 1917. He ground litho stones as part of his apprenticeship (he boarded on Maryboro Place, now McClary Avenue). My son Galen and I have dug up Knowles Company litho stones from the back of our building. My most recent prints were three editions of lithographs, drawn directly on litho stones. The lithographer/owners who worked here were well connected socially to the extent of belonging to the exclusive Forest City Bicycle Club around that time with the then famous author Arthur Stringer and the Saunders family of the Saunders Drug Company. The club rode ordinaries and safety bicycles. The Knowles brothers rode their bicycles from 38 Weston Street to their club rides. I leave from the same place for club rides with the London Centennial Wheelers.

I phoned the United Church Archives in Toronto for information on

Reverend Leonard Bartlett who was born next door. They sent me back a mimeographed biography. Although it was unsigned, I suspect it was written by my late friend the Reverend Robert Cumming. He gave me copies of several biographies of ministers from this area that he was writing about twenty years ago. They were also mimeographed, with the same typeface, titles and layout. Leonard Bartlett was the sunday school superintendent of the High Street Mission, which later became Calvary United Church.

By the early 18th century when the Petit Côte settlement was founded, Canada's historic equation was in place. It operates to this day in our constitutional discussions and led a few years ago to the end of the Meech Lake Accord. The struggle between the Native Nations that moved and shifted around south-western Ontario, the French and the English in the eighteenth century District of Hesse is not very different from the situation today and the revival of the political power of Canada's First nations is bringing us much closer to the original historic relationship of Canada's constituent cultures.

My primary information on native cultures has come from Delbert Riley, chief of the Chippewas of the Thames, Ken Labert, Mrs. Albert, Doris Fisher and Sylvester Simon from the same nation at Muncey; Roberta Miskokomon for information of the Munsee nation, Jim Bobb and Margaret Jackson for information on the Ojibwa language and Ray John for information on the Oneida language; Gord Chrisjohn from the Oneida Settlement; Darryl Stonefish and Diane Snake of the Delaware Nation at Moraviantown; Dean Jacobs of Walpole Island; Tom Hill and Phil Monture at Six Nations, and Colleen Thibaudeau and her sister Sheila Lambrinos. My discussions with Del Riley began about 20 years ago when our mutual friend Murray Favro brought him to visit at 38 Weston Street. Michael Spence initiated my education into the archaeological riches of this area when he patiently answered my questions about visual art from the Paleo-Indian period. Neal Ferris and Robert Pearce have also answered a lot of my questions.

For the period after the Surrenders I have received a lot of assistance from Dick Kirkpatrick and Charles Chapman, Ontario Land Surveyors. I used to work for them in the Surveys Department of the City of London. Surveyors Don Redmond, Brad Holstead, Murray Fraser and Jack Webster have all been very helpful. Joanne Scott has been of great assistance in property searches at the Registry Office and Linda Davey has given me many insights into the legal aspects of deeds, mortgages and family law.

With the help of Glen Curnoe, Ed Phelps, Dan Brock, Guy St. Denis, Theresa Regnier, the Reverend Greg Smith and many others, I continued my research into deeds, abstracts, church records, cemetery records, census returns, assessment rolls and so on. I began to notice another invisible element in our society. Local histories have tended to be about prominent families and public figures. I began to gather information about other families, uncommented on except as statistics or entries in ledgers. I was amazed to find how little was known about the area I live in. I found also that a 1905 London and Middlesex Historical Society paper by Harriet Priddis *The Naming of London Streets* contained inaccuracies about street names in my area, and I couldn't find the name of various physical features of this area of the city. I couldn't find the name of the now tiled creek at the foot of our street for a long time (it is called Foxbar Creek) and still can't find the origin of the name. My brother Glen Curnoe, librarian of the London Room at the London Public Library, has been constantly giving me information and connections about these more local features, as has my mother Nellie (Porter) Curnoe.

It became clear as Sheila and I talked to Mark Gladysz the heritage planner for the city, that designation of historical buildings in London has had a lot to do with the social status of the former occupants and until recently, little to do with the intrinsic value of the buildings to be designated. For this reason London has lost most of its 19th century industrial architecture, and areas like south London, west London and east London are drastically under-represented in this city's inventory of historical buildings. He clearly wishes to help change this. Apparently Manor Park contains no buildings of historical importance in spite of the existence of the large and handsome 19th century home of the notorious Murrell family there. These attitudes in London are infectious. The day after the charges against the London Art and Historical Museums for practising archaeology without a licence under the Ontario Heritage Act were dismissed (they had destroyed the remains of London's earliest Euro-Canadian street to build a vault to store historical collections!) looters showed up at the Dundurn Castle archaeological site in Hamilton. They told archaeologist Linda Gibbs that they had a right to loot the site because the London decision proved that the Heritage Act no longer applied to them.

What is being discussed here is not history so much as the underpinnings of our culture. We need to know that the area contained within

London's current city limits had a population of around 5,000 in 1500, it didn't start with Governor Simcoe naming the forks London. We have only a warped and exclusive view of our culture if we insist on naming in a way that isn't really connected to what is being named. This is part of the problem with the use of social status as the main criterion for determining historical importance. Continuing to name in imitation of London, England is alienating. Partridge says that *London* comes from lond, a celtic term meaning wild, bold, powerful, irascible. *The Forks* was the term for this immediate area before London was established. It has continued to be used in a more limited sense. Partridge also says that *Thames* derived from the Old English *Temes* meaning *The Dark River*. The name *Askunessippi* is far more descriptive of our river. It comes from *eshkanh*, Ojibwa for *antlered* and *ziibi*, Ojibwa for river. *Eshkanhziibi* therefore means *antlered-river* after its many creeks and branches. La Rivière à La Tranchée, Waubuno, Echo Bridge, Meadowlily Road, The Coves, Cove Road, Beechwood Place, Elmwood Ave., Winery Hill, Brick Street (part of Commissioners' Road, named after the many brick works there), Riverview Ave., Reservoir Hill, Base Line Road (the base line of Simon Zelotes Watson's survey of Westminster Township in 1810), Front Street (the broken front of Watson's survey), Rectory Street, Pond Mills, and Riverview Heights, all named after physical features around London, carry a lot of meaning in their names. The same is true of streets and features named after local inhabitants: Askin Street, Weston Street (William Weston [1799-1871] British Army veteran, tanner, currier, market gardener) and Anna Weston [1799-1852], Tecumseh Public School, Tecumseh Ave., Whetter Avenue (Richard Whetter, farmer), Frank Place and Frank Mount (the Frank family), Clarke's or Wellington Bridge (Reverend William Clarke [1801-1878] London's first Congregationalist minister), Watson Street (George Watson [1812-c.1909] carpenter and architect), Colgrove Place (Robert Colgrove [1834-1893] market gardener), Sumner Road (the Sumner family of farmers), Commissioner's Road and so on.

London's black community in the 19th century did not support the rebellion of 1837 because many of its members were refugees from slavery in the US, and they knew what American freedom meant for them. Around this time members of the black community were stationed at railway stations and when they would see an American with his slave they would telegraph ahead to the next stop where the slave was taken from the owner.

Upper Canada was one of the first jurisdictions anywhere to abolish slavery (gradually) in 1793. It was finally outlawed in the British Empire in 1834.

Alan Cohen has told me that London had a substantial Jewish anarchist community, located around Grey and Waterloo Streets. It brought Emma Goldman here to lecture in the 1930's. A few years later part of the Jewish community was concentrated in the area around Frank Place, south west of Weston Street, across Wellington Road. Hyman Ginsberg and an architect who was a student of Frank Lloyd Wright designed and built a classic modernist house beside Frank Mount (the Frank family homestead) on Wellington Crescent in the 1940's.

The waves of immigration from Europe and increasingly Asia continue. Weston Street experienced a continuous flow of immigrants from the British Isles from its beginnings in 1840 until the 1930's. In the 1950's people from continental Europe began to settle on the street, including people from Germany, Italy, Malta, Latvia and Holland. In the 1960's families from Russia and Jamaica moved onto the street. Our neighbours the Kintings across the street first rented a house on Weston Street in the early 1960's because it felt like a United Nations street and they felt at home. At the same time Weston Street has held onto many of its earlier residents. It is not uncommon for people to have lived here for over 50 years. Much of the oral history I have obtained has come from Ernie Potter who has lived on the street since 1920; Mr. and Mrs. McKone who have lived here since the 1920's; May Abrams who lived on Weston Street from 1925 to 1991 and her husband Walter who lived here from 1946 to 1991; the late Albert Knowles who owned and worked at 38 Weston from 1943 until 1960; his son-in-law Ken Smith; Albert Templar who apprenticed at 38 Weston Street in 1917; Hans and Monica Hoeltzl who have lived here since 1953; and Eddie Pranskus who was brought up on Weston Street in the 1950's. Many others in the neighbourhood have been of great assistance.

*

Today, Thursday, March 26, I was talking to Bill Sabo who lives on the south side of Weston Street beside Foxbar Creek. He has lived on Weston Street all his life. We walked to the back of his yard and we tried to see if there were any remnants of a lane from the old frame house on Wellington Road to the back of the lots on Weston Street. Bill told me that the frame house was one of the oldest in the area. It has a red brick foundation and

could be the Weston homestead or the house built by George and Anna June Adelaide Weston. Could there be a log house under the frame siding? His older brother remembers the open creek and the bridge over it on Weston Street.

The question of the power of histories of broad conclusions and great events in contrast to histories of details has occurred to me as I am writing this. I have felt the power of many details adding up to an understanding of the ground I am standing on. It is an understanding that is new to me, in spite of the fact that I have worked with this kind of information for years.

Greg Curnoe
1 February – March 26, 1992

Foreword

The eastern part of sub-lot 7 is 250.1 metres (820.538 feet) above sea level near its south-east corner. The northern limit of sub-lot 7 is 236.8 metres (776.902 feet) above sea level. The old river bank is about 13 metres (44.947 feet) high. (Planning Dept., City of London)

January mean temperature for London: -5.27°. Record low: -37°
July mean temperature: 20.88°. Record high: 41.11° Average last frost: May 16. Average first frost: October 1. Average precipitation: 96.52cm. Average snowfall: 198.12cm.
Length of the Thames River: 262.31 kilometres/163 miles.
(Dean, *Economic Atlas of Ontario*, plate 111)

Oneida and Ojibwa Nations claim all of the Thames River. (*London Free Press*, April 23, 1991)

60'(minutes) = 1°. 60"(seconds) = 1'. 3600" = 1°.
1 chain = 66 feet. 1 link = 7.92 inches. 100 links = 1 chain.
1 rod or pole = 5 1/2 yards or 16.5 feet. 1 perche = 5 1/2 verges.
3 miles = 1 league. 1760 yards or 5280 feet = 1 mile.
1 foot = .3048 metre. 1 perch(e) = 1 pole = 1 rod = 1 rood.

30 1/4 square yards = 1 square rod. 40 square poles = 1 square rood.
4 square roods = 1 acre. 1 square perch = 1/100th of an acre.
640 acres = 1 square mile. (LE CAHIER ALOUETTE no. 8116 back cover; *The Shorter Oxford English Dictionary*, vol. II, pp 1330, 1551, 1841)
1 score = 20

1 lot (Westminster) = 200 acres. (Middlesex County Registry Office)

1 British Shilling = 1 Québec Shilling = 1 Halifax Shilling 1 American Dollar = 5 Québec Shillings. 'The currency of Halifax and the Two Canadas is the same.' (Gourlay, *Statistical Account of Upper Canada*, vol. I, p. 216 [1820])

'DOWER Provided the necessary conditions were satisfied, a widow was entitled to dower, which was a life interest in one-third of the realty of her deceased husband. Her interest was not terminated by remarriage nor by adultery, unless she left her husband for her paramour and was not reconciled to her husband, in which case it was immaterial that she left under a separation agreement or was driven away by her husband's cruelty and misconduct.' The Dower Act was replaced in 1978 by the Family Law Act in Ontario. (McGarry and Wade, *The Law of Real Property*, p. 517.; Linda Davey)

Compare with: 'Of this cabin the wife was the absolute mistress; and not only was this true of the cabin and all that it contained, but "C'est en elles que réside toute l'autorité réelle: le païs, les champs et toute leur récolte leur appartiennent". This statement is made without the least qualification by the author from whom I quote, and as an evidence of its truth we find that it was distinctly asserted at a council held in 1791. At that council, the women told Col. Proctor, the American Commissioner, "...you ought to hear and listen to what we, women, shall speak, as well as the sachems; *for we are the owners of this land* – and it is ours"'. (Lafitau, *Moeurs des Sauvages Americains*, vol. I, p. 72; Carr, *On the Social and Political Position of Women Among the Huron-Iroquois Tribes*, pp. 216-7)

Aarendarhonon, Aattigneenongnahac, Attignawantan, Tahontaenrat = Huron Confederacy.

Cayuga, Mohawk, Onandaga, Oneida, Seneca = Five Nations Confederacy.

Huron = Wendat = Wyandot of south-western Ontario/northern US.

Leni Lenape = Delawar = Delaware Nation (three divisions).

Mingoe = Five Nations Iroquois who moved south-east of Lake Erie.

Mississauga = Ojibwa east of Brantford and north of Kitchener.

Munsee = Monsey = Muncey = Delaware Nation (northern division).

Neutral = La Nation Neutre = Attawandaron (Huron name for them).

Odawa, Ojibwa, Pottawatomie = Three Fires Confederacy.

Odawa = Ottawa = Ottoway = Outaouak = Outaouas = Ooutaoüas.

Ojibwa = Odgiboweke = Ochipoué = Chippeway = Chippewa = Saulteur.

Pétun = Tionontaté (allies of the Huron) = Wyandot.

Pottawatomie = Pattawatina = Poutéouatami = Pouteoüatemi.

Sac = Sauk = Sack = Saukie = Saqui = Ousaki.

Saugeen = Ojibwa from the Saugeen River community.

Shawnee = Shawanoe = Chaouanon = Chaoüanon.

Tuscarora = Iroquois Nation who joined the Five Nations Confederacy.

Unami = Delaware Nation (southern division).

8600 BC to 1800

Part One

c. 8600 BC:

♥ Paleo Period: Small, mobile groups of hunter-gatherers live around London in camps or way-stations (Dorchester site). 'Climate and vegetation was comparable to that of the modern sub-arctic of Canada's northland.' (Ellis, Deller, 'Paleo Indians,' p.43)

c. 7000 BC:

♥ Archaic Period: Archaic campsites and populations are larger than those of the Paleo Period. Longer seasonal occupations of campsites. There are fall or winter camps around London (there is a terminal Archaic site located near Blackfriars Bridge). (Ellis, Kenyon, Spence, 'The Archaic,' p. 65 ff.; Spence phone conversation February 15, 1992)

c. 1000 BC:

♥ Early Woodland Culture: 'Archaeologists arbitrarily define the beginning of the Early Woodland as that time when ceramics first appear.' This culture uses small fall camps for deer and nut processing. Temporary fishing camps are used in the spring. New communities are created by fission (Pond Mills site). (Spence, Pihl, Murphy, 'Cultural Complexes of the Early and Middle Woodland Periods,' p. 125 ff.; Ferris interview May 1991; note Sept. 1991)

c. 200 BC:

♥ Middle Woodland Culture: There are patrilineal bands with open band memberships in this culture. Macro-band settlements exist in the spring and micro-bands in the summer. There are now well developed trade or exchange networks. (Pond Mills, Dingman's Creek at Bradley Ave. sites). (Murphy, Pihl, Spence, 'Cultural Complexes of the Early and Middle Woodland Periods,' p. 142 ff.; Spence phone conversation February 15, 1992)

c. 500:

♥ Princess Point Culture: Corn horticulture is introduced during this time. There are village settlements located on the Ekfrid sand plain, the Ingersoll moraine, lakeshores, and prairie borders. There is dense forest over much of southern Ontario. 'Clay soils remained wet throughout much of the year.' In the winter, small groups dispersed along smaller streams and drainages (Highbury and Commissioners' Road site). (Ferris interview May 1991; Fox, 'The Middle to Late Woodland Transition,' p. 174 ff.)

'Moraine. A knobby ridge either of (a) boulder clay built by a thrust of a glacier or of (b) gravel and sand deposited at the edge of a glacier by escaping melt water.' (Chapman and Putnam, *The Physiography of Southern Ontario*, p. 370)

'*Ingersoll moraine*. This moraine, the first south of the Thames River, does not touch the town of Ingersoll but swings away from the river along the boundary of West Oxford Township. It skirts a group of drumlins, then turns northward to the river again east of Woodstock crossing No. 2 Highway three or four miles east of the city. West of Woodstock it is silty clay till with a few kames while its extension, found in the disconnected morainic hills between Woodstock and the Nith River, consists of loose, loamy or sandy till.' (Chapman & Putnam, *The Physiography of Southern Ontario*, p. 61)

c. 800:

'The current evidence indicates that the region between Lakes Huron and Erie was heavily populated in pre-contact times. Anthropologists have identified these people as being of the "Younge tradition" which might be either Algonkian or Iroquoian in origin.' (Leighton, *The Historical Development of the Walpole Island Community*, p. 5)

c. 900:

♥ Early Ontario Iroquoian Culture: The Ekfrid sand plain south west of London is the western limit of the Glen Meyer branch of the Early Iroquoians. There are camp, hamlet, village components in this culture. Village life is based on agriculture (corn, squash, beans). There is a gradual increase in corn use. Camps are adjacent to river flats and large marshes.

They are used episodically by fishing, hunting and collecting parties from larger settlements. Hamlets are villages in miniature, single homes with palisades. Villages are built in beech/maple zones, away from major waterways, on sandy soil. They are palisaded. The palisades may have expressed permanence as well as being for defence. The society was possibly matrilineal. Southdale Road, Byron, Pond Mills, and Westmount Mall sites. (Williamson, 'The Early Iroquoian Period of Southern Ontario,' p. 291...; Ferris interview May 1991)

c. 1200:

♥ Middle Ontario Iroquoian Culture: Most but not all Middle Iroquoian villages are palisaded. 'Classic, long "cigar shaped" longhouses first appear in the 14th century.' There is a substantial increase in house length. Middle Iroquoian longhouses vary in length from 6 metres to 45 metres. The first local use of five cultigens (corn, beans, squash, sunflowers, tobacco) in one village occurs in this culture. Highbury and Commissioners' Road (Bryan), Pond Mills, and Westmount Mall sites. (Dodd et al, 'The Middle Ontario Iroquoians,' p. 321 ff.; Ferris interview May 1991; Spence interview May 1991)

c.1400:

♥ Bob Calvert, an archaeologist from Hamilton, discovers Middle Ontario Iroquois pottery fragments and other artifacts at the intersection of Foxbar Creek and the old bed of the Thames River, near the present site of the Moose Lodge on sub-lot 5, 6 Weston Street. The discoveries are made around 1947. (Ferris conversations, December 1991 and February 15, 1992)

Before 1500:

♥ Chert chippings are found on the surface at the top of the old river bank at the rear of 38 Weston Street indicating the existence of camps along the river before 1500. (Ferris conversation, September 1992)

c. 1500:

♥ La Nation Neutre/Neutral/Attiuoindaron/Attawandaron/ Attiwandaronk inhabit at least four large towns (over 1000 people in each), located on the perimeter of the present city of London. They also occupy smaller

villages, camps (Meadowlily Woods) and a very large longhouse (Southdale site) in the same area. The towns are not on the Thames River with the exception of the Norton site which is about 1 kilometre south of the present bed of the Thames and a site shown on the town plan of Waubuno by William McClary in 1855. Waubuno is located on River Road on the north side of the Thames River opposite lot 1, broken front, Westminster. (This site was not found when the area was investigated by archaeologists in 1990.) Most of the other sites are located on the Ingersoll moraine.

'The known distribution of Iroquoian sites within the city includes four distinct site clusters. Three of these clusters involve primarily Late Iroquoian sites (ca. 1400-1500 AD) and are found in the northwest, southwest, and southeast corners of the city. This evidence (size, location, lack of debris) leads to the speculative but intriguing hypothesis that the Southdale site may have served a socio-political function as a meeting house, built on neutral ground, where chiefs from the surrounding communities may have gathered to hold tribal councils.' The Neutral towns were interacting communities. They were not formally organized as tribes.

An investigation of the Thames River valley at the Adelaide Street Bridge, in July 1991 by the Lawson Museum, revealed no evidence of Neutral or other pre-historic activity. Neutral towns: Lot 33 concession B, S1/2 Lot 21, lot 22 Westminster, Spettigue's Pond, east of Highbury Avenue south of Bradley Avenue (Pond Mills site/Brian site). The area bounded by The Second Concession Road, Southdale Road, Wonderland Road and Highway 2 (Pincombe site). Kensall Park, north of Springbank Drive, west of the sewage plant, south of the bikeway lot 34, broken front Westminster (Norton site). Medway Creek at Wonderland Road (Lawson site). South London sites include: Cove Road Bridge – lot 32, broken front Westminster, and Tecumseh Avenue at Edward Street – lot 30, broken front Westminster, and camps in Meadowlily Woods. (Canniff, *The Settlement of Upper Canada*, p. 369; Ferris interview Apr. 1991; Keron, *Kewa*, April 1981, pp. 2-6; Spence interview May 1991; Pearce interview July 31, 1991; Timmins, Southdale: A Multi-Component Historic and Prehistoric Site in London, Ontario, pp. 18-20)

'The Lawson site is one of several sites of the same culture in London Township (One on lot 17 and another on lot 18, con. IV, one on lot 26, con. III, one on the Norton farm on the Pipe Line road, and another on lot at the

corner of Edward and Tecumseh Sts., London) as well as in Westminster Township (on Parks lot and McArthur farm, London South, and on the Thomas farm near Lambeth, on the E. Hodgetts farm, north of Talbot road, on the Nixon farm near Pond Mills (lot 18 con. I) and on lot 33, con. B, known as the Bogue farm).' (Wintemberg, *Lawson Prehistoric Village Site, Middlesex County Ontario*, p. 2)

after 1400:
♥ Large scale conflict occurs between the Neutral Nation and the Western Basin culture. (Trigger, *Natives and Newcomers*, p. 107)

♥ 'Thus by the start of the 15th century much of southwestern Ontario had been abandoned and remained so until well into the historic period.' 'Actually we are referring to another archaeologist's view here. We feel that South-Western Ontario was abandoned more around the second half of the sixteenth century.' (Ferris note, Sept. 1991; Murphy and Ferris, 'The Late Woodland Western Basin Tradition in Southwestern Ontario' p.272)

c.1550:
The Neutral Nation gradually withdraws to east of the Grand River, and the Western Basin culture retreats to the St. Clair lowlands. 'Creating a buffer zone between themselves and the Fire Nation is a more plausible explanation for the Neutral migration since an intensity of hostilities between these groups is clearly evident by the presence of extensively fortified 16th century settlements, generally with earthworks, on both Neutral and Western Basin Tradition sites.' Contact between these two cultures continues either through warfare and the capture and intermarriage of female prisoners or through trade and intermarriage. (Lennox and Fitzgerald, 'The Culture History and Archaeology of the Neutral Iroquoians,' p. 438; Trigger, *Natives and Newcomers*, p.107; Trigger, Yaffe, Daudet, Marshall, Pearce, 'Parker Festooned Pottery at the Lawson Site,' p. 9)

c. 1550:
The Attawandaron/Neutral (Chief Tsouharissen)/Quieunontati (Gens du Pétun) form an alliance with: the Huron (Wendat, Wyandotte), Wenrohronon, and Erie (Erieehronon) Nations. (Ferris interview, Apr. 1991;

MacDonald, *The Uncharted Nations*, p.198; Riley phone conversation, May 1991)

['The Huron name for this group, Erieehronon, was construed by the French to mean Nation du Chat. They were so-named, it was stated, for the great numbers of wildcats in their country. It is likely, however, that the Huron word the French translated as "cat" (*tiron*) actually meant racoon.' (Trigger, *The Children of Aateantsic*, p. 96)]

c. 1590:

♥ 'It is important to stress that, for the 100 years or so prior to settlement by Ojibwa groups, the region of southwestern Ontario was largely abandoned as the result of various hostilities extending for the latter part of the 16th century through to the second half of the 17th century. French visitors and travellers who passed through southwestern Ontario along Lake Erie and through to Lake Huron during the 1670's and 1680's, such as Hennepin [Jean Louis Hennepin, Recollet friar, France 1640-France 1705], Tonti [Henri de Tonti, France 1650-Mobile, Alabama 1704], Galinée [Renée François Bréhant de Galinée, Sulpician priest, died in France, 1678], and Lahontan [Baron de La Hontan, army officer, passed through Windsor region in 1747], all reported no Native settlements, although they invariably commented on the abundance of game in the region and its suitability for settlements.' (Ferris, *Continuity Within Change: Settlement-Subsistence Strategies and Artifact Patterns of the Southwestern Ontario Ojibwa AD 1780-1861*, p. 23; La Jeunesse, *The Windsor Border Region*, pp. xxxvi, 4, 8, 9)

c. 1600

Attawandaron/Assistaeronon (Nation de Feu/Central Algonkian /Mascouten) conflict forces the Attawandaron Nation further east to Burlington area. The area around the forks of the Thames River is deserted. (Ferris interview, Apr. 1991; Trigger, *Natives and Newcomers*, pp. 107, 223)

1615:

Etienne Brûlé [c.1592-1633] travels to Neutral territory, initiating direct European/Attawandaron (Neutral) contact. (Trigger, *The People of Aataentsic*, p. 305)

Oct. 18, 1626:
Father Joseph de la Roche Daillon [d. Paris 1656], Grenolle, and La Vallée travel to the Pétun (Tobacco) and Attawandaron (Neutral) Nations where they meet Chief Neintahoy at the first Attawandaron Village, Chief Souharisen at the sixth Attawandaron village, and ten men from the farthest village, Ouroronon. (Joseph de la Roche Daillon [Recollet friar], letter of July 18, 1627, written at the Huron village of Toenchain, translated by H. Langdon, *Kewa*, December, 1981, pp. 2-7; Gingras, *Dictionary of Canadian Biography*, Vol. I pp. 420-1)

'Their powerful war chieftain Souharissen, with 10 Neutral tribes united under his rule, had far more political power than those of other groups whose chiefs had little control over their tribesmen.' (Noble, in Marsh, ed., *The Canadian Encyclopedia*, p. 1229)

1632:
'The Treaty of Saint-Germain-en-Laye returns Québec to France.' (*The Canadian World Almanac*, p. 48)

c.1640:
'Early in the 1640's, the Neutral won a series of spectacular victories over the Assistaeronon.' (Trigger, *The Children of Aataentsic*, p. 624)

Trade axes are found at the forks of the Thames River dating from around this time. (Ferris conversation, Aug. 19, 1991)

1643:
'The Neutral army captured and brought back 800 [Mascouten] prisoners, both male and female, torturing some of them.' (Noble, in Marsh, ed., *The Canadian Encyclopedia*, p. 1229)

1647:
The Assistaeronon destroy the principal town of the Tionnontaté /Pétun/Tobacco Nation. (Trigger, *The Children of Aataentsic*, p. 659)

1648:
The Mohawk, Onandaga and Seneca defeat and disperse the Huron/Wendat/Wyandotte. (Trigger, *The Children of Aataentsic*, p. 751)

1649:
The Mohawk, Onandaga and Seneca defeat and disperse the Tionnontaté/Pétun. (Trigger, *The Children of Aataentsic*, p. 777)

1650:
The Mohawk, Onandaga and Seneca defeat and disperse the Neutrals. (Trigger, *The Children of Aataentsic*, p. 790)

1652/1653:
'In July 1653 word reached Québec that a band of 800 Neutrals had wintered at Skenchioe, a place situated to the west of their historic tribal land [near Detroit]. This is the last reference to the Neutrals as a nation or as a tribe.' (Elsie McLeod Jury, *The Neutral Indians of Southwestern Ontario*, p. 21)

Summer 1654:
The Mohawk, Onandaga and Seneca defeat and disperse the Erie Nation. (Trigger, *The Children of Aataentsic*, p. 795)

♥ The Five Nations exert control over the area around the forks of the Askunessippi (La Rivière à La Tranchée/Thames River). (Trigger, *Natives and Newcomers*, pp. 263-73)

'The Mohawk, assured by a firm alliance with the Dutch and a growing supply of firearms, of which they and their allies had possibly 800 by 1648, seized the chance to destroy their old enemies. Their ideal of combining all their neighbours into one Iroquoian people in one land and the necessity of replacing their population, depleted by epidemics and warfare, seem to have been major contributory motives.' !!!(Heidenreich, 'History to 1650,' p. 491)

1663:
♥ Louis XIV makes New France a royal province. (*The Canadian World Almanac*, p.49)

July 1667:
♥ A treaty between the Five Nations and the French is signed; the Five Nations retain their hunting grounds in Central and Southern Ontario, but

their trading is curtailed in Québec and North of the Great Lakes. (Trigger, *Natives and Newcomers*, p. 284)

c. 1690:

♥ 'We learn that sometime during the late 17th and early 18th Century, the Chippewa and Ottawa nations arrived in this area and forced the Seneca, who apparently made use of the hunting grounds, back across the Niagara River.' Extended Ojibway family units occupy the London Regional Art Gallery grounds, Western Fairgrounds. (Ferris, *Continuity Within Change*, p. 18; Stott, *Witness to History*, p. 12)

c.1690:

♥ Around this time the area around the forks is named Pahkatequayang and the river is named Eskanh (antlered) ziibi (river) or Askunessippi by the Ojibwa. (Wilson, *Missionary Work Among the Ojebway Indians*, p. 80; Margaret Jackson, conversation 1991)

July 25, 1701:

Antoine Laumet, dit de Lamothe Cadillac [1658-1730] establishes a fort and trading settlement at *Ville d'étroit* (Detroit). 'By 1703 settlements of Ottawa, Pottawatomi, Wyandot and Ojibwa (on Walpole Island) settle into the region.' (Ferris, note Sept. 1991; *The New Columbia Encyclopedia*, p.415; Maude, in Marsh, ed., *The Canadian Encyclopedia*, p.254; Schmalz, *The Ojibwa of Southern Ontario*, pp. 30, 31; Trigger, *Natives and Newcomers*, p. 288; Lajeunesse, *The Windsor Border Region*)

July 1701:

At Montréal a treaty is ratified in which the Iroquois agree to remain neutral in wars between the French and English. (Marsh, ed., *The Canadian Encyclopedia*, p. 904)

1701:

♥ A peace treaty between Ojibwa and Five Nations is signed at Albany in what is now the United States.

1721:

'On Lake St. Clair he [Pierre François Xavier Charlevoix 1682-1761, Jesuit]

noticed a river with a wide mouth on his right, and was told that it was "navigable for four-score leagues (240 miles) without any rapid current, a rare thing in rivers of this country," but no one could tell him its name.' (Hamil, *The Valley of the Lower Thames* 1640 to 1850, p. 8; Lajeunesse, *The Windsor Border Region*, p. 26)

c. 1735:
Paris Documents: VIII. 'North of Lake Ontario. The Iroquois are in the interior and in five villages about fifteen leagues from the Lake, on a pretty straight line, altho' distant from each other one day's journey. This nation, though much diminished, is still powerful. Lake Saint Clair, which leads to Lake Huron. At the end of the little Lake Saint Clair, there is a small village of Mississagués, which numbers sixty men. They have the same devices as the Mississagués [Souter] of Manouatin and Lake Ontario; that is to say, a crane,....60. Lake Huron. I have spoken before of the Mississagués who are to the North of this lake. On the South side, I know only the Outawa, who have a village of eighty men at Saquinan, and for device the Bear and Squirrel,....80.' (Canniff, *The Settlement of Upper Canada*, p. 380; NYCD, vol. VIII, pp. 1056-8)

1744:
'The Thames River is first exhibited in Bellini's [Bellin's] map of 1744, but without giving it a name. Appended to this map is a note stating that it had been explored for eighty leagues from its mouth, without meeting a rapid or obstacle of any sort. Previous to and for a long time after this date it was called by the Chippewa Indians the "Ask-un-e-see-be" or the "Antlered River," alluding to its appearance at the forks. In 1745 it was called by the French trappers who frequented its neighbourhood, "La Rivière La Tranchée" or simply La Tranche by many of the older French Canadians who reside below Chatham.' (Poole, The Battle of Longwoods, p.57; Hamil, *The Valley of the Lower Thames*, p. 8)

1745:
La Rivière La Tranchée (Askunessippi) is changed to La Tranche. (Bremner, *Illustrated London*, Ontario, Canada, p. 20)

1755:
'Mitchell's map of the same year labels the Thames the "New River" and

this is followed by Thomas Kitchen on his maps of 1773 and 1794.' (Hamil, *The Valley of the Lower Thames*, p. 8)

c.1760:
♥ War Chief Sekahos [Seckas fl. 1763-1788] and extended Ojibway family units are present in the Askunessippi (Thames River) Valley from Lake St. Clair to east of the forks of the Thames River. Ojibwa hunting grounds are near Dorchester. Delbert Riley states that the Chippewa settled west of what is now Delaware 'because they liked it.' (Ferris, *Continuity Within Change*, p.25; Riley phone conversation, June 1991)

1764:
'Bellin's maps of 1764 call the Thames "Grande Rivière inconnue," or "Rivière peu connue."' (Hamil, *The Valley of the Lower Thames*, p. 8)

Feb. 10, 1763:
♥ The Treaty of Paris is signed and Canada becomes a British possession. (NIN.DA.WAAB.JIG, *Walpole Island*, p. 13)

Oct. 7, 1763:
♥ Royal Proclamation: George III creates Indian Territory where settlement and alienation of land is forbidden unless land rights are purchased by the Crown. Indian Territory is the area North and West of rivers draining into the Atlantic Ocean. It also erects the Government of the Province of Quebec. (This document is a major irritant to the American colonies and helps lead to their eventual independence.) (Foulds, in Marsh, ed., *The Canadian Encyclopedia*, p. 1491; Morris, *Indians of Ontario*, p. 5)

1763:
Chief Sekahos, Ojibway war chief of the Askunessippi (Thames River) community, with 170 warriors (including members of the Kettle Creek and Grand River communities) participates in The Pontiac Revolt including Odawa Chief Pontiac's [born near Windsor c.1720, died at Cahokia, Illinois, US in 1769] siege of Detroit. Warriors from his community capture 11 traders and 3 barges of supplies at the mouth of the Grand River. At the end of May with a party of Ottawas his warriors attack Lieutenant

Abraham Cuyler at Point Pelee where 46 English soldiers and 2 boats are captured. (Chevrette, Pontiac, *The Dictionary of Canadian Biography* Vol. IV, p. 528; Lajeunesse, *The Windsor Border Region*, p. lxxviii; Marsh, ed., *The Canadian Encyclopedia*, p. 1449; Ferris, *Continuity within Change*, p. 25; Schmalz, *The Ojibwa of Southern Ontario*, p.72)

1763:

The Delaware are formally adopted into the Iroquois Confederacy in New York. They had left what is now the state of Delaware in the United States shortly after 1720. They then moved to near the Lackawaxen Creek in what is now northern Pennsylvania. 'It would appear that the Grand River Delaware derived from the Alleghany.' 'In 1783 they inhabited a number of villages in the Niagara area on the American side.' In July or August 1783 they leave Issioha (near present day Buffalo). The Delaware had been established on the Grand as early as 1780. They settle near Cayuga in two villages. (Gray, *Wilderness Christians*, p. 14; Kjellberg, *Seeking Shelter: Canadian Delaware Ethnohistory and Migration*, pp. 10-14)

1763:

According to Oneida Chief Ninham, a group of British soldiers, survivors of the Ojibway/Sac attack on Fort Michilimakinac construct a rampart and palisade in Wyandotte corn fields between Hamilton Road and the Thames River near Dorchester (four miles east of the present London city limits). They are attacked and killed by the Wyandotte in 1765. (Stott, *Witness to History*, p. 12)

March 6, 1764:

Samuel Holland [served at Louisburg and the Plains of Abraham under Wolfe, c.1720-1801] is appointed Surveyor General of Québec. On March 23, he is appointed Surveyor General for the Northern District of North America. He serves until 1791 when he is appointed Surveyor General of Lower Canada. Holland appoints John Collins Deputy Surveyor General with the responsibility for surveys within the Province of Québec. (Finos, 'The Surveyors General in Ontario,' p. 32)

February 27, 1772:

'Next day the 27th, they kill'd two Dogs boiled [them] in a large Kettle, I

was obliged to give them two kegs more of Rum [] went out soon after and stood behind a tree, heard them say among themselves, they would kill me and then go to River Trange and [visit?] Negigs house, Men, Women, and Children eat part of the Dog and [].' This is part of a deposition by David Ramsay submitted to William Johnston at Niagara in May 15, 1772 in which rum trader Ramsay defends his actions in killing and scalping men, women and children at Kettle Creek (near Port Stanley) and Long Point. Negig was probably an Ojibwa chief who lived in the area between what is now London and Lake St. Clair. This declaration contains possibly the first written mention of a named person (Negig) living near London. (PSWJ, Vol. VIII p. 483)

1772:
'Peter Bell's map of 1772 calls it [Askunissippi/Thames River] the "New River," which name it retained, at least officially, until May 22nd, 1784, as shown by a land grant from the Indians to the Canadian Government of that date.' (Poole, *The Battle at Longwoods*, p. 56)

1774: ♥ The Québec Act attaches what is now Ontario to the Province of Québec. (Dean/Matthews, *Economic Atlas of Ontario*, plate 97; *The New Columbia Encyclopedia*, p. 2005)

1775:
The Colonial Authorities instruct Governor Carlton that 'No purchases of Lands belonging to the Indians, whether in the Name and for the Use of the Crown, or in the Name and for the Use of proprietaries of Colonies may be made but at some general Meeting, at which the principal chiefs of each Tribe, claiming a property in such Lands, are present...' (Johnson quoting Paterson, 'The Settlement of the Western District,' p. 21)

May 10, 1783:
Surveyor General Holland instructs Deputy Surveyor General Collins to examine land at Cataraqui and Niagara, resulting in the first survey under civil authority in what is now Ontario. (Finos, 'The Surveyors General in Ontario,' p. 32)

Oct. 13, 1783:
'Jacob Schieffelin, secretary of the Indian Department at Detroit, had, by

the use of liquor, persuaded a number of local Indian chiefs to sell him the entire area of Malden Township.' Governor Haldimand, on the recommendation of the Hesse Land Board (who desired the same land), laid aside his claim on April 26, 1784. (*The Dictionary of Canadian Biography*, Vol. 5; Johnson, 'The Settlement of Western District,' p. 21; Lajeunesse, *The Windsor Border Region*, p. 154)

Oct. 25, 1784:
'Treaty No. 3 (and indicated on compiled plan by letter "D") was made with the Mississagua Indians 7th December, 1792, though purchased as early as 1784. This purchase in 1784 was to procure for that part of the Six Nations Indians coming into Canada a permanent abode.' 'As shewn on the compiled plan "E" is a parcel or tract of land given to the Six Nations Indians by Governor Haldimand October 25th, 1784 (forming part of Lot Letter D and conveyed by grant the 14th of January, 1793).'

'Also that parcel (indicated on Compiled Plan by Letter "G") and known as No. 3 3/4, conveyed by the Principal Chiefs, Warriors and people of the Mississague Nation to the Crown (for the benefit of Chief Joseph Brant) on the 21st of August, 1797.' (Morris, *Indians of Ontario*, pp. 17, 19, 21)

The Patent of 1784, between Frederick Haldimand, Captain, General and Governor in Chief of the Province of Québec and Territories depending thereon etc. and the Six Nations, gives the Six Nations a tract of land 6 miles deep on each side of the Grand River from Lake Erie to the head of the river.

1783/1785:
Part of Minisink (Munsee, wolf totem), Lenni Lenape (Northern Delaware) Nation arrive in the Thames River Valley near Delaware from around Dunnville on the Grand River. Some travel on to Moraviantown sometime between 1785 and 1792. They settle near large river flats, south-west of what is now the village of Delaware ('an English name given to Ebenezer Allen's settlement, but which had nothing to do with the Monsey Indians or the Moravians' [Gray, *Wilderness Christians* p. 157]. 'It was named after an Indian tribe who removed from the United States and settled on the Thames River in Upper Canada. The name comes from Lord De la Warr of Warre, Governor of the English Colony of Virginia in the early years of the 17th century' [Armstrong, *The Origin of Place Names in Canada*, p.80], east

of the Chippewa community, where they can cultivate corn. Their village is called Munseytown (now Muncey). Traditional family names include; Snake (Ahook), Peters, Dolson (originally Dutch). (Kjellberg, *Seeking Shelter* pp. 2, 13, 45; Roberta Miskokomon phone conversation June 25, 1991; Gray, *Wilderness Christians*, p. 14 ff.)

'It is generally accepted that, this group [the Delaware] sought permission from the local Ojibwa to settle along the Thames.' (Ferris, *Continuity Within Change*, p. 70)

'They [the Delaware] had been permitted to live there by the Chippewa Indians.' (Kjellberg, *Seeking Shelter*, p. 46)

Roberta Miskokomon states that the Munsees arrived on the Thames before the Chippewas. (Miskokomon phone conversation, June 1991)

The Delaware community was fixed while the Ojibway were dispersed along the river in small hunting and sugaring camps. (Ferris, *Continuity Within Change*, p. 70 etc; Gray, *Wilderness Christians*, pp. 71, 153) (The Moravian Delaware included Unami/Delaware and others who came from the southern range of the Delaware Nation. They were members of the Turtle clan. They settled with Moravian missionaries farther down the Thames near Thamesville around 1798.)

July 24, 1788:
♥ Guy Lord Dorchester, Governor-General, 'at Our Castle of Saint Lewis, in Our city of Quebec,' divides Canada into four districts by proclamation. The forks area is in the district of Hesse, with its capital at Detroit. [The District of Hesse is the area west of a line running north from Port Dover through Penetanguishene.] (Dean, *Economic Atlas of Ontario*, plate 98; Lajeunesse, *The Windsor Border Region*, p. 105; Priddis, 'The Naming of London Streets,' p.7)

Sept. 20, 1788:
Chippeway Chiefs: Aquetakami, Bacacaban, Boiniashy, Chaboquoi, Iatowaywinasy, Kagaian, Kenow, Ketchieanaway, Kicasen, Kikeniny, Kitchiamick, Mequokicon, Meshinaway, Mesquonebin, Mocan, Naganigapoway, Namegouse, Nawiseseneby, Nebisdoquoi, Nesseloganny, Newitchieapoway, Okiway, Otanoy, Oteakitchiwanoaquoy, Ottamagan,

Pandigecawa, Pekikan, Pesintaway, Quiwatisshoam, Seckas, Sheneau, Teckamegasey, Wabinaqui, Wabisy, to Jonathon Schieffelin [merchant 1762-1837]: on the North side of the Eshean Sippy (Eskunessippi/ Eskonne/The Horns/Rivère La Tranche/Thames River), from Sarah Willson's farm (near Chatham), 20 leagues up the river (60 miles, the present site of London) then 4 leagues into the woods. Deed written on deerskin, registered at Fort Detroit, Province of Quebec. This deed, which was not recognized by the Hesse land board, was the first Euro-Canadian deed for the present site of London. (BHC; Ferris interview, May 1991; Gray, Wilderness Christians, p. 91; Hamil, *The Valley of the Lower Thames*, pp. 11-14; Hamil, *Sally Ainse, Fur Trader*, pp. 2, 5, 12)

Jacob Schieffelin II, born on February 4, 1732 in Waldheim, Germany and Regina Margaretha Kraften Ritschaueren, born on September 9, 1731 in Mulhaus, Ender Ense, were married on September 16, 1756 in Germany. Their first child, Jacob III was born in Philadelphia on August 24, 1757. Another son Jonathon was born on July, 16, 1762, probably in Philadelphia. Jonathon and Jacob both became traders. Jacob was secretary to Major De Peyster, commandant of Detroit in 1781. Lieutenant Jonathon Schieffelin was a member of Louis Chabert Joncaires' company of Detroiters. With them he took part in Captain Henry Bird's invasion of Kentucky and several other expeditions on the British side in the Revolutionary War. In 1793 he petitioned for half pay. Jacob left Detroit for Montréal around 1783 but Jonathon remained. He retained British Citizenship under the terms of Jay's Treaty in 1796. He ran for the North West Assembly in 1800 but there were objections because he was not an American citizen. He recanted his British citizenship and was elected to the Assembly where he served from 1801 to 1803. He was subsequently voted the freedom of the Corporation of Detroit. By 1827 he was living in New York City where he died on about March 12, 1837. On March 14, 1837 he was buried at St. Mary's Episcopalian Church at 521 West 126th Street in Manhattan-Ville, New York, US. Jacob II had pre-deceased him in the same city on April 16, 1835. He was buried in the same cemetery. (BHC, including John Askin Papers, Vol. I, p. 316)

The headmen draw their totems on legal documents to indicate their assent. These drawings are copied by Euro-Canadian clerks when true copies of cessions are made. 'totem n. [<Algonk.; cf.Ojibwa *ototeman* his brother

sister kin] 1a. among certain Indian peoples, a spirit in the form of a creature or plant with which a group, such as a family, and its members are identified, and which is supposed to watch over each of them 1b. a graphic representation of such a creature or plant' (Avis, *A Dictionary of Canadianisms on Historical Principles*, p. 793)

May 19, 1790:
♥ Council held at Detroit with the Ottawa, Chippawa, Pottawatomy, and Huron Nations. 'E·gouch·e·ouai, Chief of the Ottawas in the name of the Lake Confederacy arose and spoke, 'Father. We are now within the Paternal House where everyone is free to Speak his mind; therefore Father, I request you to hear me; I request the Same of our Fathers the Officers, our Brethren the Merchants and of all you my Brothers of my own Colour, Indians of different Nations. Father. you have told us that you have received letters from our Father the General, and our Father Sir John Johnson acquainting you that our Father the Great King had written to them, to know if we would cede him a Piece of Land extending from the other side of the River to the line of that ceded by the Messesagas. Father. Is there a Man amongst us who will refuse this request? What man can refuse what is asked by a Father so good and so generous, that he had never yet refused us anything? What Nation? None Father! We have agreed to grant all you ask according to the limits settled between us and you, and which we are all acquainted with. We grant it you all Father, in presence of our Fathers the Officers and our Brothers the Merchants.'

E·gouch·e·ouai. Speaking to the Hurons. "Brothers. Altho' we have granted the Land on the other side of the River to our Father, we have not forgotten you. We always remembered Brothers, what our ancestors had granted you, that is to say Brothers, from the Church to the River Jarvais, as well as a piece of Land commencing at the entry of the River Canard extending upwards to the line of the Inhabitants, and which reaches downwards beyond the River au Canard to the line of the Inhabitants.' 'Father. You have heard what I have said, I request you Father not to suffer our Brothers the Hurons to be molested, and you Brothers the Hurons, that you will not molest our Brothers the Inhabitants. This is all I have to say, I salute you and all my Brothers here present, as well as all the Indians of the different Nations present and as a proof that all we have agreed to is done from our Hearts, we are ready to sign our marks. – Father. I request you

produce the Deed, the contents of which have been already explained to us, that we may Sign it in the presence of our Fathers and Brothers.'

Captain McKee spoke 'The Commanding officer having returned your thanks on behalf of your Father the King. It remains now only with me to pay you the consideration agreed upon, which shall be done tomorrow, so soon as your several Nations are assembled for the purpose.' (PAC, RG10 Ser. 11 Vol. 13)

♥ Chippewa Chiefs: Cha-bou-quai, Essabance, Mesh-qui-ga-boui, Nan·gie, Ouit-a-nissa, Ti-e-cami-go-se, Wa-ban-di-gais, Wasson. Pottowatomie Chiefs: E-sha-ha, Key-way-te-nan, Met-te-go-chin, Pe-nash, Shè-bense, Sko-neque. Huron Chiefs: Dow-yen-tet, Meng-da-hai, Mon-do-ao, Rou-nia-hy-ra, Sas-ta-rit-sie, She-hou-wa-te-mon, Ska-hou-mat, Son-din-ou, Ta-hou-ne-ha-wie-tie, Ted-y-a-ta, Te-ha-tow-rence, Tren-you-maing, Tsouh-ka-rats-y-wa. Ottawa Chiefs: At-ta-wa-kie, Egouch-e-ouay, En-dah-in, Ki-wich-e-ouan, Maug-gic-a-way, Ni-a-ne-go, O-na-gan, Wa-wish-kuy: to Alexander McKee, Deputy Superintendent General and Deputy Inspector General of Indians [White Elk, c.1725-Jan. 4, 1800] for the Crown, in a line South from the Thames River to the mouth of Rivière au Chaudière or Catfish Creek (Port Bruce), westward along the shores of: Lake Erie, the Detroit River and Lake St. Clair to the mouth of the Chenail Ecarté, and up the Chenail Ecarté to its 1st fork then in a line due East until that line intersects the Thames River, then up the Thames River to the place of beginning. £1200 (Québec currency) or .214 pence per acre, paid in merchandise, including: 12 dozen ivory combs, 12 dozen horn combs, 30 dozen looking glasses, 39 gallons of rum, 20 dozen plain hats, 24 laced hats, 400 lbs. tobacco. McKee Treaty or Surrender #2, signed at Detroit. (Clifton, 'The Re-emergent Wyandot: A Study in Ethnogenesis on the Detroit River Borderland, 1787,' p. 12.; Gray, *Wilderness Christians*, p. 56; Hamil, *Sally Ainse, Fur Trader*, p.14; Jacobs, *Indian Land Surrenders*, p. 64; Leighton, *The Historical Development of the Walpole Island Community* app. B4)

'The lodge itself with all its arrangements is the precinct of the rule and government of the wife. She assigns to each member his or her ordinary place to sleep and to put their effects. These places are permanent and only changed at her will....Husband has no voice in the matter....In the lodge

the man may be looked upon as the guest of his wife.' (Schoolcraft, *Indian In His Wigwam*, pp. 73, 77). These passages, which refer to the Ojibway, could suggest that those cessions which are not signed by principal women, do not have the full approval of the Ojibway Nation. (Frank Davey conversation, Aug. 5, 1991) 'Not so, Ojibwa are a patrilineal group. Also, in matrilineal groups like the Iroquois, males still made decisions publicly (although the degree of influence on male decision-making by women was likely heavy).' Ferris note, Sept. 1991.

The Ojibway (Chippewa), Pottawatomie, Wyandotte (Huron) and Odawa (Ottawa) men who signed the cessions usually had some knowledge of English or French and had varying degrees of consent from the nations they represented. Some were government chiefs, that is they were in the pay of the Crown. Wapinose (1) would seem to have been a government chief. He negotiated with Chippawas and Missassaugas during a survey at Lake Simcoe in 1794 when they objected to his involvement with the survey and with the potential and subsequent sale of their lands. (Schmalz, *Ojibwa of Southern Ontario*, pp. 72, 107; conversation with Dean Jacobs, July 4, 1991, Walpole Island; Jacobs, *Indian Land Surrenders, The Western District*, Essex County Historical Society 1983 pp.64...)

May 20, 1790:
♥ Alexander McKee paid the Lake Confederacy £1200 in goods for Surrender #2.

May 21, 1790:
♥ 'Gentlemen

I take the earliest opportunity of informing you that the Cession from the Indians to the Crown is now completed according to the limits specified in a resolve of the Land Board of the 7th December last excepting the Land between the Huron Church and and Rivière au Jarvais, running in depth one hundred and twenty arpents which is reserved for the Hurons; and a tract beginning at the Indian officers Land running up the Strieght to the French Settlement and seven miles in depth, which the Indians have also reserved the rest will be entered into the Register and then transmitted to the Superintendent General.

I have the honor to be
Gentlemen
Your Most Obedient Servant
[Signed] A. McKee'
(Archives of Ontario, reel 180)

before 1790:
The Detroit Path is shown on the plan of cession #6 of 1796, drawn for D. W. Smith acting Surveyor General on March 22, 1793. It runs from the Mohawk village on the Grand River north-west to the Thames River where it crosses the river two miles west of present day Nilestown. It runs west until it crosses the river again near Dorchester and gradually curves south-west to the Delaware Village (Muncey). (Gray, Wilderness Christians, p. 152; Leighton, *The Historical Development of the Walpole Island Community* app. B2.

Oct. 1790:
Patrick McNiff [deputy surveyor for the District of Hesse] begins to survey the District townships and to front them on the Thames River. (Hamil, *The Valley of the Lower Thames*, pp. 6, 16)

January or February 1791:
David William Smith [1764-1837], an officer of the Fifth Regiment of Foot is appointed Acting Surveyor General of Upper Canada by Lieutenant Governor John Graves Simcoe [England 1752-England 1806]. His position is confirmed in 1797. In 1792 he is elected to the Upper Canada Assembly as representative for Essex County. He later becomes Speaker of the Assembly. (Finos, 'The Surveyors General in Ontario,' p. 33; Lajeunesse, *The Windsor Border Region*, p. 108)

March 24, 1791:
'Mr. [Alexis] Maisonville [L'Oranger dit Maisonville] warden of Assumption parish before 1781] is in the actual possession of the best farm in the settlement of Detroit (the farm he now personally occupies) which he holds from no better authority, of title, than I do a tract of eighty leagues situate à là riviére á lá trenche,...', letter from Jonathon Schieffelin to David William Smith acting Surveyor General. (Hiram Walker Museum, Windsor Public Library; Lajeunesse, *The Windsor Border Region*, pp. 307, 349)

1791:
♥ The Canada Act provides for the division of the Province of Québec into the Provinces of Upper and Lower Canada. Westminster is in the Western District of Upper Canada. The district's eastern limit is the same as the eastern limit for the District of Hesse. (Dean, *Economic Atlas of Ontario*, plate 97/98; Priddis, 'The Naming of London Streets,' p.7)

Feb. 4, 1792:
Governor Simcoe, Major Littlehales [Military Secretary], Captain Fizgerald [5th Regiment], Lieutenant Smith [5th Regiment], Lieutenant Talbot [Provincial Aide-de-Camp], Mr. Gray [Solicitor General], Lieutenant Givens, travel in sleighs to Sandwich from York. On March 2, Littlehales writes 'Various figures were delineated on trees at the forks of the River Thames, done with charcoal and vermilion. The most remarkable were the imitation of men with deer's heads.' (Bremner, *Illustrated London, Ontario, Canada*, p.17; Canniff, *The Settlement of Upper Canada*, p.513; Goodspeed, *The History of the County of Middlesex*, p.567; Mealing, in Marsh, ed., *The Canadian Encyclopedia*, p.1699.

July 16, 1792:
The name of La Tranche (Askunessippi) is officially changed to the Thames River by Governor John Graves Simcoe and Royal Proclamation. (Bremner, *Illustrated London, Ontario, Canada*, p.20; Priddis, 'The Naming of London Streets,' p.8)

July 16, 1792:
♥ Governor Simcoe and the Parliament of Upper Canada divide Upper Canada into 19 Counties. (Dean, *Economic Atlas of Ontario*, plate 98; Priddis, 'The Naming of London Streets,' p. 8)

Dec. 7, 1792:
Messissague Indian Nation: Principal Chiefs; Kautabus, [Mattatow, amended version/1793], Nanaughkawestrawr, Nannibosure, Nattoton, Peapamaw, Peasanish, Pokquawr, Sawainchik, Tabendau, Wabakanyne, Wabanip, Wabaninship, Wapamanischigun, Wapeanojhqua, Sachems, War Chiefs, and Principal Women to the Crown, 'and Our Sovereign Lord George the Third'; 'all that tract or parcel of land lying and being between

the Lakes Ontario and Erie, beginning at Lake Ontario 4 miles south west-
erly from the point opposite to Niagara fort known by the name Messissague
Point and running from thence along the said lake to the creek that flows
from a small lake into the said Lake Ontario known by the name of Wash-
quarter; from thence a north westerly course until it strikes the River La
Tranche or New (Thames) River; thence down the stream of the said river to
the part or place where a due south course will lead to the mouth of Cat Fish
Creek (Port Bruce) emptying into Lake Erie, and from the above mentioned
part or place of the aforesaid River La Tranche following the south course to
the mouth of the said Cat Fish Creek; thence down Lake Erie to the lands
heretofore purchased from the Nation of Messissague Indians; and from
thence along the said purchase to Lake Ontario at the place of beginning as
above mentioned-.' Surrender #3 (Jacobs, *Indian Land Surrenders*, p.64;
Canada, *Indian Treaties and Land Surrenders*, Vol. I, pp. 5-7; Morris, *Indians of
Ontario*, p. 11; Schmalz, *Ojibwa of Southern Ontario*, p. 79)

1793:
Thomas Ridout joins the office of Surveyor General Smith at York as chief
clerk. (Finos, 'The Surveyors General of Ontario,' p. 33)

Jan./Feb., 1793:
♥ Survey of the River Thames or La Tranche by Augustus Jones: from the
Delaware Village to the upper forks or Oxford. At 163 chains 30 links east of
the forks: ♥ 'Across flat at 12 chains the river 3 chains off narrow flat N 19°
30'W" (the north limit of lot 25).' At 169 chains 30 links: 'Narrow flat, high
ridge back N 60° E" (the north limit of lots 24 or 23).' (Jones, survey notes p.
7, RCWL)

Augustus Jones was born in 1757 or 1758 on the Hudson River in New York
State. He was trained as a surveyor in New York City and was hired upon
completion of his training (around 1792) by Governor Simcoe as a King's
Deputy Provincial Surveyor. Smith states that he moved to Canada in 1788
and was followed by his father and several of his brothers and sisters. He
maintained a relationship with Tuhbenahneequay, the daughter of
Mississauga/Ojibwa Chief Wahbanosay, at the same time that he married
Sarah Tekerihogen, the daughter of Mohawk Chief Tekarihogen. He fath-
ered at least two children with Tuhbenahneequay including Kah-ke-wa-

quo-na-by (Waving Sacred Feathers) or the Reverend Peter Jones, a noted Wesleyan Missionary. In 1824 Augustus Jones had a farm near Brantford. Augustus Jones died on November 16, 1836 at his home on the Grand River near Paris. (Kahwewaquonaby [Peter Jones], *Life and Journals of* KAH-KE-WA-QUO-NA-BY, pp.1-2, 380; Smith, DCB, vol. VII pp. 450, 451)

March 16-9, 1793:
There is a heavy flood of the Thames River. (Hives, *Flooding and Flood Control*, p. 178)

summer 1793:
'Chippewas, Monseys, Onandagas and Mohawks, including Thayendanegea, (Captain Joseph Brant [b.near Akron Ohio 1742-d.Burlington Bay 1807]), pass down the Thames River on their way to the Miami [Maumee] Treaty Council to demand 'the demolition of all forts north and west of the Ohio, "and that River for a boundary forever".' There are few women present which indicates a war council. This council results in Jay's Treaty. (Gray, *Wilderness Christians*, p. 115)

1793:
Patrick McNiff [deputy surveyor, born in Ireland-died in Detroit May 1803] draws a map of the Thames River or La Tranche using his own and Augustus Jones' field notes. In 1796 he moves to Detroit when it falls under American control. The Commandant of Hesse, Colonel England, describes McNiff as 'a troublesome, radical character, who had been concerned in improper conduct towards some officers of the government.' 'When the Americans occupied Detroit in 1796 he did not choose to remain a British subject, and automatically became an American citizen.' (Hamil, *The Valley of the Lower Thames*, p. 24; Lajeunesse, *The Windsor Border Region*, p. 178; RCWL)

March 1794:
Governor Simcoe visits the forks of the Thames again. 'It would appear that he went overland to the river, striking it about Ingersoll; there took boats, and followed it down to Detroit, stopping at the forks; the return trip was made by way of Lake Erie.' (*London and Middlesex Historical Society Transactions*, VIII, 1917, p. 17)

August 1794:
'Flotillas of canoes carrying grotesquely painted warriors to the war zone of the Miami, swept downstream' on the Askunessippi/Thames River. They are travelling to the grand council at Brownstown, called by the Wyandot. Ottawas, Ojibway, Pottawatomies, Delawares, Muncies, and the Six Nations are present. The attending nations 'decide to remain neutral in any struggle between the British and Americans.' (Goltz, 'The Indian Revival Religion and the Western District, 1805-1813,' p. 25; Gray, *Wilderness Christians*, p. 124)

November 19, 1794:
Jay's Treaty is signed by Britain and the United States. It 'provided for British evacuation of the Northwestern posts [including Detroit] by June 1, 1796, allowing settlers the option of becoming Americans or remaining British citizens, with full protection of property guaranteed ... and free trade between the North American territories of the two countries.' (Gray, *Wilderness Christians*, p. 115; *The New Columbia Encyclopedia*, p. 1405)

June 1795:
Abraham Iredell [loyalist b.Penn. USA-d.1806] is appointed deputy-surveyor for the Western District. (Hamil, *The Valley of the Lower Thames*, pp. 24, 138)

Sept. 29, 1795:
Agreement between principal Chiefs of the Chippawa Nation: Chab-a-qua, Che qua nunk com, Ke cha mak qua, Maa-Kounce, Mish-ke ka pana, Tick com a gasson; and Alexander McKee [c.1725-1799], Deputy Superintendent and Deputy Inspector General of Indian Affairs on behalf of George III, 'We will execute a Regular deed for the conveyance of the lands hereon marked Pink with a red line on the extremities to and for the use of his said Majesty being twelve miles square for a proposed Township on the North side of the River Thames formerly the River La Tranche and also all the lands to the Eastward of the Southpoint of the Easternmost sideline of the said Twelve square miles also on the North side of the said River Thames until the said red line [Dundas Street/Highway #2] strikes the Upper Forks of the said River [Ingersoll].' 132,000 acres, £1200 Quebec currency value in Indian Goods. Provisional surrender signed on the banks of the

River Thames. (Jacobs, *Indian Land Surrenders*, p.65; Canada, National Map Collection; Canada, *Indian Treaties and Land Surrenders*, Vol. I, pp. 17-18)

Oct. 11 to 18, 1795:
There is a severe flood of the Thames River at this time. It ruins the Muncey corn crop. (Hives, *Flooding and Flood Control*, p. 178; Kjellberg, *Seeking Shelter*, p. 55)

Before June 1, 1796:
'it (Amherstburg) became the new base for the British after they evacuated Detroit. In 1796, Ft Maldon was established, and LOYALIST refugees laid out a townsite.' (Marsh, ed., *Canadian Encyclopedia*, p. 53)

Sept. 7, 1796:
Chippawa Chiefs: Annamakance, Camcommenania, Kiashke, Kitchymughqua, Macounce, Nangee, Nawacissynabe, Negig, Peyshiky, Ticomegasson, Wapenousa, Wasson, Wittaness, for the Chippawa Nation to Alexander McKee for the Crown: London Township, North of the River Escunnisepe [Thames] and from London to Ingersoll, south of Dundas Street to the river, £1200, Quebec currency value in goods, Surrender #6. (Denke 1990, p. 15; Gray, *Wilderness Christians*, p. 186; Hamil, *The Valley of the Lower Thames*, p. 69, Jacobs, *Indian Land Surrenders*, p. 65, Canada, *Indian Treaties and Land Surrenders*, Vol. I, pp. 17-18.; Schmalz, *Ojibwa of Southern Ontario*, p.107)

1796:
Peter Russell [Cork, Ireland 1733–September 30, 1808 Toronto], senior councillor and Receiver General of Upper Canada, becomes the chief administrator of Upper Canada [until 1799]. (Hamil, *Sally Ainse, Fur Trader*, p. 17; Lajeunesse, *The Windsor Border Region*, p. 191)

1797:
Nancy Waucash [fl.1862] is born in what is now London. She is a member of the Thames River Ojibwa community. 18 years later she will marry Thomas Waucash [1782–fl.1862], an Ojibwa from the United States and their first recorded child James will be born near Muncey on the Thames River.

c.1797:
Seth Putnam begins to clear Commissioners' Road from Ingersoll (Oxford) to Delaware. The road is financed by private subscription. It leaves the Detroit Path near Beachville and continues south of the river past the present site of London. It appears to rejoin the Detroit Path near Dorchester. (Gray, *Wilderness Christians*, p. 152) 'Commissioners' Road was built by a commission appointed by the Government for the conveyance of troops, artillery, etc. from Dundas Street to Longwoods.' (Priddis, 'The Naming of London Streets,' p. 12).

1798:
'In 1798 the districts were subdivided, the eastern half of Western District taking the name of London.' They are subdivided by Upper Canada Statute. (Dean/Matthews, *Economic Atlas of Ontario*, plate 98; Priddis, 'The Naming of London Streets,' p. 8)

March 30 to April 3, 1798:
There is a very severe flood of the Thames River. (Hives, *Flooding and Flood Control*, p. 178.

1800:
David William Smith [England 1764-?] is appointed Surveyor General of Upper Canada. He retires to England in 1804. Thomas Ridout [b. England-d. 1829] and William Chewett become Deputy Surveyors General around 1802. (Finos, 'The Surveyors General in Ontario,' p. 33)

Jan. 1, 1800:
♥ 'And be it further enacted by the authority aforesaid that the Townships of London, Westminster, Dorchester, Yarmouth, Southwold, Dunwich, Alborough, and Delaware, do constitute and form the County of Middlesex.' (Crinklaw, *Westminster Township*, p. 1)

April 3 to 9, 1800:
There is a severe flood of the Thames River. (Hives, *Flooding and Flood Control*, p. 178)

1801 to 1850

Part Two

Nov. 20, 1803:

'Major Green says an enumeration has been made and turns out 64 (militia) (in Middlesex County) However persons acquainted with the Country say there are no settlers between the Moravian Indian Town on the River La Tranch and the Township of Oxford, except two in Aldboro, one in Westminster and about 20 families of drunken lumber cutters at Allan's Saw Mill a large Mill of 4 saws which supplies Detroit.' 'In 1793 the Quaker Lindley noted that large rafts of excellent pine timber were brought into the King's shipyard at Detroit from the Thames.' Detroit is built with lumber from the Thames River. (Hamil, *The Valley of the Lower Thames*, p.66; Lord Selkirk as quoted by Stott, *Witness to History*, p. 29)

1803:

John Beaver [fl.1862] is born at what is now London. He is descended from Chief Tommago, the principal chief of the Upper Thames River Ojibwa community. John Beaver will marry a woman named Ellen [1802-fl.1862] from the United States. He is a brother of Nelson Beaver who will be born near Lambeth in 1818.

1804:

Charles Wyatt is appointed Surveyor General for Upper Canada. 'He was a tactless and impetuous person who, almost immediately after assuming his duties, quarrelled with Thomas Ridout (acting Deputy Surveyor General) and later dismissed him. Wyatt then offended Lieutenant Governor Francis Gore by submitting the Surveyor General's books to the Assembly for inspection, rather than to the executive as was the custom for executive matters. The Lieutenant Governor, concerned that there was no suitable replacement for Ridout, over-ruled his dismissal. Then, on the advice of the Executive Council, he suspended Wyatt (about 1806). He introduces the

Double Front system of survey to Upper Canada in 1818.' (Finos, 'The Surveyors General in Ontario,' p. 33)

c.1804:
'Lord Selkirk reports purchasing a quantity of black bass from an Ojibwa at the forks of the Thames.' (Ferris, *Continuity Within Change*, p. 107)

Sept. 13 to 18, 1804:
There is a severe flood of the Thames River. (Hives, *Flooding and Flood Control*, p. 178)

1807:
Thomas Ridout goes to England to 'seek appointment to the full position' (the Surveyor General of Upper Canada). (Finos, 'The Surveyors General in Ontario,' p. 33)

1810:
Thomas Ridout is installed as Surveyor General for Upper Canada. He had been acting Surveyor General with William Chewett from 1806 to 1810. (Finos, 'The Surveyors General in Ontario,' p. 33)

There are two families of European descent living in Westminster Township by this time. (Goodspeed, *The History of the County of Middlesex*, p. 567)

Early 1810:
Simon Zelotes Watson [land surveyor/magistrate, born in the District of Montreal d.in the US 1814] is sent to Upper Canada by 210 Lower Canadian farmers and heads of families to find out about land grants and the terms under which they are available. (St. Denis. *Byron*, p. 12)

Apr. 24, 1810:
The Executive Council at York grants Simon Zelotes Watson settlement duties for the Township of Westminster. On April 30, he is directed by messrs. Chewett and Ridout [acting Surveyors General] to execute his proposed survey of Westminster Township. (St. Denis, *Byron*, pp. 12-13)

June 30, 1810:
Simon Zelotes Watson [deputy surveyor, Province of Upper Canada] completes survey, lots 1 to 48 from the broken front on the Thames River to concession 2, Westminster Township. 'Station 22: South 78° 30' west, 6 chains/good land, beech, maple and bas, 3 chains, ♥ good land to the river, 1 chain/for a road [allowance between lots 24 and 25], 6 chains/good land to a brook from south. ♥ 14 chains/good land, beech, maple, bas. Station 23: north 11° 30' west, 9 chains 75 links/good land. Station 24: South 78° 30' North, good land to the river (site of Wellington Bridge). South 20° 30' West, 20 chains/beech, maple, bas & elm. Station 25: North 11° 30' West, 13 chains 50 links/good land. Station 26: South 78° 30' West, good land to the river at the end of a long point?, 2 chains/good land to a brook (Foxbar Creek?) from South, 18 chains/good land, Beech, Maple, Bas & Elm, good land to the river from South, 20 chains/good land, Beech, Maple, Bas & Elm.' (Crinklaw, *Westminster Township*, p. 536; Watson, survey notes pp.8-9; St. Denis, *Byron*, p.15-17.

'A PLAN shewing a survey of the front of the Township of Westminster Surveyed by order of His Excellency Francis Gore Esquire Lieut. Governor of the Province of Upper Canada in the months of May and June 1810' shows the area bounded by; the Thames River on the north, the base line on the south, the east side of lot 25 on the east and the west side of lot 32 on the west as a school reserve. (RCWL)

The irregular northern boundary of Westminster Township follows the south bank of the Thames River. This is the broken front of Westminster Township. The lots formed between the base line (Base Line Road) and the river are in the broken front concession. They are of varying sizes. Lot 25 contains 123 acres. Lot 24 contains 150 acres. The lots formed between the base line and the Second Concession Road (Southdale Road) are in the first concession. They all contain 200 acres. Watson allows for a 66 foot wide, north/south road every six lots. His survey is called a double front special. (Farncomb and Kirkpatrick phone conversation, July 1991)

'base line 1 in government surveys, the east-west line that functions as a starting point for the parallel lines demarcating blocks, townships etc.' (Avis, et al., *A Dictionary of Canadianisms on Historical Principles*, p. 35)

'concession n. [Canadian French 'a grant of land'] Property, in Canada, is divided by what is called concessions, which means a range of land that extends from east to west, through the whole length of a township. The first

range from the south is called the first concession; that behind the second, and so on.' (Avis, p. 164)

Feb. 1811:
♥ Simon Zelotes Watson assigns to John Odell [farmer 1789-1862], lot 25 broken front and north part of lot 25, 1st concession, approx. 225 acres, 5 cleared. (Crinklaw, *Westminster Township*, p. 546)

May 24, 1811:
Simon Zelotes Watson proposes a revised survey of Westminster Township incorporating a picket line South of the Base Line and settlement to take place along the 2nd Concession (Southdale Road) to Surveyor General Ridout. Colonel Thomas Talbot opposes Watson's revised survey. (Crinklaw, p. 543, St. Denis, *Byron*, pp. 17-18)

Fall 1811:
The last Munsee of the Thames bear hunt takes place at this time. (Kjellberg, *Seeking Shelter*)

Feb. 8, 1812:
The Executive Council at York; terminates Simon Zelotes Watson's settlement duties for Westminster Township, and Lieutenant-Governor Isaac Brock issues a declaration that: opens Westminster for 'General Application and Settlement' ('excepting....; The Northerly part of Lot No. 23 in the 1st concession, and the broken Lot No. 23 in front, on the River Thames;'). (Crinklaw, *Westminster Township*, pp. 538, 539; St. Denis, *Byron*, pp. 37, 59)

June 18, 1812:
The United States declares war on Great Britain. (Marsh, ed., *The Canadian Encyclopedia*, p. 1918)

July 10, 1812:
'The above persons resident in Upper Canada are all Americans by birth and sentiment and are a select part of the inhabitants of the above named towns which I humbly conceive may be depended upon as staunch friends to the United States.' S.Z. Watson, Detroit. Watson's list includes: Joseph L. Odell [1787-?], Joshua Odell [1785-1862], John Odell [1789-1862] lot 25

Westminster, and James Lester [1784-?] lot 24 Westminster. (Glen Curnoe; St.Denis, *Byron*, p. 152)

August 1812:
I was told by my father that General Isaac Brock [1769-1813] and his troops marched down Commissioners' Road to Niagara after the fall of Detroit, and that Brock spent the night in a frame house [Swartz Tavern, demolished c.1965] on the south side of the road on lot 24, just west of the L & PS tracks. 'Much controversy has swirled around Swartz Tavern [demolished around 1975], a structure, which may be the oldest surviving building in what is now London. Tradition has it that it was built in 1817 by a veteran of the Napoleonic Wars named Swartz who secured a land grant from Col. Thomas Talbot for the purpose of constructing a tavern. If so the old colonel must have been disappointed, for it became a Reform Party centre in the 1830s and William Lyon McKenzie stayed there either before or after the Rebellion of 1837.' (Elliott and Honey, *London Heritage*, facing plate 44)

1812:
Post riders travel down Commissioners' Road from Burlington to Amherstburg three or four times a week. (Gray, *Wilderness Christians*, p. 212)

Aug. 20, 1813:
Simon Zelotes Watson receives a commission in the United States Army as a major with the Topographical Engineers. (St. Denis, *Byron*. p. 71)

Oct. 5, 1813:
Shawnee Chief Tecumseh [Tecumthe, born on the banks of the Mad River, Ohio, USA c.1760] is killed at the Battle of the Thames. (Hamil, *The Valley of the Lower Thames*, pp. 90, 91)

Oct. 6, 1813:
General Henry Procter [England 1765-1822] flees East along Commissioners Road passing through Westminster to Burlington. (Hamil, *The Valley of the Lower Thames*, p. 93; Poole, *The Battle at Longwoods*, p. 45)

Dec. 1813:
US 'General Harrison received orders to destroy completely the settlements

on the Thames River, and to bribe the Indians to drive out every settler west of Kingston.' (Hamil, *The Valley of the Lower Thames*, p. 94)

1814:
There are American raids throughout the London District in this year, with farms and mills burnt and livestock confiscated. (St. Denis, *Byron*, pp. 70-76)

Nov. 4, 1814:
US General Duncan McArthur marches through Westminster with an army of 600 Kentucky Volunteers, 50 Michigan militia and 70 Indians (Hamil, *The Valley of the Lower Thames*, p. 95)

Dec. 24, 1814:
The War of 1812 is brought to an end with the signing of the Treaty of Ghent. (Hamil, *The Valley of the Lower Thames*, p.101)

Map No. 19 of the townships south of the River Thames shows 12 houses on Commissioners' Road between The Talbot Road and the line between Dorchester and Westminster Townships. (U. of Western Ontario Map Library)

The Ojibway population at Muncey is 209 approx. 172 are counted at Burlington and 37 are counted at Amherstburg. There are 195 Thames River Muncey under the care of Captain John Norton (73 women, 67 men, 55 children). (Ferris, *Continuity Within Change*, p. 73; Kjellberg, *Seeking Shelter*, p. 72)

Feb. 12, 1815:
'I shall adopt a pretty strict regimen for the River Trench and the New Settlement population; a little blood letting may do them good and make the country tranquil; yet I am of the opinion decidedly that the safest course is to depopulate the territory. I have issued a very strict order to the New Settlement. A similar one is prepared for the River Trench. The order shall be enforced' [order not carried out]. Colonel A. Butler, commander at Detroit. (BHC, McArthur papers, Feb. 12, 1815)

May 10, 1815:
Christian Dencke and Anna Maria Dencke travel by raft from Dorchester to

Delaware, on their way back to Fairfield (Moraviantown) which was destroyed by American troops during the war. It begins to pour with rain as they approach the forks via the south branch. (Gray, *Wilderness Christians*, p. 257)

Nov. 1, 1815:
Claim No. 1677, 2nd affidavit: Joseph L. Odell claims war losses totalling £20 3s 9p for: cash taken by enemy £2 18s 9p, 3 vests, 1 shirt, 1 case razors, 1 large iron pan, 4 yards of cotton, 1 voucher book, 25 bushels corn, 2 large hogs, corn and hay wagon, all by dragoons. He is awarded £20 3s 9p on Nov. 11. 1837 (see Simon Watson's list of July 10, 1812). (Crinklaw; Glen Curnoe)

Feb. 13, 1816:
The Crown to James Lester [farmer b. 1784] lot 24, broken front, Westminster Township, 200 acres. 'commencing at the North-East angle of the said lot 24 in the broken front, then South 11° 30′ East 101 chains more or less to the picket line South of the Commissioners' Road, then Westerly along the picket line, then 20 chains more or less to the allowance for road between lots no. 24 and 25, then North 11° 30′ West to the River Thames, then against the stream to the place of beginning, containing 200 acres more or less with allowance for road, for which an allotment of 28 acres and 4/7 is made for protestant clergy in lot no. 6 in the 3rd concession of the said Township of Westminster.' Crown patent. (Government of Ontario, Official Documents; Crinklaw, *Westminster Township*, p. 546)

Feb. 15, 1816:
Albert Scriver Odell [farmer 1793-1856] is granted lot 20, broken front, Westminster Township, 100 acres. (near Pond Mills Road at the River Thames). Crown patent granted Oct. 22, 1819. (Crinklaw, *Westminster Township*, p. 493)

1817:
Westminster Township contains: 428 people, 107 houses, 2 schools, 1 grist mill and 1 saw mill. Albert Scriver Odell is elected to the first Westminster Township council. He is appointed town warden. (Goodspeed, *The History of the County of Middlesex*, p. 566)

March 1817:
'Rough Sketch of part of Westminster' shows James Lester occupying lot 24 from Watson's picket line to the River Thames, and John Odell junior occupying lot 25 from the picket line to the river. (U. of Western Ontario, Map Library)

Dec. 17, 1817:
♥ 'Queries. 25th. QUALITY OF PASTURE: 1ST. AS IT RESPECTS FEEDING, AND WHAT WEIGHT AN OX OF FOUR YEARS OLD WILL GAIN WITH A SUMMER'S RUN; 2d. AS IT RESPECTS MILK, AND THE QUALITY OF DAIRY PRODUCE, NOTING THE PRICE WHICH BUTTER AND CHEESE MADE IN THE TOWNSHIP WILL NOW FETCH?' 'Not only the flats of the Thames, but the woods in general, are covered with grass, in a state of nature, which is good. An ox will gain one-fourth of his weight with a summer's run.' Daniel Springer, committee chairman. (Crinklaw, *Westminster Township*, p. 533; Gourlay, *Statistical Account of Upper Canada*, vol. I, pp. 272, 274)

1818:
Albert Scriver Odell is elected to the Westminster Township Council. He is appointed collector. (Goodspeed, *The History of the County of Middlesex*, p. 568)

Jan. 15, 1818:
The Crown to James Lester, north 1/2 of lot 24 broken front concession, Township of Westminster. Crown patent. (Crinklaw, Westminster Township, p. 493)

c. 1820:
In this decade the number of people of European descent becomes equal to the number of people of aboriginal descent in Westminster Township.

c. 1820:
The Ojibway (Chippewa) are settled east and west of two central Delaware settlements known as the lower and upper Muncey villages. West is a camp of 15 wigwams and 4 chiefs. Tumeko [Tommago Surrender #25/1822] is the head chief of this group. To the east is a more dispersed community, extending from a few miles east of Muncey to a clearing at Big Bend.

(Ferris, *Continuity Within Change*, p. 71) The Thames river basin is utilized by the Ojibway for fishing, hunting and agriculture as far east as the eastern limit of cession #2. (Del Riley, phone conversation, June 1991)

Jan. 25, 1820:
James Lester to Albert Scriver Odell, north 1/2 of lot 24 broken front concession 200 acres, in exchange for lot 20 broken front Westminster, Township of Westminster. Deed poll #364 ('a deed to which there was only one party.' (McGarry and Wade, *The Law of Real Property*, p. 601; Middlesex County Registry Office)

July 8, 1822:
Chiefs and Principal men of the Chippewa Nation: Canotung, Maquamiss, Metwetchewin, Pawbetang, Pemekumawassigai, Pemuseh, Quekijick, Sagawsouai, Sagetch, Tecumagasaie, Tummago, Wawiattin, to Lieutenant Colonel William Claus [Williamsburg, September 8, 1765-November 11, 1826 at Niagara-on-the-Lake, Deputy Superintendent of Indian Affairs, successor to Alexander McKee] for the Crown; 580,000 acres on the north side of the Thames River in Lambton, Kent, and Middlesex Counties, £2400 annually in perpetuity, the number of persons should not at any time exceed two hundred and forty. Surrender #25. (Jacobs, *Indian Land Surrenders*, p. 66; Leighton, *Walpole Island*, paper #22; appendix B7; Taylor, *A Supplement to the Historical Foundation for the Walpole Island Reserve Boundary Question*, appendix B3; RCWL)

Dec. 31, 1824:
Mahlon Burwell [1783-1846] surveys the school reserve of WESTMINSTER Township: lots 25 to 33, from the Thames River to the Base Line, including the 125 acres of lot 25 in the broken front concession. (U. of Western Ontario Map Library; Middlesex County Registry Office)

April 26, 1825:
'Provisional agreement made and entered into at Amherstburg, in the Western District of the Province of Upper Canada.... between James Givens, Esquire, Superintendent of Indian Affairs, on behalf of His Majesty George the Fourth, Defender of the Faith, &c., &c., &c., of the first part and Ani-mick-ence or Animikence, Ano-ta-win or Anatowin, Cha-o-

ge-man or Chaoge-man, Chi-ka-ta-yan or Chikatayan, Equoc-ke-gan or Equiokegan, Macada-gick-o or Macadagicko, Mich-i-ke-ha-bick or Michikehabeck, Mo-ke-ge-wan or Mokegewan, Ne-gig, Oge-bik-in, Osaii-a-wip or Osaw-a-wip, Penece-o-quin or Penence-o-quin, Petaw-wick, Puck-a-nonce or Puckeneuse, Shoquona or Sho-quo-na, Shau-squa-ge-wan or Showsquagewan, Shaw-gi-nosh or Shawginosh, Shaw-wine-penance or Shaw-win-penence, Wa-pa-gace, Way-way-nosh, Chiefs and Principal men of that part of the Chippawa Nation of Indians inhabiting and claiming the territory or tract of land hereinafter described....' for 2.2 millions acres in Lambton, Huron, Middlesex, Oxford and Perth Counties, for the yearly sum of £1100. Surrender 271/2. (Jacobs, *Indian Land Surrenders*, p. 67; Leighton, *Walpole Island*, paper #22: appendix B8; NIN.DA.WAAB.JIG, *Walpole Island* p. 32; Taylor, *Walpole Island*, paper #21(a) appendix A1/A6)

c. 1826:
Wellington Street is named 'for Arthur Wellesley, Duke of Wellington, the hero of Waterloo, and in his youth the personal friend of Colonel Talbot.' (Priddis, 'The Naming of London Streets,' p. 10)

July 1826:
Peter Robinson is appointed Commissioner of Crown Lands. He is to supervise a new system of sales on credit in place of the old system of free grants subject only to payment of fees. He will decide; what government lands are to be sold and the time and place of sale. The land will be sold at public auction. The sale of a portion of the clergy reserves is also authorized. (Hamil, *The Valley of the Lower Thames*, pp. 211, 214)

July 10, 1827:
Chiefs and Principal men of the Chippewa Nation: Animikince, Annatown, Cheebican, Chekatayan, Mokeetchiwan, Mshikinaibik, Mukatuokijigo, Negig, Osawip, Pinessiwagum, Peetawtick, Pukinince, Quaikeegon, Saganash, Shaiowkima, Shashawinibisie, Shawanipinissie, Wawanosh, to James Givens, Superintendent of Indian Affairs for the Crown; 2.2 million acres in Lambton, Middlesex, Huron, Perth, and Oxford Counties, £1,100 annually in perpetuity. Signed at Amherstburg. Surrender #29. (Jacobs, *Indian Land Surrenders*, p. 67; Leighton, *Walpole Island*, appendix B8A;

NIN.DA.WAAB.JIG., *Walpole Island*, p.32; Taylor, Walpole Island, appendix A1/A5; RCWL)

1828:
Albert Scriver Odell is elected to the Westminster Township council. He is appointed collector. (Goodspeed, *The History of the County of Middlesex*, p. 569)

Sept. 1829:
Samuel Hurd is appointed Surveyor General of Upper Canada. He does not report for duty until forced to do so under threat of suspension in 1831. 'Under Hurd's administration, the efficiency of the Surveyor General's office steadily declined.' He retires under pressure in 1836. (Finos, 'The Surveyors General in Ontario,' p. 34)

1830:
The Ojibway population at Muncey is 234. (Ferris, *Continuity Within Change*, p. 75)

c. 1830:
'It was years and years after before there was anything but a ferry at Wellington Street.' (Priddis, 'Reminiscences of Mrs. Gilbert Porte,' p. 67.)

Spring 1830:
There is a sharp freshet or heavy flood of the Thames River. (Hives, *Flooding and Flood Control*, p. 178)

Dec. 22, 1830:
Mahlon Burwell survey PE.7: lots 20 to 36, from the Thames River to concession 1. This plan also shows the area north of the base line to the Thames River, from lot 25 on the east to lot 33 on the west, as a school reserve. (Middlesex County Registry Office, U. of Western Ontario Map Library)

1832:
The Bear Creek Band [Sydenham River] Ojibway join the Ojibway near Muncey. (Ferris, *Continuity Within Change*, p. 75)

1832:

There is an epidemic of Asiatic cholera in the Town of London. (Bremner, *Illustrated London*, Ontario, Canada, p. 34)

c. 1835:

'A handful of Potawatomie were reported to have also settled with the Muncey Ojibwa and Delaware.' (Ferris, *Continuity Within Change*, p. 46)

1836:

'The 1836 harvest in Upper Canada had been poor for the potato crop had largely failed and the wheat harvest had not been successful. The crisis in food production coincided with the depths of the commercial depression. Money became exceedingly scarce. At London (Reverend) Proudfoot observed that poverty had fallen upon thousands.' (Read, *The Rising in Western Upper Canada 1837-38*, pp. 65-66)

July 1, 1836:

'In his memorial he (Charles Duncombe) stated that when he came near London on the last polling day he encountered one of the Reform candidates, Elias Moore, fleeing for his life from Tory Orangemen and found the Reformers generally being driven from the polls. This, he declared, was being done in the presence of officers of the law and of the rector of the endowed Church of England parish [Benjamin Cronyn, Ireland 1802-London, Canada 1871].' 'The most distinctively Reform section of the whole province was to be found in the three western counties, Middlesex, Oxford, and Norfolk, which among them sent six Reform members to the assembly. Except for the London seat, these three counties formed a solid Reform block.' (Crowfoot, *Benjamin Cronyn, First Bishop of Huron*, p. 53; Landon, *Western Ontario and the American Frontier*, pp. 153,154)

Spring 1837:

Reverend William Clarke arrives in London under the auspices of the Colonial Missionary Society of the Congregationalist Church. The Society was founded in England in 1836. (United Church Archives)

'The Congregationalists were the other denomination whose members were frequently linked with the insurgents' cause.' (Read, *The Rising in*

Western Upper Canada 1837-38, p. 188) 'Our body being well known to entertain liberal opinions on all subjects relating to liberty, religion and education; when some in the Colonies who push these sentiments to dangerous and violent extremes, broke out into actual rebellion, odium, and suspicion fell on our friends as holding, though in just and moderate form, the same general views with the insurgents.' (Henry and Roaf, quoted in Read, *The Rising in Western Upper Canada 1837-38*, p. 189)

Oct. 6, 1837:
Motions from the Westminster Reform Meeting:
'Moved by Albert S. O'Dell, seconded by Wm. Norton,
 Resolved 2. That inhabiting a soil of the richest and most fertile description, which was at the commencement of our settlement placed in the hands of the government free and unencumbered – and to which has been added the continual labor of an industrious and energetic people, together with the vast sums of money brought into the country by emigration, as well as the thousands derived from the sale of public lands, and the large amounts borrowed, for the interest of which our revenue from every source (though insufficient) is pledged, Upper Canada with even a moderate share of good management, possesses every requisite to make a most prosperous country.' 'Moved by Albert S. O'Dell, seconded by Wm. Munro, *Resolved 13*. That we heartily concur in the address by the Reformers of Toronto; that we highly approve of the measures being taken throughout the Province to provide a Convention of Delegates to deliberate on the causes that have sunk our country into ruin and distress, to devise and suggest some measures for her restoration and to preserve, if possible, her few remaining advantages; and that in pursuance of the recommendations contained in that address, we do hereby appoint the following Members to attend on our behalf, viz. –

HUGH CARMICHAEL }
JOSEPH ALWAY } *Lobo*

CALVIN BURCH }
JOHN GREEVE } *Westminster*'

(Read and Stagg, ed., *The Rebellion of 1837 in Upper Canada*, pp. 83, 86-87)

Dec. 21, 1837:

'We have frequently been advised by the Liberals, and Messrs. Waldern, and Carey to remain quiet, and let the white men fight their own battle. We tell them the War Cry of the Britains, will raise the war club of the Red Men, and at a moments warning we will be prepared to go where duty calls us to make it red with the blood of their enemies We sent immediately for Pa-shik-ka-shik-ques-kum of Walpole Island, and Wa-wa-nosh of the St. Clair, the former is now with us and is ready with his young People to fight for his Father the Governor. Wa-wa-nosh would not come but sent us a very bad letter. Mr. Clench [Joseph Brant Clench c.1790-1857, superintendent of the Chippewas and Munsees of the Thames from 1837 to 1854] would neither read it to us; not let us have it to send to you – we are not pleased with Mr. Clench for so doing, and fearing he would not write our determination to die for you, we have caused it to be written by the Young Man You was pleased to allow us to Keep. We think Mr. Clench has neglected us very much, and is too great a friend to Missions, to be friendly disposed towards your dutiful, and loyal subjects, the Chipewas of the Thames –

 Canotung
 Mas-Kan-oou-je
 Mus-Ko-Koo-mon
 Wen-ta-gashe
 Chicken-Mas-Kan-oouje
 Yan Cause'

(Read and Stagg, pp. 15-16, 328)

1837:

Captain Joseph Odell commands 14 minute-men of the 4th Middlesex Militia from Westminster during the Rebellion. They are the only volunteers from a muster of 500 men. (Goodspeed, *The History of the County of Middlesex*)

'Hard times followed the rebellion.' 'To add to the trouble there came an outbreak of hydrophobia. Whether one mad dog did all the damage, or whether it could have been in the air I never heard; but the excitement was intense. Most of the cows were bitten and sacrificed; and the loss of milk was a serious hardship to mothers and housekeepers in the prevailing distress.' (Priddis, 'Reminiscences of Mrs. Gilbert Porte,' p. 67)

John Macaulay [appointed to the Legislative Council in 1835] accepts

the positions of Surveyor General and customs arbitrator for the province. He resigns to accept the position of Secretary to the Lieutenant Governor in 1838. (Finos, 'The Surveyors General of Ontario,' p. 35)

May 31, 1838:
'Great dissatisfaction and excitement prevails in the country [London], and many are daily leaving.' (Jane O'Brien, letter to Mrs. Crichton, quoted in Read, *The Rising in Western Upper Canada 1837-38*, p. 159)

1839:
Robert Sullivan [lawyer and member of the Legislative Council] succeeds Macaulay as Surveyor General for Upper Canada. He is also appointed Commissioner of Crown Lands and Surveyor General of Woods and Forests. His office is investigated for corruption and mismanagement. 'Sullivan himself was exonerated...Nevertheless, he was relieved of his duties.... in 1840.' (Finos, 'The Surveyors General of Ontario,' p. 35)

July 1839:
Reverend William Clarke joins a temperance society in Toronto. (Garland and Talman, 'Pioneer Drinking Habits and the Rise of the Temperance Agitation in Upper Canada Prior to 1840,' p. 182)

Oct. 22, 1839:
♥ The Crown (Thomas Talbot for the Treasurer of the Board of Education of the Province of Upper Canada) to Albert Scriver Odell [yeoman], N1/2 lot 25, broken front, 621/2 acres, (Crown school reserve) £62 10s, date of last payment Sept. 7, 1839. Crown patent. '*Commencing in the Western limit of the said lot and in rear of Lots on the East side of Wortley Road at the distance of 31 chains 25 links on a course of North 11 degrees 30 minutes West from the allowance for Road between the first Concession and the broken front of the said Township of Westminster then North 11 degrees 30 minutes West to the River Thames, then South Easterly along the Water's edge of the River to the allowance for Road between Lots number 24 and 25 then South 11 degrees 30 minutes East to within 31 chains 25 links of the allowance for Road between the first Concession and the Broken front Concession aforesaid; then South 81 degrees 30 minutes West 20 chains, more or less to the place of beginning.*' (Government of Ontario, Official Documents; Crinklaw, *Westminster Township*, p. 468; Middlesex County Registry Office, Abstract)

c. 1839:
'The Wellington Road, often erroneously styled the Port Stanley Road, from its running almost parallel with the Port Stanley Railway, was originally planned to connect with Waterloo Street; but the irregular flow of the river at that point made it necessary to cross at Wellington Street.' (Priddis, 'The Naming of London Streets,' p. 14)

1840:
Oneida 'Chief Moses Shuyler and August Cornelius were appointed "to go to look for a place for future abode".' (Meyer, ed., *Onoyota'a:k a:*, p. 7)

Jan. 4, 1840:
Albert Scriver Odell to Richard Frank [1799-1872], south part of the north 1/2 of lot 25, £112 12s for 25 2/5 acres. Deed Poll #4455 (Middlesex County Registry Office abstract, Woodland Cemetery)

March 1840:
First lands purchased by Chief Schuyler and William Taylor Doxtator, held in trust by the Indian Department for the Oneida at Munceytown, Delaware Township. Others arrive in May 1841 and November 1845. The Oneida are formally associated with the Grand River League at the Six Nations Reserve before selling their lands in New York in 1840. It is said that the area around the Oneida Settlement was traditional Oneida hunting territory. (Chrisjohn conversation Aug. 23, 1991, *Onoyota'a:k a:* p. 7-9)

June 26, 1840:
♥ Albert Scriver Odell to Reverend William Clarke, Congregationalist minister [1801-1878], north part of N1/2 lot 25, broken front, 37 acres, 30 links, £150. Charlotte (Percevil) Odell [1782-1846] assigns her dower to Clarke for 5 shillings.
 '– *commencing on the western limit of said lot and in rear of lots on the East side of Wortley Road at the distance of 43 chains and 30 links on a course North 11 ° 30' West from the allowance for road between the front concession and the broken front of the said Township of Westminster, then 25 chains North 11 ° 30' West to the River Thames, then north-westerly along the broken edge of the river to the allowance for road between lots number 24 and 25, then South 11 ° 30' East to within 43 chains 95 links of the allowance for road between the front concession*

and the broken front aforesaid, then South 81 ° 30' West not 20 chains more or less to the place of beginning.' [North side of Weston Street from number 38 to Wellington Road, South side of McClary Avenue from Wellington Road to High Street, West side of High Street from McClary Avenue to the River, along the old River bed to the rear of number 38.] Bargain and sale #5052. (Middlesex County Registry Office)

1839/1840:
'Clarke's Bridge was named for the Reverend William Clarke, Congregational Missionary to the London Settlement, who was undoubtedly, a man of originality and enterprise, adapted to the requirements of a new country.'
'To the surprise of his people, Mr. Clarke secured property and built himself a house on high land on the south bank of the Thames, overlooking Wellington Street. "How impractical! How like a parson!" was the general verdict. How did he expect to reach his congregation? His reasons satisfied himself, at all events. He said the walk around the banks of the river to the bridge would be a pleasure, and for a short cut there was always the ferry at the foot of the hill. The view was fine, and the high land healthy; so he went on improving his grounds and getting his house in order, not interrupted too much by idle callers. When everything was settled to his satisfaction, and people had ceased to discuss his eccentricities, he canvassed the town for funds to build a very necessary bridge at the foot of Wellington Street. He got the money with little trouble; the necessity of the bridge was so apparent and who had a right to it, name and all if not the impractical Parson!' (Priddis, 'The Naming of London Streets,' p. 15)
 'Clarke Street [now Grand Avenue east], from the bridge to which it leads, or what is practically the same, the Rev. Wm. Clarke, whose cottage here overlooked the river.' (Priddis, 'The Naming of London Streets,' p. 23)
 Reverend Clarke's house is shown on lots 11 and 12 of Registered Plan 11 by Samuel Peters made for Messrs. Mellish and Russell by Samuel Peters on Nov. 15, 1851. It is about 100 feet east of Wellington Road on what is now Kennon Place. It appears to have faced Wellington Road. (Middlesex County Registry Office)

Aug. 5, 1840:
Reverend William Clarke to Robert Thacker [plasterer], 6 1/2 acres £50. Mary Ann Clarke assigns her dower to Thacker for 5 shillings. [South side

of Weston Street from 41 to Wellington Road, across Wellington road, from Wellington Road west along the lane south of McClary Avenue to High Street, 214.5′ deep, including a right of way 66 feet wide angling across the property the gravel road to Clarke's Bridge constructed in late 1840 or early 1841.] Bargain and sale #5797. (Middlesex County Registry Office)

Oct. 25, 1840:
'To William McMillen esq., Surveyor of Highways for the District of London. We the undersigned freeholders of the Town of London and its vicinity represent that in consequence of the improvements in the Town of London and for the convenience of the public, it is desirable to open a road from Wellington Bridge in the Town of London, now erecting, angling across lot no. 25 broken front to the side road between lots no. 24 and 25. in Westminster, thence, following the side road to the Commissioners' Road we therefore request you to lay out the same, and report thereon to the next quarter sessions for this district. William Clarke [clergyman], Robert Thacker [plasterer/bricklayer who buys part of Lot 25 from Clarke Aug. 5. 1840, 16 1/2 acres 1 rood 13 perches], George King [carpenter arrived 1831 who buys part of lot 25 from Clarke, March 18. 1842, 2 acres], Sam Peters [distiller 1790-1864], John M. Sande, Andrew McCormick [arrived 1829 plasterer], John Blair [arrived 1830 carpenter], John Balkwill [England, brewer is brewery will eventually become Labatt's member Board of Police for St. David's ward (south side of Bathurst St. to the river) March 1840, arrived 1830], James Farley [arrived 1818 grocer], Joseph Manning.' (Dan Brock phone conversation, June 1991; Glen Curnoe; Linda Davey; Central Library, London Room; RCWL)

Nov. 7, 1840:
Notice in the London Gazette 'Wellington Bridge In the Town of London The subscribers to the erection of the above Bridge are informed that the work is drawing rapidly to a close, and it is hoped that the subscriptions will be handed over with as little trouble as possible on its completion. A. S. Odell W. Clarke. London Nov. 2d. 1840.' (Brock, London Room)

'There is equal uncertainty as to the date of the first structure over the river at the foot of Wellington Street, but it was called "new" in 1840, reported dangerous in 1847, and in the latter year ordered to be rebuilt.'

(Bremner, *Illustrated London, Ontario, Canada*, p. 24)

'Although the number of bridges occupying the site is not known, each was called Clarke's bridge. An iron structure was erected in 1882 which required replacing after the 1937 flood.' (Hives, *Flooding and Flood Control*, p. 170)

Dec. 26, 1840:

'I have examined the premises and consider the application well grounded, I have the honor to report that I have laid out the road on the following courses, commencing at the southern end of Wellington Bridge and at the western limit of lot no. 25. broken front Westminster, where in the 1st place

 1st. S 30°E 27 chains 50 links

 2nd. S 55°E 16 chains 50 links more or less to the side road between lots 24 and 25 there following the said side road to the Commissioner's Road. William McMillan.' Presented to the general quarter session in and for the London District.

McMillan diverts Wellington Road on the above courses in order to avoid: a steep bank, swampy ground and ponds south of Weston Street. (Davey; Kirkpatrick phone conversation, June 1991; Potter interview June 1991; RCWL)

William L. Odell [keeper of the Warrior Hotel, Concession 1, Westminster] 'assisted in building the old Wellington Bridge across the Thames... He also assisted in cutting through the Wellington Road from Concession 1 to London.' (Goodspeed, *The History of the County of Middlesex*, p. 570)

1841:

Census: *Reverend William Clark*, parson, proprietor of real property on lot 25, concession 1? Westminster, 4 years in the Province, 3 children born in Canada, 7 natives of England, 2 females under 5, 2 males between 5 and 14, 2 females between 5 and 14, 1 male between 14 and 18, 1 female between 14 and 45 (all single), 1 male between 30 and 60 married (William Clark), 1 female between 14 and 45 married (Ann Clark), lives on 16 acres 8 of which are improved, 10 members of the Congregationalist church. *Robert Thacker*, farmer?, proprietor on lot 25, concession 1?, 1 year in the Province, 1 child born in Canada, 2 natives of Scotland, 1 male under 5, 1 married male between 21 and 30, 1 married female between 14 and 45, lives on 6 1/2 acres, 2 of which are improved, 2 members of the Church of Scotland, 1 Church of

England. ♥ *Robert Gibbons*, farmer?, proprietor on lot 25, concession 1?, 4 years in the province, 1 child born in Canada, 6 natives of England, 1 male under 5, 1 male 14-18, 1 female 14-45 (all single), 2 married males 30-60, 1 married female 14-45, 1 married female over· 45, lives on 61/2 acres of which 1 is improved, 7 members of the Congregationalist church. *Albert S. Odell*, farmer, proprietor on Lot 24, concession 1, 40 years in the province, 2 natives of the US, 1 not naturalized, 1 married male 30-60, 1 married female over 45, lives on 200 acres. *John Wood*, farmer?, proprietor on lot 25, concession 1?, 7 years in the province, 3 children born in Canada, 1 native of Ireland, 5 natives of England, 2 females under 5, 1 female 5-14, 2 males 14-18, 1 married male 21-30, 1 married female 14-45, 1 married male 30-60, 1 married female over 45, lives on 1 improved acre, 9 members of the Church of England. *William Weston*, tanner, non-proprietor on lot 45, concession 1, 4 years in the province, 1 native of Canada, 6 natives of England, 1 native of Scotland, 1 male 14-18, 1 male 18-21, 1 male 21-30, 1 female 14-45 (all single), 1 married male 21-30, 1 married male 30-60, 2 married females 14-45, 7 members of the Church of England, 1 member of the Church of Scotland. (Weldon Library, U of Western Ontario)

1841:
Thomas Parke [architect/builder/member of the Legislative Assembly and of the first parliament of the united Province of Canada] is appointed Surveyor General for Upper Canada. He resigns in 1845. Andrew Russell is placed in charge of the Surveys branch of the Crown Lands Department for Canada West, reporting to Parke. Russell begins to sign survey instructions in 1851, following the abolishment of the position of Surveyor General for Upper Canada in 1845. 'He is credited with implementing the use of the transit for government surveys, replacing the compass and magnetic bearing references.' (Finos, 'The Surveyors General of Ontario,' p.35)

Feb. 1841:
The Act of Union reunites Upper and Lower Canada into the Province of Canada. (Dean, *Economic Atlas of Ontario*, p. 98)

Jan. 14, 1842:
♥ Reverend William Clarke to Robert Gibbons [carpenter], part of lot 25, broken front, 61/2 acres, £40. Mary Ann Clarke assigns her dower to

Gibbons for 5 shillings. '– commencing at the river in the north-eastern limit of the said lot, along the allowance for road between lots number 24 and 25, South 11° 30' East 191/2 rods, then South 81° 30' West 43 rods 14 feet, to the Commissioner's Road, Westminster, then 261/2 rods along the said new road, then 21 rods to the river as fenced, then along the water's edge to the place of beginning.' [South side of Weston Street from number 38 to Wellington Road, East side of Wellington Road from Weston Street to Watson Street, Watson Street to the old river bed, along the old river bed to the rear of number 38, along the East boundary of 38 to the South side of Weston Street.] Bargain and sale #7985. (Middlesex County Registry Office)

March 18, 1842:
Reverend William Clarke to George King [carpenter]: 'That parcel of land on lot number 25, in the broken front concession, in the Township of West-minster, and lying between lots purchased by Robert Lacker on the south and Richard Smith Esq. on the north measuring on the south side, 271/2 rods [453.75'] on the west side, along the line between lot number 25 afore-said and the rear of lots on the east side of Wortley Road, 11 rods 9 feet [189.5'] on the north 23 rods [379.5'] and on the east along the new road leading from Wellington Bridge to the Commissioners' Road Westminster, 12 rods [198'].' Sold to William Horton [lawyer, Ireland 1818-St. Thomas 1891], 2 acres, Jan. 25. 1848. Mary Ann Clarke assigns her dower to King for 5 shillings. Bargain and sale #5800. (Glen Curnoe; Middlesex County Registry Office)

Sept. 5, 1842:
Robert Thacker to Margaret Bissett, part of N1/2 of lot 25, broken front Westminster (from the west side of Wellington Road to High Street, south of McClary Avenue) 3 acres, £100. 'commencing on the westerly limit of said lot 25 and in rear of lots on the east side of Wortley Road at the distance of 43 chains 94 links from the allowance for road between the first conces-sion and the broken front of the said township north 3 chains 25 links, then on an easterly direction 7 chains 75 links, then in a southerly direction 3 chains 25 links, then west 7 chains and 75 links to the place of beginning.' Catherine Thacker assigns her dower to Margaret Bissett for 5 shillings. Bargain and sale #6248. (Middlesex County Registry Office)

Sept. 6, 1842:

Robert Thacker to William Weston [corporal in her Majesty's Corps of Royal Artillery stationed at London, tanner and currier, 1799-1871], part of N1/2 lot 25, broken front Westminster (south side of Weston Street from Wellington Road to number 41), 3 acres 1 rood 13 perches (214.5′ deep), £33 15s. Catherine Thacker assigns her dower to William Weston for 5 shillings. 'Being composed of a part of lot number 25 in the township of Westminster and lying, and being on the East side of the Road running through the said lot to connect Wellington Street on the town of London with the Commissioners Road in the township of Westminster and being the East half more or less of six and one half acres of land conveyed by the Reverend William Clarke to the said Robert Thacker by Indenture bearing date the fifth day of August in the year of our Lord one thousand Eight hundred and forty.' Bargain and sale #5799. (Middlesex County Registry Office)

'Weston Street, named for the well-known market gardener who lived in the neighbourhood.' (Priddis, 'The Naming of London Streets,' p. 23)

Jan. 12, 1843:

William Clarke to Thomas James List: '4/5 of an acre of an acre, be the same more or less, being composed of that parcel of land on lot number 25, in the broken front concession in the Township of Westminster, lying on the east side of the new road leading from Wellington Bridge in the Town of London to the Commissioners' Road, Westminster, measuring 120 feet fronting the said road, then following the fence separating it from the land in the possession of Robert Gibbons, to the River Thames, then in a straight line 110 feet along the bank of the said river, then to the north-west boundary of the said new road, then to the place of beginning.' Mary Ann Clarke assigns her dower to List for 5 shillings. Sold to George Watson by Benjamin Shaw on Jan. 19. 1855. Bargain and sale #8434. (Middlesex County Registry Office)

May 1843:

Reverend William Clarke is transferred to Simcoe, Ontario. (United Church Archives)

c.1844:

'The Thames was a great highway for the Indians; processions of bark

canoes passing and repassing constantly, and in the spring of the year lum-
berers, on rafts of pine timber from the Dorchester pineries, with their row
of long sweeps at each end, would pass quickly on the way to Lake St. Clair.'
(Crowfoot, *Benjamin Cronyn, The First Bishop of Huron*, p. 61)

1845:
Westminster is now in the Province of Canada. 'Original "districts" abol-
ished in 1849.' (Dean, *Economic Atlas of Ontario*, plate 98)

Jan. 2 to 12, 1846:
There is a heavy flood of the Thames River. (Hives, *Flooding and Flood Con-
trol*, p. 178)

March 13 to April 4, 1846:
There is a severe flood of the Thames River. (Hives, *Flooding and Flood Con-
trol*, p.178)

1846:
'WESTMINSTER. A Township in the London District; is bounded on the
east by the township of South Dorchester; on the north by London; on the
west by Delaware; and on the south by Yarmouth and Southwold. In West-
minster 56,695 acres are taken up, 16,751 of which are under cultivation.
This is an old-settled township and contains many fine farms, which are in a
good state of cultivation, and have flourishing orchards. The township is
watered by branches of the Thames and of Kettle Creek. Westminster is
principally settled by Canadians, Americans and Pennsylvanian Dutch.
There are four grist mills and two saw mills in the township. Population in
1842, 3,376. Ratable property in the township, £45,656.'
'THAMES, RIVER. One of the principal rivers in Canada West, formerly
called La Tranche.' 'At the town of London it is joined by the east branch,
which takes its rise in Easthope forms the dividing line between Blandford
and Zorra, separates West from North Oxford, North from South Dorches-
ter, and then flows along the south border of the township of London,
separating it from Westminster.' 'There are large quantities of fine white
oak and black walnut on the banks of the river, and a considerable trade has
for some years been carried on on staves, and walnut lumber. The former
are floated down the river from the land where they are cut, to Chatham,

where they are collected and shipped on board schooners, which are sent from Kingston, and other ports, for that purpose.' 'The Chippewas and Munsees occupy a tract of land, containing about 9000 acres, in the township of Carradoc, in the London District. It is only within the last ten years that the Chippewas have been reclaimed from a wandering life, and settled in their present location. The Munsees have been settled since the year 1800, on land belonging to the Chippewas, with the consent of that tribe. Their village is called "Munsee-town." The present number of Chippewas is 378, and of Munsees 242. The Oneidas are a band of American Indians, who came into Canada in the year 1840, and have purchased, with the produce of their former lands and improvements, sold to the American Government, a tract of about 5000 acres, in the township of Delaware in the London District, which is separated by the River Thames from the Chippewa and Munsee settlements. Their number is 436. There are also several Pottawatamie families, who have fixed their residence among the Chippewas, during the last year; and a band of about 500 Senecas, from Tonawantee, in the state of New York, are expected shortly to form a settlement near their brethren, the Oneidas.' 'The Chippewas and Munsees live on small farms, scattered over their tract.' 'There is very little decrease in the partiality of these Indians [Chippewas] for hunting and fishing. They usually leave their homes towards the end of October, and remain away until the beginning of January; they also spend about a month during each spring in the chase. They resort to the unsettled lands in the London and Western Districts: and it is probable that as soon as these lands are occupied, they will be compelled to abandon the chase.' 'Of the game, deer have become gradually destroyed, and but few comparatively now remain.' 'Previous to the winter of 1842, wild turkeys were also plentiful in the Western and London Districts; but the severity of that winter, and the great depth of snow, caused them to be completely starved out of the woods; and immense numbers were killed in the farm yards, whither they had ventured in search of food. This was complete murder, as most of them were little better than skin and bones.' (*Smith's Canadian Gazetteer*, pp. 187-189, 218, 238)

July 24, 1846:
♥ Robert Gibbons to James Brakurridge Strathy [born in Scotland, 1813, died in Kingston August 2, 1896], district clerk, collector of customs from 1856 to 1878, London magistrate in 1846, lives in Bishop Benjamin

Cronyn's house 'The Pines' on Dundas Street, north side between William and Adelaide], part of lot 25, broken front, 61/2 acres, £85 (same Jan. 14. 1842) d. c. 1885]. Hannah Gibbons assigns her dower to James Strathy for 5 shillings. Bargain and sale #8433. (Brock; Glen Curnoe, London Room; Middlesex County Registry Office; Queen's University Archives; *Smith's Canadian Gazeteer*, p. 272)

1847:
The Ojibway population at Muncey is 378. (Ferris, *Continuity Within Change*, p. 74)

1847:
There is a typhus epidemic in the Town of London. (Bremner, *Illustrated London, Ontario, Canada*, p. 35)

Jan. 31, 1848:
Albert Scriver Odell to William Weston [yeoman] and Annah Weston [1799-1852], part of N1/2 lot 24 broken front Westminster (south side of Weston Street from number 41 to Trevithen Street; 660' x 214.5'), £44 12s 6p, 31/4 acres. 'Containing by admeasurement three acres and one quarter Being Composed of a part of Lot number twenty four in the Broken front of the Township of Westminster aforesaid and may be known as follows that is to say, Commencing at the distance of forty four chains from the South West angle of the Lot of Land lying in the Broken front aforesaid on a course of North Eleven degrees thirty minutes West and in the Easterly limit of the allowance for Road between Lots numbers twenty four and twenty five in the said Broken front Then North eleven degrees thirty minutes West three chains twenty five Links along the Easterly limit of the Side Road Then North eighty one degrees thirty minutes East Ten chains Then South Eleven degrees thirty minutes East Three chains twenty five Links Then South eighty one degrees thirty minutes West ten chains to the place of beginning.' Bargain and sale #69. (Middlesex County Registry Office)

July 28, 1848:
'The subscriber has laid out into lots of different dimensions, & part of lot 25 on the broken front Concession of the Township of Westminster and immediately adjoining London Bridge in the TOWN OF LONDON

embracing the most delightful sites in the vicinity. A portion is laid out into Lots, containing two acres with a river frontage to each and a good road to the rear. Further particulars can be had and a plan of the Property seen, on application to J.B. Strathy, Esq. London or to the subscriber at Brantford. William Walker, Brantford, 24th May, 1847.' Walker is probably acting for William Clarke. (Crinklaw, *Westminster Township*, p. 4; *The London Times and Canada General Advertiser*).

Dec. 13, 1848:
♥ James Brakurridge Strathy to John Gumb [England brickmaker 1793-c.1870 West Nissouri], part of lot 25, broken front, 61/2 acres, £200 (same as July 24, 1846). Elvira (Lee) Strathy [born 1811- died Kingston, January 26, 1918, daughter of Dr. Hiram Lee] assigns her dower to John Gumb for 5 shillings. Bargain and sale #240. Middlesex County Registry Office, Queen's University Archives.

March 16, 1849:
The Reverend William Clarke (now living in Simcoe) to John Aston Wilkes on March 16, 1849, 18 acres for £500, bargain and sale #177. This is the last portion of Clarke's original purchase from Albert Scriver Odell on June 26, 1840 at a price of £150. John Wilkes is a Birmingham born merchant, who moves to Brantford in the 1820's where he organizes a Congregationalist church. The congregation meets in his warehouse. [His son Henry Wilkes is a Congregationalist minister in Brantford, 1838]. John Ashton Wilkes helps correct and complete Kenwendeshon's (Henry Aaron Hill) translation of the New Testament into Mohawk in 1838. It is published in 1839 by the American Bible Society. (Ruggle, DCB, vol. VI pp. 373, 374.

Prior to that purchase he has sold: 61/2 acres to Robert Thacker for £50, bargain and sale #7985, 1/2 acre to William Noyes [carpenter] for £12 10d on Jan. 11, 1842, bargain and sale #1842, 61/2 acres to Robert Gibbons for £40, bargain and sale #7985, 2 acres to George King for £20 on March 18, 1842, bargain and sale #5800, 1/3 acre to Andrew Yerex [yeoman] for £12 10d on Sept. 6, 1842, bargain and sale #8000, 6 acres? to Richard Smith [merchant/justice of the peace] for £? (see Aug. 19, 1861, bargain and sale #3570), 1/2 acre to William Grannan for [painter] £12 10d on Dec. 1, 1842, bargain and sale #6546, 1/3 acre to John Wood [mason] for £10 on Jan. 12,

1843, bargain and sale #2364, 4/5 acre to Thomas J. List from Cleveland, Ohio, born in England [carpenter] for £25 on Jan. 12, 1843, bargain and sale #8434, 3 acres 37 perches to George Jervis Goodhue [merchant, 'George J. Goodhue came to the London District from Vermont in the United States by 1820. The young American businessman, whose brother was also an important early store owner in St. Thomas, became the wealthiest entrepreneur in Western Ontario by the 1850's.'] for £50 on Apr. 22, 1843, bargain and sale #6225, 1/2 acre to Dudley Siggins [stone mason 1805-1883] for £50, Oct. 3, 1845, bargain and sale #7772, ? to Edward C. Watson for ?, and 18 acres to Wilkes. Mary Ann Clarke assigns her dower to Noyes for 5 shillings, to Yerex for 5s, to Grannan for 5s and to Siggins for 5s. In 8 years and 8 months Clarke has sold off portions of his original lot for at least £793 40d for a profit of at least £653 40d or 566%. (Brock phone conversation June 1991, Glen Curnoe, phone conversation, July 1991; Middlesex County Registry Office; Paddon, *Steam and Petticoats*, p. 43)

Sept. 28, 1849:
Albert Scriver Odell [Yeoman] to John Gumb [1793-], part of N1/2 lot 24 broken front Westminster (North side of Weston Street from number 48 to Trevithen Street, north to the old river bed). £100. 'Containing by admeasurement Nine acres, be the same more or less, being composed of part of lot number twenty four in the broken front of said Township of Westminster, and which is butted and bounded or may be otherwise known as follows, that is to say, Commencing on the side line between lots number twenty four and twenty five and at the North West angle of the land deeded to William Weston by the said Albert S. Odell, then Easterly along the Northerly limit of the said William Weston's land, ten chains more or less to the North East angle of the said William Weston's land, then Northerly and parallel with the sideline aforesaid nine chains more or less to the Water's Edge of the River Thames, then Westerly along the Water's Edge of the said River Thames to the sideline, between the said lots number twenty four and twenty five, then Southerly along the said sideline to the place of beginning.' Bargain and sale #226. (Middlesex County Registry Office)

1849:
There is a second cholera epidemic in the Town of London. (Bremner, *Illustrated London, Ontario, Canada*, p. 35)

c.1850:

Frank Mount [now Redeemer Lutheran Church, on the south-west corner of Wellington Road and Frank Place] is built of yellow brick. (Redeemer Lutheran Church secretary)

1850:

Westminster Township contains: 4,525 people, 3 grist mills, 2 carding machines, 1 fulling mill. (Goodspeed, *The History of the County of Middlesex*, p. 566)

c. 1850:

William McClary [surveyor/civil engineer 1812-1893] obtains a true copy of Simon Zelotes Watson's 'Rectangular Traverse of the River Thames in front of the Township of Westminster' of 1810 with lot numbers added in a new column. 'Note the numbers ? added by me, Lot reference.' 'Lot 24, station 22: course south 78° 30′ west, distance 6 chains/good land, beech, maple and bass, good land to the river, ♥ 1 chain/for a road, 6 chains/good land to a brook from south, Lot 25, 14 chains good land, beech, maple, bass. Lot 25, station 23: course north 11° 30′ west, distance 9 chains 75 links/good land, good land to the river [site of Clarke's /Wellington Bridge]. Lot 26, station 24: course south 78° 30′ west, distance 20 chains/good land, beech, maple, bass and elm, course north 11° 30′ west, distance 13 chains 50 links/good land.' (Moore, Woodland Cemetery)

1851 to 1900

Part Three

Feb. 21 and 22, 1851:

'During the flood of 1851 the [Clarke's] bridge was threatened by the waters but four men somehow managed to save it for which they were each given £1.' (*The London Free Press*)

Aug. 28. 1851:

♥ John Gumb to George William Strathy of Toronto [brother of James Brakkuridge Strathy?], part of lots 25 and 24, broken front, 15 1/2 acres, £200 [North side of Weston Street from Trevithen Street to Wellington Road, East side of Wellington Road to Watson Street, Watson Street to the old river bed, along the old river bed to the North end of Trevithen Street, East side of Trevithen Street to Weston Street]. Bargain and sale #437. (Middlesex County Registry Office)

1851:

Census: B.F. 25: William *Weston*, farmer, born in England, 52, Church of England, married. Sarah Ann Weston, born in England, 52, Church of England, married. Ann Weston, 21, single. Eliza Weston, 17?, single [1834?-1867, marries John Shopland in 1865] [they live in a one story log house on the south side of Weston Street, east of Wellington Road]. B.F. 25: John *Gumb*, brickmaker, born in England, 58, Church of England, widower. William Gumb [1825-1863], labourer, born in England, 26, Church of England, single. Daniel Gumb [1829-], labourer, born in England, 22, Church of England, single. Caroline Gumb [1834-1911], housekeeper, born in England, 18, Church of England, single [they live in a one story frame house on what is now the north side of Weston Street]. B.F. 25: William *Horton* [1818-1891], barrister, born in Ireland, arrived in London in 1834, 34, Church of England, 'He had studied law in Brockville after emigrating from Ireland as a youngster. Horton had served in the militia rising to the rank of

‹ 87 ›

major. He moved up from the position of Recorder of London to District Judge.' Martha Horton, born in England, 30, Church of England, married. Augusta Horton, Upper Canada, 8. Emily Horton, Upper Canada, 6. Fanny Horton, Upper Canada, 5. Mary Horton, Upper Canada, 3 [1848-1974]. Madeline Horton, Upper Canada, 1. James Kennady, servant, born in Ireland, 22. Christina McKellar, servant, Upper Canada, 17. Barbra McDougall, servant, Scotland, 26. Eliza Hull, servant, England, 14. Margaret McMillan, servant, Scotland, 25. John Thomas, servant, England, 50. [They all live in a two story brick house on what is now McClary Avenue {Maryboro Place} at number 113/115.] Albert S. *Odell*, farmer, born in the United States, 66, widower. Leonard Odell [1819-1889], farmer, born in Upper Canada, 34, Church of England. Jane [Niles] Odell, Upper Canada, 28, Church of England. Joseph L. Odell, farmer, born in the United States, 64, Congregationalist. Gesie [Jessie?] M. Odell, Upper Canada, 59, Congregationalist. Polly M. Odell, Upper Canada, 26, Congregationalist. Joseph B. Odell, labourer, Upper Canada, 24, Congregationalist. Hiram L. Odell, Upper Canada, 21, Congregationalist. Elizabeth Odell, Upper Canada, 19, Congregationalist. [They all live at the south east corner of Commissioners Road and Wellington Road.] Richard *Frank* [1799-1872], farmer, England, 50, Church of England. Elizabeth (Pickering) Frank [1805-1892], England, 47, Church of England . William Frank, Upper Canada, 17. Richard Frank, Upper Canada [1838-1905], 14. John Frank, Upper Canada, 10. George Frank [1847-1881], Upper Canada, 5. Jean Frank, Upper Canada, 16. Elizabeth Frank [1840-1919], Upper Canada, 12. Ann C. Frank [1844-1901], Upper Canada, 8. [They all live in a one story frame house near Wellington Road and Frank Place?] James Strathy, customs-clerk, Scotland, 57, Church of England. (Glen Curnoe, note July 31, 1991; London Room; Paddon, *Steam and Petticoats*, p. 44; Priddis, 'The Naming of London Streets,' p. 10; RCWL; Woodland Cemetery)

March 22, 1852:
♥ George William Strathy of Toronto to John Gumb, part of lots 25 and 24, broken front, 15 1/2 acres, £200 (same as Aug. 28. 1851). Quit claim #620. (Middlesex County Registry Office)

Nov. 3, 1852:
Sarah Ann Weston dies, the wife of William Weston, 50 years old.

1854:
Mignon Innes [England Jan. 21, 1826-London Ont., July 29, 1903] marries Elizabeth Ann Clarke [d.1865], only daughter of Colonel John Clarke of the 76th Regiment stationed in London. (Anglican Diocese of London records; Glen Curnoe, phone conversation July 1991)

1854:
There is a third cholera epidemic in the Town of London. (Bremner, *Illustrated London, Ontario, Canada*, p .35)

Jan. 19, 1855:
Benjamin Shaw to George Watson [Straffordshire, England, town carpenter/architect, Methodist, 1813-c.1910] , part of lot 25 in the broken front concession of the Township of Westminster, 4/5 acre at the south east corner of what is now Watson Street and Wellington Road. Bargain and sale #1417. (Middlesex County Registry Office abstract) Watson Street is named after him. 'Watson Street was originally called Turley-Tooloo Street, the name of Renold's and Shaw's sawmills on the river nearby, then Mill Street.' (Priddis, 'The Naming of London Streets,' p.23)

Sam Peters Registered Plan 95, Oct. 10, 1854 shows the Turtulla Steam Mill Property as proposed to be sold by Messrs. John Raynard and Benjamin Shaw. It also shows Turtulla Street. (Middlesex County Registry Office)

June 11, 1855:
Samuel Peters [surveyor/architect, 1822-1882, arrives c.1845] completes and registers plan #206 for John Gumb. Part of Lot No. 24 in the broken front Concession of the Township of Westminster, subdivided into sub lots 1/2/3/4/5. 'We Samuel Peters of the City of London, Provincial Land Surveyor, and John Gumb of the Township of Westminster, at the date of this survey, but now of Nissouri in the County of Middlesex, original owner of the Land in this Plan shewn, at the time of the Survey thereof in 1855. Do hereby certify that this is a correct Plan or map of such Survey so made by the said Samuel Peters. London C.W. 29th Septr. 1865.' (Samuel Peters notebooks, London Art and Historical Museums; London Room; Middlesex County Registry Office)

June 16, 1855:
John Gumb to William Henry Fairhall [1829-1906], sub lot 3, registered plan #206, lot 24, broken front, 3 acres, bargain and sale #1573. (Middlesex County Registry Office)

Aug. 27, 1855:
♥ John Gumb to his sons: William Gumb [yeoman 1826-1863] and Daniel Gumb [yeoman 1829-?], part of lot 25, broken front, less 30 foot right of way along south side of lot, 6 acres, 5 shillings. (Same as July 24. 1846, 33 foot right of way reserved along the south side of the property). Bargain and sale #1778. (Middlesex County Registry Office)

June 1856:
John Gumb to Thomas Gumb [1828-?], sub lot #5, Registered Plan 206, (48 to 50 Weston Street), 1 acre 2 roods 16 perches. Bargain and sale #2302. (Middlesex County Registry Office)

Dec. 24, 1856:
John Gumb to Thomas Gumb, sub-lot #2, Registered Plan 206, £500. Bargain and Sale #2331 (Middlesex County Registry Office)

1857:
Leonard Odell becomes a founding director of the Westminster Insurance Company. (Goodspeed, *The History of the County of Middlesex*, p. 575) Reverend William Clarke is transferred to Dresden. He also preaches in Bothwell. (United Church Archives) 'William Clark was pastor of a small Congregational Church built in the south-east part of Dresden about 1855 and it served the community until other churches were established.' (Hyatt, *The Story of Dresden*, p. 15)

A severe panic and depression hits the London District. It will take nearly half a century for land prices to reach their former heights. (Armstrong and Brock, 'The Rise of London: A Study of Urban Evolution in Nineteenth-Century Southwestern Ontario,' p. 93)

Feb. 6 and 7, 1857:
'A spring thaw during the first week of February 1857 resulted in the

destruction of Clark's Bridge at the south end of Wellington Street. Large masses of floating ice, carried by the rapidly flowing water, bombarded the supports until the entire structure was carried off.' (Hives, *Flooding and Flood Control*, p. 25)

1857:
Captain George Mignon Innes retires from the Royal Canadian Rifles. (Glen Curnoe, phone conversation, July 1991)

1858:
'Decimal system of monies established.' Canadian dollars replace Quebec pounds. (*The Municipal Year Book* 1958, p. 132)

c.1859:
John Gumb and his sons; Daniel, Thomas, and William Gumb move to West Nissouri Township. (Middlesex County Registry Office abstract)

March 1 and 2, 1861:
There is a severe flood of the Thames. 'According to eye witness reports, the ice moving down the river presented a magnificent spectacle. The ice gouged the river banks so badly that water eventually forced its way out of the channel and overflowed onto the unprotected low-lying ground around Clark's bridge.' (Hives, *Flooding and Flood Control*, pp. 26, 178)

Jan. 12, 1862:
1861 Census: William *Weston*, gentleman, widower, born in England, 61, Church of England, 6 1/2 acres, lives in log house with Liza Weston, single, Canada, 21, Church of England, 1/4 acre. They own 1 horse, 1 cow, 1 pig, 2 carriages [they live on the south side of what is now Weston Street east of Wellington Road]. Richard Gumb, England, 33, Methodist. Catherine Gumb, Canada East, 32, Methodist. William Gumb, Canada West, 11. Elizabeth Gumb, C.W., 5. Alfred Gumb, C.W., 3. Emily F. Gumb, C.W., under 1 year (They live in a one story frame house on sub lots 1 or 4, Plan #206 north side of what is now Weston Street). Henry Fairhall, maltster, England, 32, Wesleyan Methodist. Caroline (Gumb) Fairhall, England, 27, Church of England. Mary Fairhall, Upper Canada, 5 [they live in a one story brick house on sub lot 3, plan #206 north side of

what is now Weston Street, possibly number 66 Weston Street, demolished in 1970]. William *Horton*, Ireland, recorder, 43, Church of England. Martha Horton, England, 39, Church of England. Augusta Horton, UC, 17. Emily Horton, UC, 15. Fanny Horton, UC, 14. Mary Horton, UC, 12. Madeline Horton, UC, 10. William Horton [1853-1870], UC, 8. Charles Horton, UC, 6. Caroline Horton, UC, 4. Constance Horton, UC, 3. Ida Horton, UC, 1. Emma Horton, UC, 3 mos. [they live at what is now 113/115 McClary Ave.{Maryboro Place}]. George *Watson*, England, carpenter/ architect, 48, Methodist. Margret Watson, dressmaker, England, 48, Methodist. Isabele Watson, Canada, 19. Richard Watson, Canada, 14. John Watson, Canada, 9. James Watson, Canada, 8. [they live at the south east corner of Watson {Turtulla} Street and Wellington Road in a brick house.] John B. Taylor, Ireland, Gentleman, 31, Church of England. Jane Taylor, Ireland, 25, Church of England. Jeremiah Taylor, Canada West, 4. Sophia Taylor, Ireland, 6. Hedly Taylor, Canada West, 2. [They all live in a three story brick house on Wortley Road]. (London Room; Glen Curnoe, note July 31, 1991; RCWL)

1862/1863:
Christ Church is built. 'The Reverend Mr. G. M. Innes, appointed by Bishop Benjamin Cronyn to organize the new parish, must have been a very dedicated man. He worked without a salary; he himself raised $500 in Britain towards the cost of the new church; and he evidently had to face some trials from the more unruly members of his gathering congregation.' The church is designed by William Robinson [1812-1894]. Robinson's funeral is conducted in this church. Pew holders at Christ Church in 1863 include: Richard Frank, John Barton Taylor, George Goodhue, William Horton, William Whitehead, the Weston family (probably George and Anna Weston) and the Odell family [probably Leonard Odell] (Christ Church records; Tausky and Di Stefano, *Victorian Architecture in London and Southwestern Ontario*, pp. 142, 143)

Feb. 11, 1863:
♥ William Gumb, now of West Nissouri to his siblings: Thomas Gumb [West Nissouri, blacksmith], Richard Gumb [Westminster, farmer, 1828-], Daniel Gumb [West Nissouri, yeoman, 1829-?], Caroline (Gumb) Fairhall [1833-1911] part of lot 25, broken front, 6 1/2 acres (same as Aug. 27, 1855),

to be divided equally between them. Bargain and sale #4000. (Middlesex County Registry Office)

July 21, 1863:
♥ William Gumb leaves to his siblings: Thomas Gumb, Richard Gumb, Daniel Gumb, Caroline (Gumb) Fairhall; part of lot 25, broken front, 6 1/2 acres (same as Aug. 27, 1855). Will #4178. (Middlesex County Registry Office)

1863:
'The sandy flats which are met with in many places along the Thames from St. Mary's to Chatham, contain land and river shells in great abundance. At London the fine fluviatile sand rests upon a mixture of coarse clay with sand and pebbles. Both the land and fresh-water shells, which comprise many species, are disseminated throughout the deposit, to a depth of seven feet, and perhaps more, but are most abundant in certain beds. It is observed that the proportion of land shells greatly increases toward the surface.' 'Superficial Geology,' Geological Survey of Canada, *Report of Progress from its Commencement to 1863*, p. 913)

March 31, 1864:
John Barton Taylor buys a plot in St. Paul's Anglican cemetery. (Church of England cemetery records at Woodland Cemetery)

Sept. 27, 1864:
♥ Thomas Gumb [of Nissouri, blacksmith] and Jane Gumb [of Nissouri 1829-?], Richard Gumb [Westminster, farmer] and Catherine /Christian Gumb [Westminster, born in Canada East 1829-?], Daniel Gumb [Nissouri, yeoman] and Jane Gumb [Nissouri], John Gumb [Nissouri, blacksmith], Henry Fairhall [Westminster, maltster 1829-1906] and Caroline (Gumb) Fairhall [Westminster] to Reverend George Mignon Innes [minister of Christ Church, Anglican, 138 Wellington Street (north-west corner of Hill Street)1863/1864/1865, missionary at the same church in 1862 {does the Gumb family attend this church?}], part of lot 25, broken front, with a 30 foot right of way reserved along the south side of the property, 6 acres, $600 (same as Aug. 27, 1855), Bargain and sale #4419. (Anglican Diocese of London records; London Room; RCWL; Middlesex County Registry Office)

1864:

Reverend William Clarke travels to the north shore of Lake Huron, Colpoy's Bay and Manitoulin Island under the auspices of the Indian Mission of the Congregationalist Missionary Society, 'establishing mission stations and preaching the gospel to the aborigines.' (United Church Archives)

March 17 to 20, 1865:

There is a severe flood of the Thames River. (Hives, *Flooding and Flood Control*, p. 178)

Oct. 20, 1865, Thursday:

Eliza Weston is married to John Shopland at William Weston's log house on Wellington Road. (*London Advertiser*)

Nov. 22, 1865:

♥ Reverend George Mignon Innes [assistant at Québec Cathedral, Diocese of Québec 1865/1866/1867/1868, he marries Annie McCallum of Quebec there in 1867] to John Barton Taylor [1830-?, Church of England], part of lot 25, broken front, with a 30 foot right of way reserved along the south side of the property, 6 acres, $200 [same as Aug. 27, 1855]. Bargain and sale #4720 (Anglican Diocese of London records; Middlesex County Registry Office)

Nov. 7, 1866:

John Barton Taylor assumes the mortgage of Henry and Caroline Fairhall on sub lots 3 and 4 of Registered plan #206 [part of number 54 to part of number 72 Weston Street]. Instrument number #4997. (Middlesex County Registry Office abstract)

1866:

Colonel John Barton Taylor commands the London Home Guard Infantry during the Fenian Raids. The Infantry is sent down to Fort Erie. Are they engaged in the battle of Ridgeway on June 1, when the Roberts wing defeats the Canadian Militia? (Senior, in Marsh, ed., *The Canadian Encyclopedia*, p. 623; Goodspeed, *The History of the County of Middlesex*, p.158)



Feb. 14 to 17, 1867:
There is a severe flood of the Thames River. (Hives, *Flooding and Flood Control*, p. 178)

July 16, 1867:
Eliza (Weston) Shopland dies at the age of 28 in Westminster Township. (Woodland Cemetery)

Aug. 20, 1867:
Thomas Gumb to Leonard Bartlett [market gardener 1828-1904], sub lot 5 Registered Plan #206 [numbers 48, 50 and part of 54 Weston Street] 1 acre 2 roods 16 perches, $110. Jane Gumb bars her dower. Bargain and sale #5270. (Middlesex County Registry Office)

c.1867:
Leonard Bartlett's red brick house is built? This house could have been built by Henry and Caroline Fairhall around 1856 (modern number 64), along with a brick barn which is right on the north edge of Weston Street. The sidewalk still ends where the barn stood (1991). The house is torn down around 1970. (Abrams interview, June 1991; Curnoe, Potter phone conversation, June 1991)

Oct. 19, 1867:
John Barton Taylor to John Broomfield [1847-1906]: 'containing by admeasurement 1/4 of an acre, be the same more or less, being composed of part of lot number 25, in the broken front concession of the said Township of Westminster, and which may be known and described as follows: that is to say, commencing on the east side of the road leading from Wellington Bridge to the Commissioners' Road at the distance of 91 feet south from the northwest corner of land conveyed by the Reverend George M. Innes to the said party of the first part hereto, thence easterly parallel to the northern limit of said land, 324 feet more or less, to the River Thames, thence southerly along the River Thames, 33 feet 8 inches, thence westerly parallel with the northern limit of the lot, 324 feet more or less to the said road, thence northerly along the said road 33 feet and 8 inches to the place of beginning.' Conveyance #6673. (Middlesex County Registry Office; Woodland Cemetery)

Nov. 1868:
George Mignon Innes is appointed curate at St. Paul's Cathedral in London. (Anglican Diocese of London records)

January 1869:
'The 7th Battalion London Light Infantry, commanded by D.A.G.Taylor consisted of 363 men in 7 companies.' The actual strength is 380 men. (Goodspeed, *The History of the County of Middlesex*, p. 159)

Nov. 6, 1869:
Lulu Mabel Hayes Weston is born to Anna Jane Adelaide Weston, the daughter-in-law of William Weston. Lulu is christened at Christ Church. (Christ Church records)

1869:
George Mignon Innes is appointed Canon at St. Paul's Cathedral. (Anglican Diocese of London records)

June 2, 1870:
'2nd Lieut.-Col. Taylor recalled the battery, cavalry and all from the frontier.' They had returned to Sarnia on May 26 to repel a threatened invasion of Canada by the Fenians. Taylor is an officer of the First Brigade Division of Military District No.1, of the Militia. (Goodspeed, *The History of the County of Middlesex*, p. 159)

Nov. 4, 1871:
George Mignon Innes is appointed Rector of St. Paul's Cathedral & Petersville. (Anglican Diocese of London records)

1871:
Census: William Weston, 70 (south side Weston Street). John Broomfield, Ontario, blacksmith, 28, Church of England [1847-1906]. Suzanne (Susan) Broomfield, Ont., 26, Church of England [1846-1904]. Mary Broomfield, 8. John Broomfield, 6. Minnie Broomfield, 4. Frederick Broomfield [1869-1906], 2 [They live on the east side of Wellington between Watson and Weston Streets]. William Weatherhead [1829-1916], Ireland, grocery keeper, 40, Church of England. Eliza Weatherhead [1830-1905], Ireland, 40, Church of

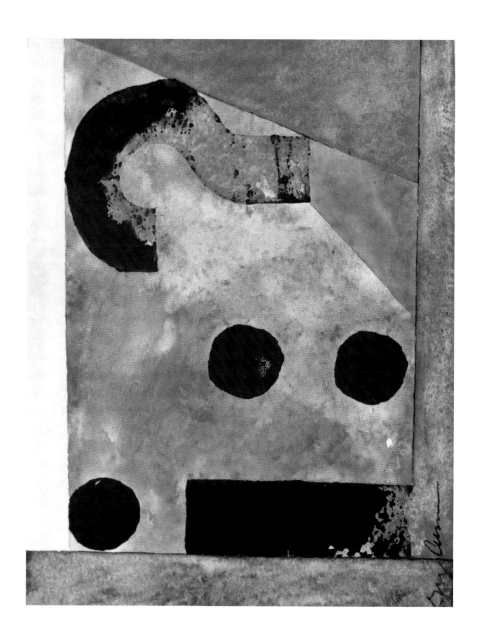

PLATE I. i:ʔ WAI (Seneca). August 10-13, 1992. (22.5 x 32.5 cm.)

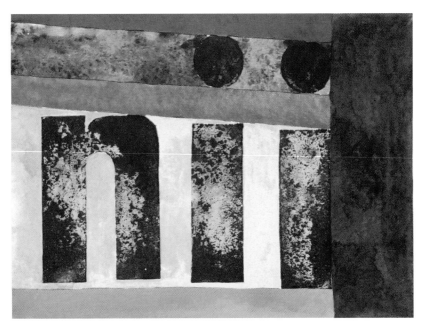

PLATE II. Wan Ha Nii. July 7, 1992. (22.5 x 30 cm.)

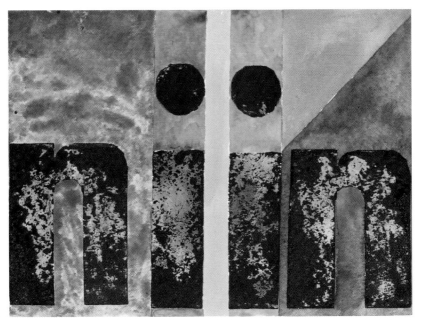

PLATE III. Miig Wa Niin. July 9/20, 1992. (22.5 x 30 cm.)

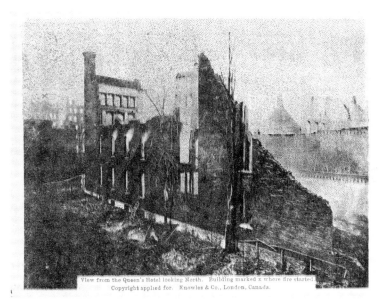

View from the Queen's Hotel looking North. Building marked x where fire started
Copyright applied for. Knowles & Co., London, Canada.

PLATE IV. Postcard printed by the Knowles printing shop, collection of Glen Curnoe.

875. View at Paris, The Prettiest Town in Canada.

PLATE V. Postcard printed by the Knowles printing shop, collection of Glen Curnoe.

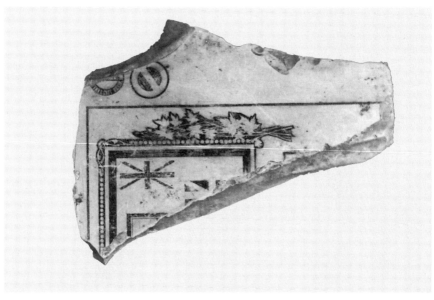

PLATE VI. Lithograph stone from the Knowles printing shop, discovered by Owen and Greg Curnoe at rear of 38 Weston Street.

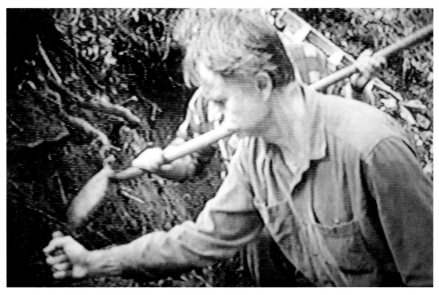

PLATE VII. Greg Curnoe during official archaeological dig, 38 Weston Street, May 1992.

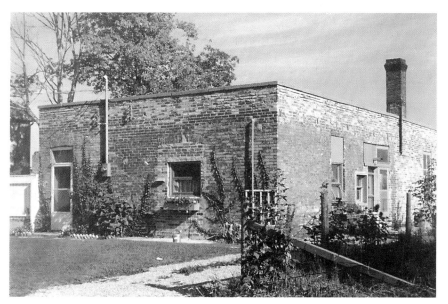

PLATE VIII. 38 Weston Street, ca. 1960.

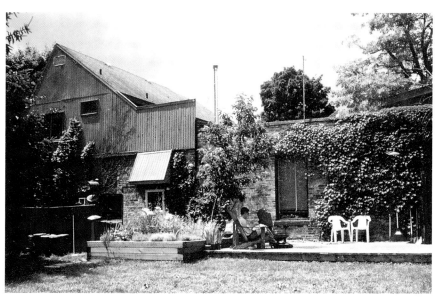

PLATE IX. 38 Weston Street, in 1995.

PLATE X. 'Deeds no. 3.' April 15/17, 1991. (106 x 168 cm.)

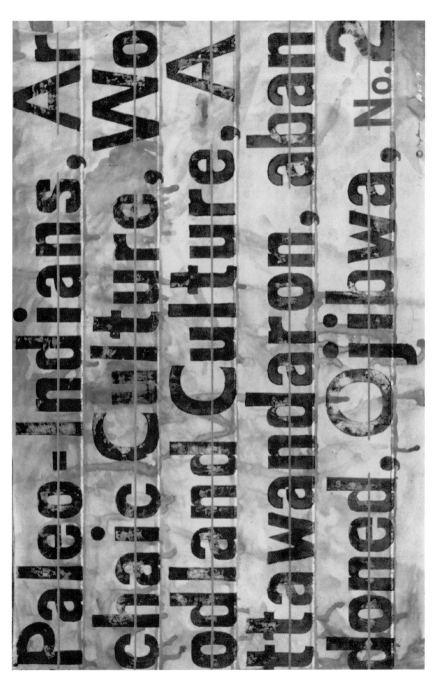

PLATE XI. 'Deeds no. 5.' August 19-22, 1991. (106 x 168 cm.)

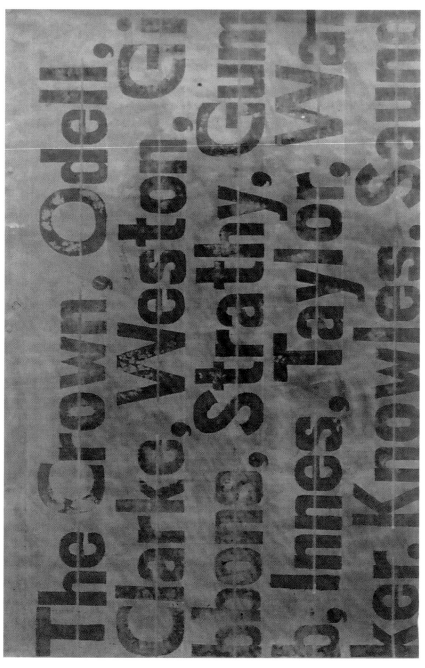

PLATE XII. '(Mis)Deeds no. 1.' December 5, 1990 / January 9, 1991.
(106 x 168 cm.)

England. [They live on sub-lot 4, 12 Weston Street.] Robert Colgrove [1834-1893, killed in railway accident at Battle Creek, Mich. US England, gardener, 34, Church of England. [Sarah Jane] Victoria Colgrove [1846-1930], Ontario, 24, Church of England. Frederick Colgrove, 5. Arthur, 3. [They live on sub lot 6, 30 Weston Street.] William Horton, barrister, 52. Martha Horton, 47. Fanny Horton, 27. Mary Horton, 20. Madeline Horton, 19. William Horton, 18. Charles Horton, 16. Caroline Horton, 14. Constance Horton, 12. Ida Horton, 10. Emma Horton, 7. [They all live at 113/115 McClary Avenue {Maryboro Place}.] Thomas Gum[b], Ontario, farmer, married, 43, Church of England. Jane Gum(b), Ontario, married, 42, Church of England. John Gum[b], Ontario, farmer, 21 [1851-1927], Church of England, 21. Caroline Gum[b], Ontario, 20, Church of England. Thomas Gum[b], Ontario, farmer, 18, Church of England. Alice Gum[b], Ontario, 12, Church of England. [They all live in West Nissouri Township.] (London Room; Mount Pleasant Cemetery; RCWL; Woodland Cemetery)

1871/72:
City directory: B. F. 25 Westminster: William Weston, Capt. J.B. Taylor, William Horton. Robert Court, Solomon Munro. B. F. 24: William P. Frank. (London Room)

May 7, 1871:
William Weston dies, leaving his estate to his son George Weston [carpenter 1835-c.1880] and his daughter Anne Walker [1830-?]. His executor is John Walker, husband of Anne [Weston] Walker. Will #176. (Joanne Scott; Middlesex County Registry Office; Mount Pleasant Cemetery records)

May 11, 1871:
John Walker, executor of William Weston's estate to George Weston [1835-c.1880], 3 1/4 acres [same as Jan. 31, 1848]. Bargain and sale #6731. (Middlesex County Registry Office abstract)

John Walker, executor of William Weston's estate to George Weston, 3 acres 1 rood 13 perches [same as Sept. 6, 1842]. Bargain and sale #6731. (Middlesex County Registry Office abstract)

May 22, 1871:
John Walker, of the State of Illinois in the United States, to Richard Frank

[1799-1872], the west side of Trevithen Street from Weston Street to Bond Street for $75. (Middlesex County Registry Office)

April 7 to 10,. 1873:
There is a severe flood of the Thames River. (Hives, *Flooding and Flood Control*, p. 178)

June 25, 1873:
♥ Lieutenant Colonel John Barton Taylor [Deputy Adjutant General] and Jane Taylor [1836-?] to John Mellis [gardener 1809-?], sub lot 7, RP #312, 3 roods, 19 perches, $125. 'sub-lot number seven according to a plan and survey made for the party hereto of the first part by Samuel Peters P.L.S. and duly registered at the Registry office of the County of Middlesex,' (numbers 34 and 38 Weston Street). Deed #7928. (Middlesex County Registry Office; RCWL)

June 27, 1873:
♥ Samuel Peters, completes and registers plan #312 'Plan of Villa Lots near the City of London, being part of lot 25, in broken front concession Township of Westminster Ont. as laid out for Lieutenant Colonel Taylor D.A.G., Subdivision into sub lots: 1,2,3,4,5,6,7.' (George Cole)

Lieutenant General William Turnbull Renwick [British Army Engineer, England 1802-London, Ont. 1890] owns the land across the river from plan #312: '... the tongue of land lying between Trafalgar Street and the east branch of the River Thames, that is to say, commencing in the southern limit of Trafalgar Street at the water's edge of the River Thames thence following the water's edge of the said river against the stream to the westerly limit of the property of the London and Port Stanley Railway Company thence northerly along the limit of the property of the London and Port Stanley Railway Company to Trafalgar Street, thence westerly along the southern limit of Trafalgar Street to the place of beginning; reserving the several streets within the above described boundaries and free access to the shores of the river for all vessels, boats and persons the above described land is intended to include all the land belonging to General Renwick lying south of Trafalgar Street and west of the London and Port Stanley Railway as described in the original grant of the Crown to one William Barker.' (Glen Curnoe; Joanne Scott; Middlesex County Registry Office)

'This land included what was later called Renwick's Island and still later Winnett's Island. When the General bought the property there was no island, however. The river at that time followed a course which moved sharply to the South at the foot of Colborne Street, and then returned to bend westward again immediately north of Front Street. This formed a peninsula which ran southward probably a thousand feet. Now General Renwick was a military engineer, and thought he knew something about rivers and streams. For some reason best known to himself he caused a ditch to be dug across the neck of the peninsula, and let the water into it. The river, however, took to the short-cut in a manner never dreamed of by the General, [in the great flood of 1883] and abandoning the course to the South, it shot across toward Front Street, carrying the earth with it, and making a channel 60 or 70 feet wide. In its newly enjoyed freedom the Thames hurled itself against the high land on which stood the house of the late Henry Winnett, a boiler maker, who was the father of the late Henry Winnett of the Tecumseh Hotel, and threatened to wash away the homestead. The result was a lawsuit, which dragged on for years in the courts, and finally resulted in the defeat of the general, who had to pay heavy damages. The island remains, but the old course of the river has almost disappeared. In the olden days, on the south bank, stood a huge elm tree where the boys of that time used to swim, the favorite hole being designated as "The Elm".' (Carty, The *London Advertiser*; Glen Curnoe)

July 3, 1873:
John Barton Taylor to Robert D. Colgrove [market gardener 1834-1893 in a railroad accident, Battle Creek, Michigan] 1 acre, sub-lot 6, Registered Plan #312, $175, bargain and sale #7788 (Middlesex County Registry Office)

July 3, 1873:
John Barton Taylor to Thomas Knowles the elder [machinist 1841-1926] 1 acre 20 perches, sub lot 5, Registered Plan #312, $150, bargain and sale #9488. (Middlesex County Registry Office)

Nov. 15, 1873:
♥ John Mellis and Catherine Mellis to Lieutenant Colonel John Barton Taylor, sub lot 7, RP #312, 3 roods, 19 perches, $161.00. (numbers 34 and 38). Bargain and Sale #7930 (Middlesex County Registry Office)

Nov. 22, 1873:
George Weston [1835-c.1880 carpenter] to James Dagg [innkeeper], 3 acres
1 rood 13 perches in lot 25 [same as Sept. 6. 1842] and 3 1/4 acres in lot 24,
1$. Conveyance #7956. (Middlesex County Registry Office)

James Dagg to Annah Jane Adelaide [Hayes] Weston [1833-1895 Detroit,
wife of George Weston], 3 acres 1 rood 13 perches in lot 25 [same as Sept. 6,
1842] and 2 1/4 acres in lot 24, 1$. Conveyance #7957. (Middlesex County
Registry Office; Woodland Cemetery)

December 14, 1873:
There is another severe flood of the Thames River. (Hives, *Flooding and
Flood Control*, p. 178)

c.1874:
Colgrove house [number 18 Weston Street] built with yellow brick.
(Abrams interview May 1991; Curnoe – Fowler, phone conversation, June
1991)

Jan. 22, 23, 1874:
There is a very severe flood of the Thames River. (Hives, *Floods and Flood
Control*, p. 178)

1875:
Westminster Township Assessment Roll: Lot 25, north side of Weston
Street: John Mellis: John Egget age 34 lives on the lot, works for Mellis.
There are 8 in Mellis' family & 1 dog on 5 acres, total value $650. Mellis
property has the same value in 1876,77,78 and 1979. Robert D. Colgrove
[market gardener], lives on sub-lot 6 on 1 acre. There are 6 in his family & 1
dog. He owns 2 3/4 acres with a total value of $700. Lot 24, north side of
Weston Street: Leonard Bartlett lives on sub-lot 5, 3 3/4 acres, total value
$600. There are 6 in his family. His property has the same value in 1876. In
1877 it has a total value of $650, in 1878 a total value of $800. Lot 24/25,
south side of Weston Street: Leonard Ardiel/George Weston age 40, lot 25,
6 acres with a total value of $1100. There are 6 in Weston's family & 1 dog.
The Ardiel/Weston property has the same value in 1878/79/80. (Ed
Phelps, RCWL)

Feb. 8, 1875:
George Weston/Huron & Erie mortgage assigned to Leonard Ardiel [farmer born in Ireland 1828-London 1890] 3 acres 15 perches [William Weston's land along the south side of Weston Street, from Trevithen Street to Wellington Road]. Mortgage #8577. (Middlesex County Registry Office)

March 31, April 1, 2, 1875:
There is a heavy flood of the Thames River. (Hives, *Flooding and Flood Control*, p. 178)

Sept. 4, 1875:
♥ Lieutenant Colonel John Barton Taylor and Jane Taylor to Thomas Knowles the elder [machinist], sub lot 7, RP #312, 3 roods, 19 perches, $200 (34 and 38 Weston Street). Conveyance #9534. (Middlesex County Registry Office)

1875/76:
The Knowles homestead is built of red brick (8/10 Weston Street near the present site of the Moose Lodge).

1876:
Westminster Township Assessment Roll: In 1876, 1877, 1878, and 1879 Thomas Knowles senior, machinist, has 8 in his family & 1 dog, lot 25, 2 acres, total value $500. Total value in 1880 and 1881 is $600 (9 in family). In 1882 there are 8 in the family and 2 dogs, $600. In 1884, 1885, 1886, 1887 there are 10 in the family, $600. In 1888 there are 11 in the family, $600. (RCWL)

1877/1878:
City directory: Thomas Knowles [machinist], residence Providence, Westminster Township. Leonard Bartlett is also listed as living at Providence (66 Weston Street exists but it is not listed) (London Room)

May 1878:
Reverend William Clarke dies at Dresden, Ontario, aged 76. (United Church Archives)

Nov. 5, 1878:
George Weston and Anna Jane Adelaide Weston to Leonard Ardiel 6 acres 15 perches [Wellington Road to Trevithen Street same as Feb. 8, 1875], final order of foreclosure [orders issued on May 14, and June 25, 1878]. Court of Chancery #11673. (Middlesex County Registry Office)

1880/81/82:
City directory: lot 25 Westminster Township: Thomas Knowles. George Weston last appears in Westminster Township, on Wellington Road in 1881. Georgia Weston, a teacher boards there in 1880. (London Room)

May 24, 1881:
Dora May Bartlett boards the steamboat *Victoria* at Springbank Park. She leaves the boat before it leaves the dock. The *Victoria* capsizes near the Coves with a loss of over 200 people. Leonard Bartlett goes to the wreck and looks through the corpses for his daughter. We can only imagine his relief when she returns home safely. (United Church Archives, Reverend Robert Cumming)

Oct. 22, 1881:
Eliza Georgina Jane Weston, the daughter of George and Adelaide Weston and the grand-daughter of William Weston, is married to W. B. Longworth of the State of Michigan in the US. at Christ Church on Wellington Street. (Christ Church marriage register)

1881:
Census: Thomas Knowles [1841-1926], 40, England, machinist, Congrega-tionalist. Elizabeth Knowles [1843-1896], 38, England, Congregationalist. John Knowles, 17, Ontario. Thomas Knowles [1866-1933], 15, Ontario. Joseph Knowles [1868-1954], 13, Ontario. Arthur Knowles [1871-1953], 10, Ontario. Theodore Knowles, 9, Ontario. Elizabeth Knowles, 8, Ontario. Sarah Jane Knowles, 4, Ontario [all at sub lot 5 plan #312 near the present site of the Moose Lodge 6/10 Weston Street]. Leonard Bartlett [1827-1904], England, gardener, 52, Methodist. Rachel Bartlett [1831-1906], 56, Ontario, Methodist. Dora Bartlett, 15, Ontario. Oliver Bartlett [1867-1898], 14, Ontario. Selina Bartlett [1869-1897], 11, Ontario. Leonard Bartlett [1872-1963], 9, Ontario. Esther Bartlett, 10 mos., Ontario [all on plan #206 north side of Weston Street, number 66]. Robert Colgrove, 45, England,

florist. Sarah Colgrove, 34, England. Frederick Colgrove, 15, Ontario. Charles Colgrove, 13, Ontario. William Colgrove, 9, Ontario. [sub lot 6 plan #312 30 Weston Street]. William Horton, 62, Ireland, barrister. Martha Horton, 58, England. Francis Horton, 33, music teacher. Madeline Horton, 30. Caroline Elizabeth Horton, 24 [marries Hugh A. Stringer at Christ Church, May 10, 1882], Charles Horton, 26, law student. Constance Horton, 22, teacher. Margaret Horton, 20, artist. Martha Horton, 15 [all at 113/115 McClary Avenue {Maryboro Place}]. George Watson, 69, England, architect. Margret Watson, 69, England. Ida Watson, 12, Ontario. George John Watson, 9, Ontario. (All at the south east corner of Wellington Road and Watson {Turtulla} Street.] John Broomfield, 38, Ireland, blacksmith. Suzannah Broomfield, 37, Ontario. Mary Ann Broomfield, 18, Ontario. John Broomfield, 16, Ontario [christened at Christ Church]. Minnie Broomfield, 14, Ontario. Frederick Broomfield, 12, Ontario. Carrie Broomfield, 16, Ontario. William Broomfield, 8, Ontario. Suzannah Broomfield, 5, Ontario [1876-1885] [all on Wellington Road east side between Weston and Watson {Turtulla} Streets]. (Glen Curnoe; London Room; Mount Pleasant Cemetery; RCWL; Woodland Cemetery)

1881:
Westminster Township Assessment Roll: Leonard Bartlett, lot 24, 3 3/4 acre, total value $1000, 7 in family & 1 dog. 1884 total value $1500, 7 in family. In 1885 and 1886 2 dogs. In 1887, 1888 and 1890 total value is $1600. Leonard Ardiel, 53/ Joseph Simpson, 24, works for Ardiel, lives on lot, 6 1/2 acres, total value $1800, 10 in family. William Guest/John Egget, age 42, works for him?, lot 25, 5 acres, total value $800, 12 in family & 1 dog. (RCWL)

1883:
City directory: Askin post office; Thomas Knowles jr. [1867-1933]. (Glen Curnoe; London Room)

April 10, 11, 12, 13, 1883:
There is a severe flood of the Thames River. (Hives, *Flooding and Flood Control*, p. 179)

July 10 and 11, 1883:
'The weather of that day (July 10) had been very humid, with rain

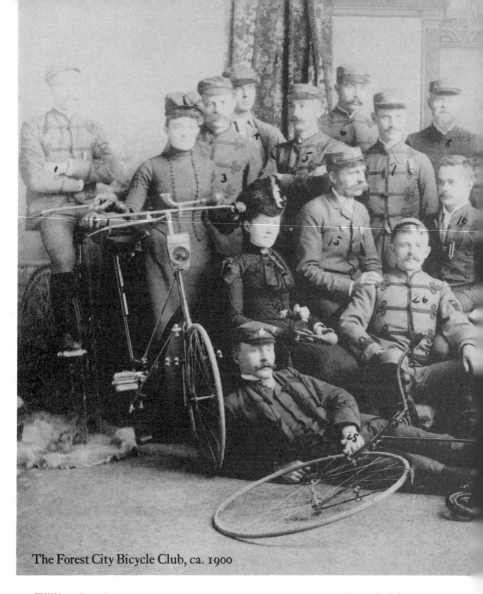

The Forest City Bicycle Club, ca. 1900

1. William Lamb
2. Mrs Willam Lamb
3.
4. Arthur Stringer, Author
5. Walter Wigmore, Painter
6. William Wigmore, Painter
7. James Mann, Coal Merchant
8. James Reid, Hardware Merchant

9. Fred Lawrason, Household Ammonia
10. Hi Ervine, Military Income Tax
11. William Mullins, Costa Rica Railway
12. George Coleman
13. Corbin Weld, Farmer's Advocate
 (Winnipeg)
14. Mrs William Payne
15. Mr William Payne, Bicycles

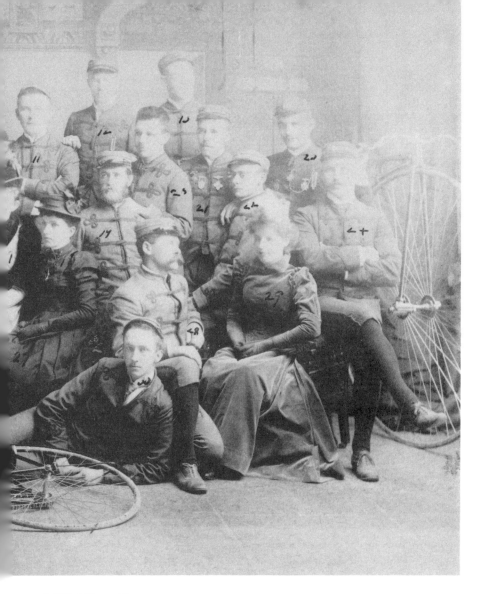

16. 'Nip' Tune, Beverages
17. Miss Payne (Mrs Chester Abbott)
18. Mrs William Saunders
19. Wm. E. Saunders, Drugs-Birds-Nature
20. Thomas Knowles, Lithographer
21. Joseph Knowles, Lithographer
22. Charles Ellis
23. William Owens, Barrister (Forest)
24.
25. Thorne, Shoes
26. R. M. Burns, Burns-Lewis
 Wholesale Clothier
27.
28. Stanley Williams, A.E. Pavey Inc.
29.
30. Bob Brebner, Druggist (Sarnia)

beginning to fall about 5 o'clock. Within an hour, the storm accompanied by thunder and lightning increased perceptibly in intensity "... a great blaze of red behind the heavy clouds which appeared to envelope the earth; extending around in dark masses. The busy people, fatigued from toil and the heat of the day had gone to rest." Soon after the folk of London retired for the evening, the storm dissipated, giving way to a clear night. Then the storm, after moving off to the east, doubled back in a semi-circular fashion, returning to this area about midnight. "... lightning flash followed by a loud peal of thunder; another and another. The rain first pattered on the roofs in large droplets then poured down in torrents. Lightning again—flash—now in the lucid glare which lit up the heavens and scattered cloud bursts while the thunder rolled—each clap seeming to shake the houses on their foundations." The storm died down about two a.m. on July 11th, "giving place to a brilliant starlight night and all were once more prepared for a night of rest." Returning home in the early hours of July 11th ... he [William Thompson, a reporter for the *London Advertiser*] decided to go down to the river to observe the effect of the tremendous rainfall. "As he approached the river, Thompson heard a peculiar sound to the north—a low pitched roar. He walked a little faster, then as the sound grew louder, he broke into a run ... he saw a peaceful village (Petersville, then a suburb) converted within minutes into a whirling gully of wildly tossing, broken houses and screaming beings".'

'In possibly the strangest event of the morning of July 11th, six acres of land disappeared on the South Branch. Behind a house on Bridge Street, now Front Street, on Winnett's Flats, a man named Fox had recently constructed four cottages at the exact point where the river broke through from its natural bed. The torrent ploughed and burrowed at such a rate that, within a few hours, the fast flowing stream carved a channel through the entire area. Not only had buildings in the path of the current disappeared, but so too had six acres of land on which they stood. There remained only an eight-foot trough and a bed of gravel. Newspaper accounts indicated that the inhabitants of the cottages had fled before the river broke through.' Mills/Winnett's/Renwick's Island is created and the old channel that forms the broken front of Westminster becomes a secondary channel. The new channel is caused, to some extent, by General Renwick – see June 27, 1873. (Hives, *Flooding and Flood Control*, pp. 45, 179)

1884:
City directory: lot 25, London South: Thomas Knowles [jr.], engraver *London Free Press*. He works there as an engraver and lithographer until 1887. (London Room)

1885:
Westminster Township Assessment Roll: Leonard Ardiel/Mrs. Anna Jane Adelaide Weston [1833-1895] lives on lot, lot 25, 6 1/2 acres, total value $1700, 4 in family. (RCWL)

April 7, 8, 1885:
There is a heavy flood of the Thames River.

Jan. 4, 5, 1886:
There is another heavy flood of the river. (Hives, *Flooding and Flood Control*, p. 179)

Dec. 30, 1886:
John Barton Taylor (now of Winnipeg) quit claim #16436 to John Broomfield. This is Taylor's last transaction with regard to his original purchase from George M. Innes for $200 in 1865.

Prior to 1886 Taylor has sold: 3/4 acre to Lachlan McGill [yeoman 1837-?, Presbyterian] for $700 on Apr. 21, 1870, conveyance #6197! 1 acre to John Broomfield [blacksmith 1847-1906] for ?, conveyance #6673! 1 rood 18 perches/sub lot 1 to Fergus Lloyd [carpenter] for $120 on June 28, 1873, conveyance #7747! 1 rood 30 perches/sub lot 2 to Charles Smart [yeoman] for $110 on July 3, 1873, conveyance #7781! sub lots 3 and 4 to Daniel Torrance [baker] for $205 and $150 on Aug. 19, 1873 and Apr. 20, 1874, conveyances #8159 and #8160! 1 acre 20 perches/sub lot 5 to Thomas Knowles Sr. for $150 on July 3, 1873, conveyance #9488! 1 acre/sub lot 6 to Robert D. Colgrove [gardener 1834-1893] for $175 on July 3, 1873, deed #7788! 3/4 acre to James Campbell for 1$ on June 12, 1880! ♥ sub lot 7 to Thomas Knowles Sr. for $200.

In ten years and three months Taylor has sold off parts of his original lot for at least $1660 at a profit of at least $1460 or eight-hundred and thirty per cent. (Glen Curnoe; London Room; RCWL; Middlesex County Registry Office)

1886:
City directory: lot 25 Westminster: Thomas Knowles, Mrs. Anna Weston. (London Room)

April 16, 1888:
George Mignon Innes is appointed Dean of Huron. (Anglican Diocese of London records)

1888/1889:
City directory: Westminster: (12) Knowles Litho, (18) Thomas Knowles, (30) Joseph Knowles. The Shop is at the rear of 8/10 Weston Street? Thomas Knowles junior and Herbert A. Sabine are the proprietors of Knowles & Co. Lithographers at 215 Dundas Street. Joseph and Theodore Knowles work there. (London Room)

May 31, 1889:
There is a heavy flood of the Thames River at London. (Hives, *Flooding and Flood Control*, p. 179)

Dec. 10, 1889:
Robert D. Colgrove to William Weatherhead [1829-1916], grocer, sub-lot 6, Registered Plan #312, 1 acre (30 Weston Street), bargain and sale #17270. (Middlesex County Registry Office abstract)

c. 1889:
The Weatherhead house is built (located at 30 Weston Street) with yellow brick.

Feb. 3, 1890:
John Mackenzie Moore [surveyor/civil engineer/architect 1857-1930, grandfather of John Henderson (Jake) Moore] surveys and subdivides what was William and Martha Horton's part of lot 25, Registered Plan #430, for William M. Gartshore. Maryboro Place [now McClary Avenue] is named for Gartshore's father's home near Glasgow, Scotland. (Middlesex County Registry Office; Moore interview, July 1991; Priddis, *The Naming of London Streets*, p. 23)

April 7, 1890:
Annexation by the City of London. 'Commencing at the intersection of the south branch of the river Thames by the centre line of the original road allowance between lots numbers twenty-four and twenty-five in the said Township of Westminster; thence southerly along the centre of said road allowance between lots numbers twenty-four and twenty-five to a point distant twenty chains northerly from the northerly limit of the base-line; thence westerly parallel to the base-line to the centre of Hamilton Street (High Street).' 38 Weston Street is in ward 6 (City Clerk; Phelps, RCWL; Priddis, 'The Naming of London Streets,' p. 22)

June 17, 1890:
♥ Thomas Knowles [machinist 1841-1926] and Elizabeth Knowles [1843-1896] to Thomas Knowles the younger [lithographer 1866-1933], sub lot 7, RP #312, 3 roods, 19 perches. $400 (34 and 38 Weston Street). Bargain and sale #25. (Middlesex County Registry Office)

Dec. 11, 1890:
Leonard Ardiel dies at the age of 62. (Middlesex County Registry Office)

1890:
Thomas Knowles Junior marries Ann Foot [born in London, England 1886-1968] who has moved from Stratford to London in 1876. (*London Free Press*)

1890:
City directory: Weston Street, London South: 8 Knowles Litho Co., 8 Theodore Knowles, 12 Thomas Knowles sr. 30 Wm. Weatherhead. Concession B, lot 25: Leonard Ardiel [1828-1890]. [Thomas Knowles Jr. lives at 348 Clarence St.] (London Room; RCWL)

c.1890:
Joseph and Thomas Knowles Junior are photographed with their cycling club, the Forest City Bicycle Club. This club, which was ranked number one in Canada, had 29 members in 1897. It was part of the Canadian Wheelmen's Association which was founded in London, Ont., on July 1,

1881. Included in the photo are Emma Louise Saunders [Mrs. William E.] and her husband. She will later hold mortgages on various Knowles' Properties. The safety bicycle in the foreground of the photograph resembles the Singer safety bicycle which was made and introduced in England in 1890. It has a curved seat tube and the seat post is fitted in a socket on the top tube as opposed to being the extension of the seat tube. All the bicycles in the photograph have solid tires. The pneumatic tire was introduced in England after 1888. (Glen Curnoe, London Room; Humber, 'Freewheeling,' *The Cyclist* 1897, p. 35; Caunter, 'Cycles,' *Historical Review*, pp. 36, 37, plate IX)

Feb. 18, 19, 20, 1891:
There are heavy floods of the Thames River. (Hives, *Flooding and Flood Control*, p. 179)

c. 1891:
Dora May Bartlett marries Marmaduke Steele. (The United Church Archives)

1891/92:
♥ 38 Weston Street is built in the British style with the window frames built into the yellow brick walls which are double brick with rough work on the inside and finished work on the outside. There are wood inserts in the interior brick walls to which lathing is nailed. The basement at the rear has a shallow barrel vaulted ceiling re-inforced with steel beams at the lowest part of each vault. The vaults seem to extend the whole length of the structure. The building is heated with steam which will also be used to heat Litho Villa. The furnace is located at the north east corner of the cellar. Steam is originally used to operate the presses and machines. The original building measures: 72 feet 5 inches in length, 29 feet in width at the front, 43 feet 6 inches in width in the centre. The centre section is 22 feet 6 inches in length. (Owen Curnoe, Greg Curnoe, Derek Lancaster conversation 1989; RCWL)

1891:
Census: City of London: Ward 3: Thomas Knowles Sr., England, age 50, machinist. Elizabeth Knowles, England, age 48. Joseph Knowles, Ont., 24, lithographer, Methodist. Theodore Knowles, Ont., 19, Methodist. Elizabeth Knowles, Québec, 18, Methodist. Sarah Knowles, Ont., 14,

Methodist. Frederick Knowles, Ont., 12, Methodist. Ernest E. Knowles, Ont., 4, Methodist [all at sub lot 5, plan #312, modern number 18 Weston Street]. Arthur Knowles, England, machinist, 20, Methodist [495 Bathurst Street]. William Weatherhead, Ireland, 60, gardener. Eliza Weatherhead, Ireland, 61 [all at sub lot 6 plan #312, modern number 30 Weston Street]. Leonard Bartlett, England, 63, market gardener. Rachel Bartlett, Ont., 56. Leonard Bartlett, pattern maker, 17. Celina Bartlett, grocery clerk, 21. Hettie Bartlett, Ont., 11 [all at sub lot 3, plan #206, 66 Weston Street]. Elizabeth Frank, England, widow, 85, Anglican. Elizabeth E. Frank, Ont., 51, Anglican. Ann Frank, Ont., 46, Anglican [all on the west side of Wellington Road at Frank Place/Redeemer Lutheran Church]. John Broomfield, Ont., retail grocer, 49. Susan Broomfield, Ont., 47. Minnie Broomfield, Ont., 21. Caroline Broomfield, Ont., 19. Charles Broomfield, Ont., 6 [all on Wellington Road between Weston Street and Turtulla {Watson} Street]. George Watson, England, architect, 79. Margaret Watson, England, 79. John Watson, Ont., married, carpenter, 41. George Watson, Ont., apprentice jeweller, 18. Ida Watson, Ont., 22 [all on Wellington Road at the south east corner of Turtulla {Watson} Street]. Richard Whetter, England, farmer, 67. Leonard Ardiel, Ireland, married, farmer, 63. Ann Ardiel, Scotland, married, 54. Jessie Ardiel, Canada, 25. George S. Ardiel, Canada, farmer, 24. James A. Ardiel, Canada, drug clerk, 22. Walter Ardiel, Canada, clerk, 20. Frederick C. Ardiel, Canada, 16. Earnest A. Ardiel, Canada, 14. Evan Ardiel, Canada, 10. [All on a farm at the north east corner of Adelaide and Oxford Streets.] (London Room; RCWL)

1891/92/93:
City directory: Weston Street north side; 8/10 Thomas Knowles sr. engraver occupies shop at 8/10 Weston]. 30 William Weatherhead [gardener, 1829-1916]. ♥ 38 *Joseph Knowles [1867-1954] lithographer occupies new printing office.* He lives with His father at 10. vacant lots. South side: not built on. (Thomas Knowles jr. lives at 341 Simcoe St. in 1891, on Wellington at Watson in 1892 and on Weston at number 34 in 1893) (London Room; Mount Pleasant Cemetery; RCWL)

1892:
City of London Assessment Roll: North Weston 14681 – Arthur Knowles machinist [1891-1953] 100 + 300 feet $450 [Cliff Parkin Flowers], 14682 –

Thomas Knowles Sr. machinist 100 feet $600 [number 10], 14683 – William Weatherhead gentleman [1829-1916] 195 feet [number 30], ♥ *$800, 14684 – Printing House [Thomas Knowles Jr.] 1 acre $500 [number 38], 14686 – Joseph Knowles printer*, South Weston 14687 – Thomas Patterson shipper [Ardiel estate] 3 1/2 acres $1100, 14688 Thomas Knowles machinist $100. (Phelps, RCWL)

December 26, 1893:
There is a heavy flood of the Thames River. (Hives, *Flooding and Flood Control*, p. 179)

1893/94:
Litho Villa (34 Weston Street) is built with yellow brick in the English style, double brick construction with the window and door frames built into the brick openings. Built for Thomas Knowles Jr. and Ann Knowles? (Curnoe)

April 9, 1894:
William Weatherhead [gardener 1829-1916] and Eliza Jane Weatherhead [1830-1905] to Ellen Knowles [married to Joseph Knowles {lithographer 1867-?}], sub-lot 6, Registered Plan #312 [30 Weston Street]. Bargain and sale #733. (Middlesex County Registry Office)

1894:
City directory: Weston Street north side: 8 Arthur Knowles. 10 Thomas Knowles sr. 18 Joseph Knowles. 30 William Weatherhead leaves, 34 Thomas Knowles Jr. ♥ *38 Knowles Litho Co.* South side:
not built on. (London Room; RCWL)

May 29, 1895:
Anna Jane Adelaide Weston dies in Detroit, aged 62. (Woodland Cemetery)

1895:
City directory: Weston Street north side: 8 Arthur Knowles. 10 Thomas Knowles. Ontario Litho Co. (Joseph Knowles proprietor). 18 Joseph Knowles. 30 vacant. 34 Thomas Knowles Jr. ♥ *38 Knowles Litho Co. (Thomas Knowles junior proprietor)*. vacant lots. South side; not built on. (London Room; RCWL)

Aug. 4, 1896:
'Intelligence from Kingston announces the death on Sunday last of Mr.
James B. Strathy at the age of 83 years. Deceased for many years was Collec-
tor of Customs in this city, and was well-known to many old-time residents.
He lived in the old stone house on the north side of Dundas Street, between
William and Adelaide. He had been ailing for a long time, and his death was
not unexpected. Mr. Strathy was the second son of the late Alexander
Strathy, of London: and father of Edward W. Strathy, H. Gordon Strathy,
Lt.-Col. J. A. L. Strathy, A. D. C., of Montreal; and Dr. F. R. Lee Strathy,
of Birmingham Eng.' (*London Free Press*; Glen Curnoe)

Dec. 27, 1896:
Elizabeth Knowles dies, the wife of Thomas Knowles senior, aged 54.
(Woodland Cemetery)

June 14, 1897:
Ellen Knowles, the wife of Joseph Knowles [1866-1954], to William Weath-
erhead, sub-lot 6, Registered Plan #312 (30 Weston Street), bargain and sale
#1418. (Middlesex County Registry Office abstract; Woodland Cemetery)

Aug. 31, 1897:
William Weatherhead to David Fenn [lives on the west side of Wellington
Road, 6 doors south of Maryboro Place in 1891] west 96 feet of sub-lot 6,
Registered Plan #312 (12 Weston Street) $800, bargain and sale #1478.
(London Room; Middlesex County Registry Office abstract)

c. 1897:
12 Weston Street is built of yellow brick for David Fenn.

1897/1898:
City directory: north side: 8 Arthur Knowles leaves, David Fenn Moves in.
18 Joseph Knowles leaves, David Fenn [moulder, Stevens mfg. ?-1904]
moves in. 30 James McCormick moves in. 66 Leonard Bartlett market gdnr.
(RCWL)

1898:
38 Weston St. is in ward 1. (Priddis, 'The Naming of London Streets,' p. 22)

1898/1899:
City Directory: 'Weston runs east from Wellington Rd. to city limits, fourth south of Clarke's Bridge, ward 6.' North side: 8 David Fenn leaves, Thomas Dicker [harness maker] moves in. 66 Leonard Bartlett, market garden. South side: not built on. Marmaduke Steele [contractor] and Dora [Bartlett] Steele live at 7 Maryboro Place [McClary Avenue]. William Weatherhead has moved to 87 Wellington Road 5 doors north of Maryboro Place. (London Room, RCWL)

March 28, 1898:
Leonard Bartlett Sr. to Leonard Bartlett Jr.[1872-1963], sub lots 1/2/3/4/5. [All of John Gumb's Registered Plan of June 11. 1855 from 48 Weston Street to Trevithen Street] $1. Deed #19594. (Middlesex County Registry Office)

February 26, 27, 1899:
There is a severe flood of the Thames River. (Hives, *Flooding and Flood Control*, p. 179)

March 12, 1899:
There is a heavy flood of the Thames. (Hives, *Flooding and Flood Control, p. 179)*

c.1899:
The Bartlett/Ayars house, double yellow brick construction, 54 Weston Street and the Morris house, yellow brick, 78 Weston Street are built. (Glen Curnoe, London Room; RCWL)

♥ There is no phone yet at Knowles Lithography, 38 Weston Street. (London Room)

Jan. 29, 1900:
Leonard Bartlett Sr., Rachel Bartlett and Leonard Bartlett Jr., Sarah Jane Bartlett to Etta Bartlett [1881-?] [Esther V. Ayars],sub lots 4 & 5 Registered Plan #206 (48, 50, 52 Weston Street) $620. Bargain and sale #20057. (Middlesex County Registry Office)

Oct. 1900:

Official Telephone Directory District of Western Ontario ♥ *Telephone number #825 Knowles & Co.......Lithographers & Printers, Weston, until around 1906.* (London Room)

1900:

City Directory: William Knapton's [carpenter] home is on the east side of Richmond Street opposite the toll gate, 9 houses north of Huron Street, 1 house north of Epworth Avenue. (RCWL)

Part Four

March 25 to 30, 1901:
There is a heavy flood at London and Ingersoll. (Hives, *Flooding and Flood Control*, p. 179)

c.1901:
The Bartlett/Steele House, double yellow brick construction, is built at 59 Weston Street. (London Room; United Church Archives; RCWL)

City directory: Weston Street north side: 52 new house Charles Ayars moves in. House facing end of street William Baird. (London Room; RCWL)

Aug. 28, 1901:
William Knapton, representing the Estate of Leonard Ardiel, to Marmaduke Steele [1863-1931], 2 acres 3 roods 2 perches (South side of Weston Street from Trevithen Street to number 41 including road allowance between lots 24 and 25) $800. Deed #20603. (Middlesex County Registry Office; Mount Pleasant Cemetery)

March 1, 1902:
There is a heavy flood of the Thames River. (Hives, *Flooding and Flood Control*, p. 179)

Sept. 30, 1902:
Charles J. Mills [merchant] and Elizabeth A. Mills to George Wells [gardener]: 'Parcel One, being composed of Lots and part tongue of land, lying between Trafalgar Street and the east branch of the River Thames; that is to say commencing at a point on the south side of Trafalgar Street directly opposite the south east corner of lot number Five, according to the

Registered Plan 215 which said lot number Five is now owned by the party of
the Third Part and is on the north side of said Trafalgar Street: thence south-
erly in a line with the east side of said lot number Five to the water's edge of
the River Thames, thence westerly and northerly along the water's edge of
the said River, down the stream to the intersection of Trafalgar Street, thence
easterly along the Southerly limit of Trafalgar Street to the place of Begin-
ning.' ('The lands hereby conveyed including the easterly part of the lands
above described and the southwesterly part thereof known as the Island
enclosed within the old southwesterly bend of the river and the new bed now
cutting off the said bend on the North side.') The Island which was called
Renwick's, then Winnett's Island, is now called Mills Island. Deed #11409.
(Glen Curnoe; Joanne Scott; Middlesex County Registry Office)

1902:
City directory: Weston Street north side: 18 Fenn leaves, Baird moves in.
house facing end of street vacant. South side: 59 Marmaduke Steele [con-
tractor [1863-1931]/Dora May [Bartlett] Steele [1864-1934] (London
Room; Mount Pleasant Cemetery RCWL)

May 23, 1903:
Ann Ardiel [1837-February 25, 1919] to Harris/William
Knapton/Marmaduke 'Duke' Steele [1863-1931], 2 acres 3 roods 2 perches
[same as May 23. 1901].

May 23, 1903:
Ann Ardiel to Harris/William Knapton/Marmaduke Steele, 3 acres 1 rood
13 perches [same as Sept. 6. 1842]. (Middlesex County Registry Office; Pot-
ter interview, June 1991; Woodland Cemetery)

c. 1903?:
The Knowles printing shop was behind and attached to the Knowles family
homestead at 6/10 Weston Street. The printing shop was a frame building.
The Moose Lodge is built there now. (Potter interview, June 1991; Abrams
interview, July 16, 1991; all questionable!)

February 6, 7, 1904:
There is a heavy flood of the Thames River, on March 24 to 29 a very severe

flood and on March 31 to April 3, a severe flood of the river. (Hives, *Flooding and Flood Control*, p. 180)

1904:
City directory: North side: 8 Thomas Dicker leaves, Thomas Knowles Sr. moves in. 12 vacant. 18 vacant. house facing end of street, Morris Henry moves in [all modern municipal numbers]. (London Room; RCWL)

March 24 to 27, 1905:
There is a severe flood of the Thames River. (Hives, *Flooding and Flood Control*, p. 180)

1905:
City directory: Weston Street north side: 8 Thomas Knowles Sr. leaves, Walter Millard moves in. 12 John Veale moves in. 18 Elizabeth Fenn [widow of David Fenn] moves in. (London Room; RCWL)

Jan. 21, 22, 23, 1906:
There is a heavy flood of the Thames River. (Hives, *Flooding and Flood Control*, p. 180)

March 27, 28, 1906:
There is another heavy flood of the Thames. (Hives, p. 180)

1907:
City directory: North side: 8 Walter Millard leaves, Charles A. Boyce moves in. 12 John Veale leaves, Thomas Knowles Sr. moves in. 66 Leonard Bartlett leaves, George Holmes moves in. (London Room, RCWL)

♥ *Knowles Lithographing Co. is no longer listed in the phone book!* (London Room)

May 22, 1907:
William Knapton to Violet Johnston [Manitoba 1876-1963], 568 1/2 feet west from the west side of number 39 Weston Street x 215 1/2 deep [on the south side of Weston Street], most of William Weston's part of lot 25, except for the lots on Wellington Road, $500. Bargain and sale #4706. (Middlesex

County Registry Office; Mount Pleasant Cemetery)

Nov. 5. 1907:
Violet Johnston to William Evans, east 70 feet [?], $975. Bargain and sale #5019. (Middlesex County Registry Office abstract)

1907:
37 and 39 Weston Street are built, both frame, same design, one story. (Glen Curnoe; RCWL)

1907/1908:
City directory: North side: 18 Elizabeth Fenn leaves, William Durham moves in. 66 George Holmes leaves, William Bestard Moves in. 78 new house. South side: 37 vacant (new frame house). 39 Vacant (new frame house). (London Room)

1908:
27, 29, 31, and 33 Weston Street are built, all frame, same design as 37 and 39, one story. (Glen Curnoe, London Room)

1908/1909:
City directory: North side: 66 William Bestard leaves, George Dunn moves in. 78 Albert Prince moves in. South side: 19 vacant, 21 vacant, 25 vacant, 27 R. D. Stewart moves in. 29 Roy E. Suhr moves in. 31 William J. Young moves in. 33 Henry Storrie moves in. 35 William Evans moves in. 37 L. Proctor moves in. 39 James McIntosh moves in. (RCWL).

June 1909:
'I don't think it took very long to find another house a few blocks east and to the south of our first home. This one was a good sized brick cottage on Baseline Road near Ridout with some land and a barn [lot 26, broken front, Westminster Township]. Across the road from us were railway tracks along which an electric train moved on its way to Port Stanley. But more about this later.

'There was much excitement to look forward to because my mother was going to have another baby.' The baby is Nellie (Porter) Curnoe. (Rhame, *They Were Such Happy Days, A Memoir*, p. 16)

1909:
25 Weston Street is built, frame, same design as 37 and 39, one story. (Glen Curnoe; RCWL)

1909/1910:
City directory: WESTON ST, north side, east from Wellington rd, 4 s Clarke's Bridge. 8/10 T Knowles sr, H E Westland. 12 C A Boyce. 18 Mrs E Semple. 30 J McCormick. 34 T Knowles Jr. 38 Knowles & Co litho 54 Chas R Ayars. 66 Edwd Long. 78 Albert Prince. house facing end of street Jno Needham. WESTON STREET south side, 21 R Campbell. 23 vacant. 25 S V Talbot. 27 R D Stewart. 29 Roy Suhr. 31 Wm J Young. 33 Henry Storie. 35 Wm Evans. 37 L Proctor 39 Jas A McIntosh 59 M Steele, contr. (RCWL)

May 17, 1910:
Elizabeth Semple [widow] takes out a $400 mortgage on 18 Weston Street with the Ontario Loan and Debenture Company, instrument #6263. (Middlesex County Registry Office)

1910/1911:
City directory: North side: 18 (3) Mrs. E. Semple leaves, Mrs. M. Holmes moves in. 78 Albert Prince leaves. South side: 21 R Campbell leaves. 23 vacant. 25 S. V. Talbot leaves. 31 William Young leaves, George Talbot moves in. 33 Henry Storie leaves, Fred Mantz moves in. 39 James McIntosh leaves, J. H. Talbot moves in. (London Room)

Jan. 8, 1911:
Carolyn (Gumb) Fairhall dies in West Nissouri Township. She is 77 years old. She is buried beside her husband Henry Fairhall at the Vining cemetery on lot 8, concession 5, West Nissouri. (London Room, Glen Curnoe)

Sept. 7, 1911:
♥ Plan A-1-21, Proposed grading and widening of Weston Street shows a maple tree near the south-east corner of 38 Weston Street and another near the south-west corner. It shows an evergreen hedge and trees in front of 34 Weston Street. It also shows 2 houses on sub-lot 6, Weatherhead on the east. It shows Thomas Knowles house on sub-lot 5. It indicates that

Thomas Knowles owns sub-lot 4 to the corner of Weston and Wellington Road. It shows that Ann Ardiel owns the south side of Weston Street from Wellington Road, 223′ 6″ east to property owned by Violet Johnston. Johnston owns 234′ 6″ east to the first of a row of 10 frame houses. The row of houses has a concrete walk in front that ends at the city limits, the original road allowance between lots 24 and 25. (City Engineer's Dept., City of London)

1911:
21 Weston Street is built, frame, same design as 37 and 39, one story. (RCWL)

1912:
19 Weston Street is built, frame, same design as 37 and 39, one story. (RCWL)

Feb. 24. 1912:
William Knapton to Canada Trust Co., 3 acres 1 rood 13 perches [same as Sept. 6. 1842]. (Middlesex County Registry Office)

May 16, 1912:
Canada Trust Co. to Eliza Henson [d. 1958], east 37 feet of William Weston's part of lot 25 [number 39].

Violet Johnston to Eliza Henson, east 37 feet [?], $1100. Bargain and sale #7398. (Middlesex County Registry Office abstracts)

May 17, 1912:
Elizabeth Semple takes out a $500 mortgage on 18 Weston Street with the Ontario Loan and Debenture Company, instrument #7351. (Middlesex County Registry Office abstract)

July 14. 1912:
♥ Thomas Knowles Jr. [1866-1968] to Emma Lee Saunders [1861-1943, mother of Muriel Robinson Saunders Fetherston], Lot 7, RP #312, $2205.84 [numbers 34 and 38]. Bargain and sale #7108. (Glen Curnoe, London Room; Middlesex County Registry Office)

Dec. 19. 1912:
Annexation by the City of London; 'Commencing at the intersection of the eastern limit of lot number twenty-two in the broken front concession of the Township of Westminster, with the River Thames; thence southerly along said eastern limit of said lot to the Base Line of said Township; thence westerly along the northerly limit of said Base Line to the London and Port Stanley Railway track; thence northerly along the said railway track to the Whetter Road; thence westerly along the northern limit of the Whetter Road to the eastern boundary of the City of London; thence northerly along the said eastern boundary of the said City of London to the River Thames; thence easterly along the River Thames to the place of beginning and more generally known as Chelsea Green, be, and the same are, hereby annexed to the City of London,.....' (Phelps, RCWL)

Jan. 16 to 19, 1913:
There is a heavy flood of the Thames River. (Hives, *Flooding and Flood Control*, p.180)

March 13, 1913:
There is another heavy flood of the Thames. (Hives, p. 180)

March 25, 26, 1913:
There is a severe flood of the Thames. (Hives, p. 180)

Nov. 6, 1913:
The Canada Trust Company, executors of the estate of Leonard Ardiel to ? Boswell the westerly portion of William Weston's land for $2500. Bargain and sale #8241 (Middlesex County Registry Office)

1913:
City directory: North side: 30 James McCormick leaves, Wilson Sherwood moves in. 54 Charles R. Ayars leaves, Peter Snider moves in. 66 Edward Long leaves, Stephen Hart moves in. 78 L. J. Proctor moves in. South side: 19 vacant. 21 Albert Kerton moves in. 25 J. H. Chatterson moves in. 27 R. D. Stewart leaves, James C. Walker moves in. 37 L. Proctor leaves, E. Dickinson moves in. 39 J. H. Talbot leaves, Joseph Henson [works at Labatt's, c.1896-1946] moves in. 63 Alfred Andrews. 65 John W. Slade. (London Room)

1914:
City directory: North side: 30 Wilson Sherwood leaves, J. Tallack Moves in. 66 Stephen Hart leaves, Edward Long [florist] moves in. 78 L. J. Procter leaves, Alfred Baldwin moves in. South side: 19 Edward Gerrard moves in. 21 Jacob Bowern moves in. 29 Roy Suhr leaves, R. H. Armer moves in. 33 Fred Mantz leaves, J. W. Cake moves in. 63 Alfred Andrews leaves, Roy Suhr moves in. (London Room)

1915:
City directory: North side: 18 Mrs. M. Holmes leaves, Mrs. Elizabeth Semple moves in. South side: 29 R. H. Armer leaves, Edward S. Walker moves in. 31 George Talbot leaves, F. S. Vousden moves in. (London Room)

London returns to the ward system. Weston Street is in ward 3. 'York Street separates Wards 1 and 3 from Wards 2 and 4. Colborne Street separates Wards 1 and 2 from Wards 3 and 4.' (*The Municipal Year Book*, 1958, pp. 114, 138)

1916:
83 Weston Street is built for Mr. Potter, father of Ernie Potter [1916-]. 62 Weston is built? (Potter interview, June 1991)

1916:
City directory: North side: unchanged. South side: 25 J. H. Chatterson leaves, Robert Short [father of Amelia Knowles] moves in. 29 Edward S. Walker leaves. (London Room)

c.1916-1918:
♥ *[A. E. Templar] 'finished apprenticeship with Tom Knowles, Lithography, London'.* (Davis, *Albert E. Templar: Retrospective*)

1917:
City directory: 8 Charles A. Boyce leaves, Fred W. Norton moves in. 12 Thomas Knowles Sr. leaves, Edwin Baggot moves in. 34 Thomas Knowles Jr. leaves, T. M. Knowles Moves in. 38 (36-40) T. M. Knowles litho. replaces Knowles & Co. litho. 54 Peter Snider leaves, Edward McFadden moves in. South side: 29 T. A. Stewart moves in. 33 vacant. (London Room)

1914/1918:

♥ *38 Weston Street is a machine shop during World War I according to Albert Knowles, March 1991.* (Knowles interview, March 1991)

Feb. 15 to 20, 1918:
There is a severe flood of the Thames River. (Hives, *Flooding and Flood Control*, p. 180)

March 29, 1918:
There is a heavy flood of the Thames. (Hives, p. 180)

June 1, 1918:
Violet Johnston to William Evans, rear of lot (number 39, 70 1/2′ x 169′, part of lot adjacent to Frank property), $1.00. Grant #11635. (Middlesex County Registry Office abstract)

c.1918:
Gil Warren is told by Richards Wilcox old timers that there was a serious explosion near the river below Weston Street at this time. Mrs. Tapp recalls an explosion of acetylene gas, at a place or business called *Sally* west of Adelaide Street. It was a huge explosion and one man was killed. Bryce Tapp recalls being told about a large explosion during the First World War that occurred on the south bank of the Thames River, west of the Adelaide Street Bridge. Old timers at city hall would talk about it. (Phone conversation with Mrs. Tapp, November 30, 1991 and Bryce Tapp in January 1992)

1918:
Tecumseh Public School is built. Weston Street is in its school district. Weston Street east of number 48 is in The Tecumseh school district prior to the existence of Princess Elizabeth Public School. Nellie Porter [1909- mother of Greg Curnoe 1936-], Greg Curnoe, Glen Curnoe [1939-], Lynda Curnoe [1941-] (Children of Gordon Curnoe and Nellie Porter), and with special permission, Owen Curnoe [1966-], Galen Curnoe [1969-] and Zoë Curnoe [1971-] (children of Greg Curnoe and Sheila Curnoe) all attend classes at Tecumseh Public School. (D. I. Bright [1909-] conversation c.1980; Nellie Curnoe conversation, June 1991; Sheila Curnoe, Zoë Curnoe)

♥ *T. Milton Knowles is listed in the London phone book at 36 Weston Street, telephone number #6022w. Duke Steele is listed as Contr'tr & Builder....Weston, telephone number #1865.* (London Room)

1918:

♥ Albert Templar [1897-] is hired by Milton Knowles to finish his apprenticeship as a lithographer and engraver after a short time at Lawson & Jones. He begins working at Knowles Lithographing Co. He polishes lithograph stones on the ground floor at the rear of the building, practices dance poses upstairs at the rear in a large storage area with a large mirror on the wall. He works at Knowles' for just a few months. He says that Milt got money from Dr. W. E. Saunders to pay him, and he quit when Milton could no longer pay him. He thinks they were related to the Saunders by marriage. He boards with the Huycks family in a small brick cottage on the south side of Maryboro Place, the name is changed in 1918 to McClary Avenue (1916 City directory: Wm. H. Huyck, 9 Maryboro Place). Albert remembers that Thomas "Did" Knowles senior was Milton Knowles' grandfather. He was called that because he "did" everything. He built the steam engines that ran the printing presses. Albert also says that Annie Knowles was a McClary [Jake Moore states that John Foot was the sales manager of McClary's prior to 1940. John Foot may have been the brother of Annie Foot Knowles]. Theodore Knowles was a fashion artist who worked in pastels. He also did commercial designs for chocolate bar wrappers and so on. He became a Christian Scientist. Albert Templar owns some of his work. Thomas Knowles Jr., Milton's father, ran the presses. He also travelled for the company, selling printing and buying and selling antiques on the side. He did a lot of work in Québec. There were double doors in the front of Litho Villa with a large oil copy of one of Shakespeare's subjects hanging in the hall. Milt Knowles lived in the big house with his parents. They did not live upstairs at the front of 38. There were several old presses in the shop, run by steam. They would go down to the steam furnace to warm up in the morning while the factory warmed up. The engraving room was located in the north west corner of the building. Amelia Knowles came from one of the row houses across the street (She was the daughter of Robert Short who lived at 25 Weston Street in 1917 & 1918). She wasn't well liked by the family who were snooty and had social pretensions. Albert last saw Milton near the bank of Montreal on Dundas Street several years ago. When he last saw Mrs. Knowles (Ann) she was

living in a shack on Weston near Wellington. It was a wooden lean-to. She used to wear running shoes. (Templar interview, June 18, 1991; phone conversation Oct. 5, 1991; Moore conversation Aug. 29, 1991)

The 1918 City directory lists: 'Templar Albt E jr litho T M Knowles, 54 Beaconsfield av.' He lives with his parents. (London Room; Lawson Library)

'After leaving Central Collegiate, Templar was apprenticed to the lithography firm of Lawson and Jones. He was not happy there, however, and after two years, broke his apprenticeship contract and finished his training with Knowles and Company.' (Nancy Poole, *The Art of London 1830-1980*, p. 81)

There is no listing for the Knowles Lithographing Co. in the telephone book in 1919, 1920. (London Room)

Feb. 8, 1919:
Elizabeth Emma Frank [1840-1919] unmarried, dies, last surviving child of Richard Frank [England 1802-1872] and Elizabeth A. [Pickering] Frank [England 1805-1892]. She has owned the land South of Weston Street to Alexandra Street [formerly the Odell Road or Thompson Road] and from High Street to the L & PS tracks. She has lived at Mount Frank at the south west corner of Wellington Road and Frank Place. (Middlesex County Registry Office; RCWL) Her property south and east of Weston Street [owned previously by Albert Odell and John Gumb] was called Old Maid's Field. In the 31920's it had been unused for many years. In 1925 a biplane landed there but it didn't have room to take off again. (Middlesex County Registry Office; Ernie Potter interview, June 26. 1991; Woodland Cemetery)

Gordon Curnoe [1909-1985, father of Greg, Glen and Lynda Curnoe] remembered tobogganing on Old Maid's Hill which was probably the hill to the river immediately west of the L & PS trestle bridge, on the south side of the river. He then lived at 361 Hamilton Road near Mamelon Street. (Gordon Curnoe conversation, c.1970)

1919:
John and Edith Webb move into 18 Weston Street. They have enigrated

from England with their children: David, Dora (Milsom), Dick and Dot. John Webb grows dahlias, keeps homing pigeons and builds a lawn bowling green at the front of their house. Edith Webb has a lot of canaries. Dora marries Thomas Milsom and they move in to 30 Weston Street. Dot Webb moves to Southgate Street. Dave Webb works at Carling's Brewery and Dick moves to Toronto. John Webb marries Dorothy and they move to Alexandra Street. Bill Webb is their son. (Bill Webb phone conversation, November 1991) The Webb family will live on Weston Street until 1990, 71 years.

March 8, 1920:
The estate of Leonard Ardiel is transferred to the trusteeship of the Canada Trust Company from executor William Knapton. Certificate of Order and Report #4618. (Middlesex County Registry Office)

1921:
City directory: North side: 8 Fred Noble. 12 Thomas Knowles Sr. 18 A. Chisholme. 30 John Tallack. 34 Thomas Knowles Jr. ♥ 38 T. M. Knowles Co. lithos. (moves in above shop?). 54 John May. 62 Henry W. White. 66 William Skiggs. 78 Alfred Baldwin. house facing end of street C. Tuttle. South side: 19 Edward Gerrard. 21 Jacob Bowern. 25 William Gerrard. 27 John W. Cake. 29 T. A. Stewart. 33 Henry Storie. 35 William Evans. 37 P. Matthews. 37 P. Matthews. 39 Joseph Henson. 59 Marmaduke Steele contractor. 61 F. Nichol. 63 E. Potter (new house). 65 John W. Slade. (London Room)

♥ The London phone book lists: Knowles T M & Co Printers 36 Weston....1865J. The same number is listed in 1922. (London Room)

Apr. 7, 1921:
♥ Emma Lee Saunders to Ann Knowles, wife of Thomas Knowles junior, sub lot 7, RP #312, $1 [34 and 38 Weston Street]. Grant #15005. (Middlesex County Registry Office)

1922:
City directory: North side: 18 A. Chisholme leaves, John Webb moves in. 66 William Skiggs leaves, George Jackson moves in. South side: 19 Edward

Gerrard leaves, Edward Newman moves in. 37 P. Matthews leaves, Enoch Walker moves in. (London Room)

Apr. 11, 1922:
William Evans to Eliza Henson, rear of lot, 70 1/2′ x 70′ $125. Grant #16067. (Middlesex County Registry Office abstract)

1922:
♥ Aerial photographs show: a building with a circular drive, 2 stories at the front with a slanting roof, the gable facing the street, a 1 story centre section, a 2 story back section, and a fence line passing down the centre line of the vacant lot between lots 24 and 25. (U. of Western Ontario Map Library)

1923:
City directory: North side: 66 George Jackson leaves, James McFarquhar moves in. South side: 19 Edward Newman leaves, John Reading moves in. 25 William Gerrard leaves, William Bottom moves in. 31 F. S. Vousden leaves, Mrs. A. Stewart moves in. (London Room)

75 Weston Street is built of stucco, one story. (Potter interview, June 1991)

The London phone book lists: 'Knowles T M Co Lithographers 36 Weston....5611, T M Knowles r 489 Tecumseh....5804w.' (London Room)

1924:
City directory: North side: 8 Fred Noble leaves, William Gray moves in. 12 Thomas Knowles Sr. leaves, Henry Morrison moves in. South side: 21 Jacob Bowern leaves, John Ready moves in. 29 T. A. Stewart leaves. 31 Mrs. A. Stewart leaves, Mrs. Edna Talbot moves in. (London Room)

The 1924 London phone book has no listing for T. M. Knowles Lithography Co. 1925, 1926, & 1927 also have no Knowles Litho. listing. (London Room)

c. 1925:
♥ The Weston Street Horse Shoe Club is founded by Harry 'Judge' Storie [c.1880–c.1950 truck driver for the *London Advertiser*] of 33 Weston Street

and Tom Stewart [1880-1953] of 29 Weston Street. They construct 4 pitches on the original road allowance between lots 24 and 25 on the north side of Weston Street. The pitches are about 40 feet long and 3 feet apart. They run north and south on the lot. The southerly pits are about 25 or 30 feet from the gravel edge of Weston Street. The northerly pits are about 15 feet from the top of the old river bank. Blue clay is brought in to fill the pits which are about 3 feet square with wooden frames. The playing area is illuminated with electric lights which are strung in 2 north/south lines from poles at each corner of the field. Each line has four, evenly spaced, 150 watt bulbs hung from it. There is a row of wooden spectator benches along the western side of the field parallel with the lane for 38 Weston Street. The eastern side of the field is fenced. There are 15 to 20 members who pay 25[c/] a week to play. Ernie Potter [1917-] of 83 Weston Street is a junior member of the club. A foreman from the City is also a member. He may have arranged the use of the field. The area champion who plays regularly on Weston Street is Simon [c.1890-?] from Muncey. He later joins the Weston Street club. The Club is disbanded around 1938. (information supplied by Ernie Potter interview June 26, Oct. 5, and Mel Stewart phone conversation June 27, 1991) A former horse shoe champion named Sylvester Simon lives on the Munsee Reserve. (Del Riley phone conversation, Dec. 15, 1991)

John Simon, his son John Simon [c.1905-c.1971] and his cousin Sylvester Simon [1911-] were all very good horse shoe players from Muncey. All were members of the Ojibwa Nation. John Simon junior was an area champion and probably the player referred to by Ernie Potter and Mel Stewart. He was asthmatic and died around 1971 at the age of about 65. He had retired as champion several years before. He worked as the janitor of the church at Muncey. (Phone conversation with S. Simon, February 3, 1992)

John Simon, a principal man of the Ojibwa of the Thames, signed Surrender #126, giving a right of way to the Canada Southern Railway on January 18, 1872. (Canada, *Indian Treaties and Land Surrenders*)

Nov. 23, 1925:
♥ Emma Lee Saunders to Thomas Knowles junior, husband of Ann Knowles, sub lot 7, RP #312, $3716 [numbers 34 and 38]. Agreement for sale #20754, not completed. (Middlesex County Registry Office)

Nov. 23, 1925:
♥ Ann Knowles to Emma Lee Saunders, sub lot 7, RP #312, $1 [numbers 34 and 38]. Grant #20757. (Middlesex County Registry Office)

1925:
Weston Street, south side: 19 John Reading leaves, Thomas W. Stewart [Scotland 1894-1980, technician, Victoria Hospital], Mrs. Stewart [Scotland 1897-1990] and Mary Stewart (May Abrams) [Scotland 1920-] move in. (May Abrams interview, July 1991)

April 25, 1926:
Thomas Knowles senior [father of Thomas Knowles junior, grandfather of Thomas Milton Knowles] dies, aged 85. (Woodland Cemetery)

Aug. 1, 1927:
♥ Emma Lee Saunders to Thomas Milton Knowles [son of Thomas Knowles Jr., lithographer 1892-1963], E 57 feet, sub lot 7, RP #312, $1400 [34 and 38 Weston Street]. Grant #22778. (Middlesex County Registry Office)

 Ernie Potter states that the Knowles Lithography Company was famous across Ontario and Quebec for the high quality of their work. This was verified by Jake Moore who was involved with a proposed purchase and revival of the Knowles Lithographing Co. in the 1960's, based on its good reputation. Mr. Potter also states that the owner of number 66 farmed the flats. He grew vegetables there and had orchards on the top of the bank on Weston Street. (Potter interview, June 26, 1991; Moore interview, July 10, 1991)

Dec. 27, 1927:
Esther Ayars to John Daley [works at Watson Street sewage disposal plant, on the river flats below Weston Street 1882-1963], sub lots 4 and 5 Registered Plan #206 (48, 50, 52 Weston Street), $3000. Grant #11777. (Walter Abrams, July 17, 1991; Middlesex County Registry Office; Woodland Cemetery)

c.1928:
There is a pond east of Wellington Road at what is now Raywood Avenue,

and another pond west of Wellington, south of what is now Frank Place. Wellington Road is about 15 feet higher than the ponds. The ponds are filled in about this time. The creek (Foxbar Creek) that crosses Weston Street flows through a culvert at the bottom of the Weston Street hill. It flows from the vicinity of what is now Bond and Beverly Streets, behind the backyards on the south side of Weston Street to the bottom of the hill, where it crosses the street and empties into the old river valley behind the Knowles homestead [now the Moose Lodge]. The creek is now tiled to the old river bank (1991). None of the long-time residents of Weston Street remembers a name for the creek. (Ernie Potter phone conversation, July 2, 1991)

1928:
Numbers 11, 15, 17 Weston Street are built, all are frame, one story, the same design.

1928/29:
City directory: Weston Street south side; 8 Thomas Knowles Sr. leaves, Thomas Knowles Jr. and Annie Knowles move in. 12 vacant, 18 Millard leaves, Webb moves in. 34 Thomas Knowles Jr. and Annie Knowles leave, Reverend Henry G. Kent and Emily Kent [medical doctor?] move in. ♥ 38 (30/40) Knowles Litho. 54 Esther Ayars leaves, John Daley and Elosia Daley move in. (London Room; RCWL)

Nov. 20, 1929:
Emma Lee Saunders to Robert H. Hawley [lineman Bell Telephone] and Edith Hawley, sub lot 7, RP #312, except E 57, $3000 [34 Weston Street]. Agreement for sale #25249. (Middlesex County Registry Office)

1929:
James McKone and Florence McKone move in to number 17 Weston Street which isn't quite complete. It is purchased from Edward Johnston [1863-1931], husband of Violet Johnston. James McKone recalls that 'There were always lots of trucks on Weston Street. It was a gravel road. There were cows out back. Dr.? J.W. Cake, a vet? [33 Weston Street], had them and horses between Bond and Weston off Beverley. Houses from Front Street were moved to Bond Street.' Mr. McKone does not know the name of the creek

that flows across Weston Street. His garage is built right over it, March 1991. (James McKone and Florence McKone interview, May 1991; James McKone phone conversation, July 30, 1991; Woodland Cemetery) *Mr. McKone does not want personal material used for publication.*

Jan. 7, 8, 1930:
There is a heavy flood of the Thames River. (Hives, *Flooding and Flood Control*, p. 181)

Feb. 23, 1930:
There is another heavy flood of the Thames. (Hives, p. 181)

1930:
City directory: Weston Street north side: 12 Thomas Knowles Jr. and Annie Knowles. 34 Thomas Milton Knowles and Amelia Louise Mary Knowles. ♥ *38 (30/40) Knowles Litho Co.* 54 John Daley and Elosia Daley. (London Room; RCWL)

Feb. 3. 1930:
♥ Emma L. Saunders to Thomas Milton Knowles and Amelia Louise Mary Knowles (Short) [1894-1961], agreement to purchase E 57′ of sub lot 7 [38 Weston Street]. Notice of sale #25270. (London Room; Middlesex County Registry Office; Templar interview June 1991; RCWL)

Apr. 2, 1930:
♥ Emma Lee Saunders to Muriel Robinson Saunders Fetherston [1890-1982], E 57 feet, sub lot 7, RP #312, $1400 [38 Weston Street]. Grant #25271. (Middlesex County Registry Office)

May 3, 1930:
♥ Thomas Knowles Jr. and Ann Knowles, to Muriel Robinson Saunders Fetherston [widow], sub lot 7, RP #312, $25 [34 and 38 Weston Street]. Deed #25540. (Middlesex County Registry Office)

Dec. 9, 1931:
Marmaduke 'Duke' Steele dies at 68 years of age. (Mount Pleasant Cemetery)

1931/32/33:
City directory: Weston Street north side: 8 Thomas Knowles Jr. Litho and Ann Knowles, 34 Reverend Henry G. Kent and Emily Kent leave, Robert Hawley and Edith Hawley move in. ♥ *38 Knowles Lithography.* 38 T. Milton Knowles and Amelia Knowles. (London Room; RCWL)

1933:
Thomas Knowles junior [the son of Thomas Knowles senior, the father of Thomas Milton Knowles, the uncle of Albert Edward Knowles] dies, aged 67. (Glen Curnoe; Woodland Cemetery)

The 1933 London phone book lists: ♥ *Knowles T M Co Lithographers 38 Weston Metcalf 1266.* The 1934 listing is the same. (London Room)

Sept. 15, 1933:
Henry Winnett [boiler maker, owner of Dominion Boiler Works, oarsman, hunter, fisherman, b.Ireland 1845] dies. 'The family resided on Front Street, and owned the strip of land on the Thames River, near the present Victoria Hospital site, which was known as Winnett's Island.' (Glen Curnoe; *The London Advertiser*)

Nov. 10, 1933:
♥ Muriel Robinson Saunders Fetherston [widow] to John Bayne [printer], Russell Joseph Hannent [printer], George Gordon Martin [printer], E 57 feet, sub lot 7, RP #312, $1750 [38 Weston Street]. Grant #27371. (Middlesex County Registry Office)

Dec. 9, 1934:
Dora (Bartlett) Steele dies at 70 years of age. She is probably the last of the Bartlett family to live on Weston Street. (Mount Pleasant Cemetery, United Church Archives)

1934:
City directory: Weston Street north side: 8 Mrs. Ann Knowles. 34 Robert Hawley and Edith Hawley leave, Reverend Henry G. Kent moves in. ♥ *38 T. M. Knowles Lithography and Amelia L. M. Knowles.* South side: (London Room; RCWL)

July 17, 1934:
♥ Russell Joseph Hannent to John Bayne, E 57 feet, sub lot 7, RP #312, $1 [38 Weston Street]. Grant #27693. (Middlesex County Registry Office)

1935:
City directory: Weston Street north side; 8 Mrs. Annie Knowles. 8 Knowles Litho Co. 34 Reverend Henry G. Kent. *38 T. M. Knowles Lithography leave.* (London Room; RCWL)

The London phone book lists: ♥ *Triangle Lithographing Co 38 Weston...Metcalf 8671.* Knowles Lithographing Co 6 Weston....Metcalf 1266. Bayne Mrs J 133 Elmwood...Metcalf 6325F (London Room)

May Abrams remembers an old tar paper covered shack right were the Moose Lodge is now. Annie Knowles lived there. 'Her place was made of wood covered with black tar paper. Annie Knowles always had lots of sunflowers around her place. She always had a nice garden.' The Knowles homestead was a rather shabby red brick cottage between the shack and Wellington Road. There was a long lane from Weston Street up the east side of the lot to the house. The creek ran between the Knowles homestead and number 12. (The source of Foxbar Creek is somewhere south of Emery Street and west of Wellington Road. It flows north under St. Andrew's Church. It flows north east under Wellington Road and curves west behind the houses on the south side of Weston Street. It flows under Weston Street and empties into the old river valley behind the Moose Lodge). She remembers Milt Knowles as a heavy set man.

She also states that 73 Weston Street was moved to the south side of Weston Street from the east side of Fairview Avenue, beside the L & PS tracks. (May Abrams phone conversation, June 23, 1991; Abrams interview July 17, 1991; City Engineer's Dept. Plan S-11, Fox Bar Creek Storm Sewer)

1936:
City directory: Weston Street north side: 34 Reverend Henry G. Kent. ♥ 38 Triangle [because there were three partners?] Lithography Co. (John Bayne manager). Weston Street south side: 59 Clarke Steele leaves, Ernest Carlyle Tupholme [driver Adams & Tanton] and Blanche Elizabeth [Minerva] Tupholme move in. (Christ Church records; London Room; RCWL)

April 26, 1937:

Weston Street is completely isolated by the great flood of the Thames River and of Foxbar Creek which flows across the bottom of the Weston Street hill to the river. Ernie Potter returns home from work at the *London Free Press* by walking across the footbridge attached to the L & PS Railway bridge. It is the only route to his house, since the Adelaide Street Bridge and Wellington [Clarke's] Bridge are both under water. (Potter interview, June 26, 1991; *The Municipal Yearbook*, 1958, p. 140) The foot bridge has since been removed. (Glen Curnoe, *The London and Port Stanley Railway 1915-1965*, p. 28)

City of London bridge reports; '"Wellington – Closed indefinitely – not known whether it will stand heavy traffic. [The Bridge was eventually declared unfit and replaced at a cost of $75,000]."' (Hives, *Flooding and Flood Control*, p.109)

Aug. 14. 1937

♥ Saturday, in the early evening 38 Weston Street is badly damaged by fire. The top floor is completely destroyed.

'Milt Knowles lived upstairs over the litho shop with his family. They moved down to the old homestead, a red brick house beside the crick at the foot of Weston Street. Old Mrs. Annie Knowles lived there. It was torn down and a new building for the printing business was built (around 1940) where the Moose Lodge is now. Gardner "Gar" Knowles [1928-1986] worked in the machine shop that replaced the lithography shop.' (May Abrams phone conversation, June 2, 1991)

'The fire in the factory was at the back, probably in the cellar. The windows were boarded up at the front. It was left as a shell. After work at the factory the workers played horse shoes in the field. Milton Knowles lived upstairs over the factory and then moved next door after the fire. [Albert Templar and Ernie Potter both say that no one lived above the factory] The son and the daughter lived in Litho Villa. Mr. and Mrs. Kent lived there before the fire. Mr. Storie who lived on Weston and worked at the London Advertiser played horse shoes.' (Mrs. Doris Smith [daughter of James McKone] phone conversation, March 1991)

'2 Blows for fire at 38 Weston St., Printers & Lithographing Owner & Occupant Mr. John Bain used 550 feet of 2 1/2" hose time 7.43 PM.

returned to quarters 8.55 PM 2nd Alarm for the same fire used 3 Gal extinguisher layed 350 feet of 2 1/2" hose dry time 11.29 PM, returned to quarters 12.12 AM.' (London Fire Department Watch Book, RCWL)

Aug. 16, 1937:
♥ 'After investigating a fire which swept through the Triangle Printing Company plant at 38 Weston Street Saturday night, Fire Chief Charles Scott today announced the cause would be listed as "unknown". He estimated damage to the building and contents at $3,000. The chief said no request for would be made to the fire marshall's department for a further probe.

'The printing plant is operated by John Payne. The flames broke out twice, first at 8.30 o'clock and then at 11.30. The blaze began in the rear of the plant and spread swiftly through the building. Participants in a horseshoe game near by discovered the outbreak and turned in the alarm. Sparks from the smouldering debris set the place on fire afresh about three hours after the original blaze began.

'Two fire companies responded to the alarm.' Front page *London Evening Free Press*. (Weldon Library)

Feb. 6, 7, 1938:
There is a severe flood of the Thames River. (Hives, *Flooding and Flood Control*, p. 181)

1938:
City directory: Weston Street north side: 34 Henry G. Kent [decorator]. ♥ *38 Triangle Lithography Company*. South side: 59 E. W. Tupholme and Minerva Tupholme. 60 Weston Street built. (London Room; RCWL)

May 1939:
Clarke Steele to the Canada Trust Company, $2800. Instrument #17782. (Middlesex County Registry Office)

June 1, 1939:
Clarke Steele [chauffeur of Niagara Falls] to Thomas Henry 'Al' Loney [postal worker d.1976] and Margaret Lillian Loney [1893- 1979], (west 176 feet of William Weston's part of lot 24) for $940. Instrument #17783

(Middlesex County Registry Office; Potter interview, June 1991; Woodland Cemetery)

June 24, 1939:
Thomas Henry Loney and Margaret Lillian Loney to Thomas Henry Loney and Margaret Lillian Loney [same as June 1, 1939] for $1. Instrument #22848 (Middlesex County Registry Office)

1939:
City directory: Weston Street south side: 59 W. Tupholme and Minerva Tupholme leave, D. C. Gaylord moves in. 62 Weston Street built. (Abrams, London Room; RCWL)

c.1940:
The Thames River is used by the Chippewa of the Thames from below Muncey to near the eastern limit of cession #2 until around this time, when the federal government begins to apply its treaty regulations more strictly. Hunting is carried out around London up to this point as well. (Riley phone conversation, July 2, 1991)

April 8, 1940:
There is a severe flood of the Thames River. (Hives, *Flooding and Flood Control*, p. 181.

1940:
City directory: Weston Street south side: 59 D. C. Gaylord leaves, Thomas H. Loney/ Margaret C. Loney/Clair Allen [Thomas Loney's sister d.1988] move in. (London Room; Potter interview, June 1991; RCWL)

♥ *According to May Abrams there were horseshoe beds lit with street lights on the original road allowance until about this time and games were played at night.* (Abrams interview, May 1991)

1941:
The London phone book lists: *Triangle Lithographing Co 38 Weston..Metcalf 8671*. Knowles Lithographing Co 6 Weston..Metcalf 1266. Knowles Mrs Violet [wife of Albert Knowles] 117 Wortley...Metcalf 4922. (London Room)

1942:
City directory: Weston Street north side: ♥ *38 Triangle Lithographing Co. leaves.* (London Room; RCWL)

1943:
'Greater interest in the chronology of Iroquoian societies was stimulated when, in the 1940's, researchers began to question the migratory hypotheses of Iroquoian origins....' 'Griffin (1943) suggested further that archaeologists seriously consider the possibility that Iroquoian peoples were indigenous to northeastern North America, not relatively recent migrants. This proposal, known as the *in situ* hypotheses stimulated researchers to think in terms of a much greater time depth for Iroquoian development –' (Smith, 'Iroquois Societies in Southern Ontario,' p. 282)

Aug. 14. 1943:
London Free Press: 'SAUNDERS – at her late residence, 240 Central Ave., on Friday, August 13, 1943, Emma Lee, beloved wife of the late Dr. W. E. Saunders, and mother of Mrs. Muriel Fetherston. Resting at the Harrison & Skinner funeral home, 520 Dundas St., where the funeral service will be held on Monday, August 16, at 3.30 p.m. Interment in Mt. Pleasant Cemetery. Flowers gratefully declined.' She is 82 years old. (Mount Pleasant Cemetery; Weldon Library)

Oct. 29, 1943:
♥ John Bayne and Irene Bayne to Frank E. Wilson, E 57 feet, sub lot 7, RP #312, $1 ($2400), they assume a mortgage in this amount [38 Weston Street]. Deed #33092. (Middlesex County Registry Office)

1943:
City directory: Weston Street north side: ♥ 38 vacant. (London Room; RCWL)

It is said that there was a machine shop making military equipment during World War II at 38 Weston Street. (Weston Street oral history)

1944:
'Nevertheless, once the possibility of an *in situ* evolution of Iroquoian

culture was in the air, B. S. Kraus (1944) was able to utilize Wintemberg's demonstration of uninterrupted cultural development in southwestern Ontario from Uren times to the historic period as evidence to suggest the local development of Iroquoian development generally.' (Trigger, 'William Wintemberg: Iroquoian Archaeologist,' p.18)

1944:
City directory: Weston Street north side: ♥ 38 vacant [the telephone book indicates that Albert Knowles has moved in]. South side: 39 Mrs. E. Henson. (London Room; RCWL)

The London phone book lists: ♥ *Knowles Machy Co 38 Weston...Fairmont 3656.* Knowles Lithographing Co 6 Westn...Metcalf 1266. (London Room)

Jan. 22, 1944:
John Daley [1882-1963] and Elosia Daley [1876-1962] to Arthur Harman, west 75 feet of sub lot #5, Registered Plan #206 (48 Weston Street), $150. Grant #20878. (Middlesex County Registry Office)

Feb. 26, 1944:
♥ Frank E. Wilson and Harriet F. Wilson to Albert Edward Knowles [machinist, 1905-1991], son of Arthur Knowles, cousin of Thomas Milton Knowles, nephew of Thomas Knowles Jr., grandson of Thomas Knowles Sr.], E 57 feet sub lot 7, RP #312, $2000 [38 Weston Street]. Grant #34005. (Knowles interview; Middlesex County Registry Office; Woodland Cemetery)

Feb. 26, 1944:
Muriel R. S. Fetherston [1890-1982 Sanichton BC] to Albert Edward Knowles [machinist], west 95 feet 6 inches of sub lot 7, RP #312, $2100 [34 Weston Street]. Instrument #34005. (Middlesex County Registry Office; Mount Pleasant Cemetery)

1944/45:
Number 48 Weston Street is built, frame, one story with Johns-Manville siding. (Abrams phone conversation June 1991)

June 7, 1945:
Thomas Joseph Henson dies at the age of 58. He has lived at 39 Weston Street for 33 years.

C. 1945:
♥ Double garages are built of yellow brick on the west side of 38 Weston Street. They are 18 feet 10 inches wide and 23 feet deep by 12 feet 10 1/2 inches high at the front. A door connects the garages with the workshop at the rear. (Greg Curnoe; Owen Curnoe)

May 18, 1945:
There is a heavy flood of the Thames River. (Hives, p. 181)

Dec. 11, 1945:
Thomas Henry Loney and Margaret Lillian Loney to William Bartlett Norman and Jean Shirley Norman [they live above the Daleys at 54 Weston], original road allowance between lots 24 and 25 on the south side of Weston Street, instrument #23222. (Middlesex County Registry Office)

1945:
City directory: Weston St. north side: ♥ 38 Knowles Machinery Co. [freight elevators]. Albert Edward Knowles proprietor and Violet Mary [Gardner] Knowles [1904-1971] move in. 48 Edwin Arthur Harman [bricklayer] and Viola Harman. 50 Walter Edward Abrams [Melville Sask. 1916-] and Mary Mudie Abrams. (Knowles interview, March 1991; London Room; RCWL)

1945/46:
50 Weston Street is built, frame, one story. (May Abrams phone conversation, June 1991)

Jan. 1946:
Walter and May Abrams move into 50 Weston Street. (Abrams phone conversation, June 1991.)

March 7, 1946:
There is a severe flood of the Thames River. Hives, *Flooding and Flood Control*, p. 181)

June 18, 19, 1946:
There is another severe flood of the Thames. (Hives, p. 181)

1946:
City directory: Weston Street north side: 34 Reverend Henry G. Kent and Emily Kent leave, Albert Edward Knowles and Violet Knowles move in. ♥ *38 Knowles Machinery Company.* 48 Edwin A. Harman [bricklayer works City of London] and Viola Harman. 50 Walter Abrams and Mary Abrams. 62 John Daley and Elosia Daley leave, Walter Melville Hawthorne and Charles Hawthorne move in. 65 new house. 67 new house. 69 new house. (Abrams phone conversation, June 1991; London Room; RCWL)

Apr. 5 to 10, 1947:
There is a very severe flood of the Thames River. (Hives, *Flooding and Flood Control*, p .181)

July 18, 1947:
Margaret L. Loney to Inez Pearl Smith, 45 feet, road allowance between lots 24 and 25, (41 Weston Street). (Grant Hopcroft letter, April 1991)

July 18, 1947:
William Bartlett Norman and Jean Shirley Norman to Inez Pearl Smith, 45 feet, road allowance between lots 24 and 25. Instrument #27021. (Hopcroft letter April 1991)

1947:
63, 65, 67, 69 and 71 Weston Street are built. (May Abrams phone conversation, June, 1991)

Mar. 16 to 21, 1948:
There is a very severe flood of the Thames River. (Hives, *Flooding and Flood Control*, p. 181)

March 23, 1948:
Eliza Henson makes a declaration regarding the road allowance on the south side. She describes Duke Steele's use of the lot and how he kept it fenced and locked, and that it was never used as a road. (Hopcroft letter, April 1991)

March 28, 1948:
Thomas Milton Knowles makes a declaration regarding the road allowance
on the south side. He describes Duke Steele's use of the lot and the fact that
it was never used as a road. (Hopcroft letter, April 1991)

Sept. 16, 1948:
Quit Claim, City of London to Inez Pearl Smith (same as July 18. 1947, 41
Weston Street). 'WHEREAS the land comprising part of Wellington Road in
the City of London was when opened granted to the corporation of the City
of London in exchange for the land comprising Beverly Street. AND
WHEREAS the said exchange was never evidenced by registered Deed and
the said Corporation now deems it expedient to complete the proceedings.
AND WHEREAS the Municipal Council of the said Corporation at its session
on the Seventh day of September, 1948, adopted the twenty-ninth clause of
the Seventeenth Report of No. 1 Committee, namely: "That the City agree
to the closing of the original road allowance south of Weston Street, it being
the understanding of the Board that this will merely complete the City's
part of a transaction involving the original opening of Wellington Road (see
Oct. 25, 1840 and Dec. 26, 1840), in place of Beverly Street; and that the
Mayor [George Albert Wenige] and Clerk [Reg H. Cooper] be authorized to
execute any Quit Claim Deeds which may be necessary in this connection,
subject to there being no cost involved to the City."' 45 feet along the south
side of Weston Street then 209 feet 6 inches south, lying between lots 24 and
25 in the broken front concession of Westminster [now in the City of Lon-
don]. Instrument #28659 (Hopcroft letter, April 1991, Mayor's office)

Sept. 20, 1948:
City of London by-law A-2615-271 is passed by City Council authorizing
the quit claim from the City to Inez Pearl Smith. (Hopcroft letter, April
1991)

Mar. 14, 15, 16, 1949:
There is a heavy flood of the Thames River. (Hives, *Flooding and Flood Con-
trol*, p. 181.

June 2, 1949:
Arthur Harman to the Sun Life Insurance Co., west 45 feet of sub lot 5

Registered Plan #206 [48 Weston Street]. Final order of foreclosure #30176. (Middlesex County Registry Office abstract)

June 22, 1949:
The Sun Life Insurance Co. to Edwin Harman, west 45 feet of lot 5 Registered Plan #206 [48 Weston Street, 1$. Grant #31249. (Middlesex County Registry Office abstract)

Dec. 22, 23, 1949:
There is a very heavy flood of the Thames River at St. Mary's and London. (Hives, *Flooding and Flood Control*, p .181)

Apr. 4, 5, 1950:
There is a heavy flood of the Thames. (Hives, p. 182)

c. 1950:
♥ One of Walter and May Abrams' sons disappears. They look all over the neighbourhood for him. He is found in the Knowles Machine shop with Gar Knowles [1926-1972], the son of Albert and Violet Knowles. The Abrams are very disturbed because their son is only 5 years old and the large machines have exposed moving parts. (Walter and May Abrams interview, July 1991)

Part Five

Aug. 29, 1951:
Edwin Harman to the Premier Trust Co., West 75 feet of sub lot 5, Registered Plan #206 [48 Weston Street], $7500. Grant #35850. (Middlesex County Registry Office abstract)

1951:
City directory: Weston Street north side: 34 Albert E. Knowles and Violet Knowles. ♥ *38 Albert Edward Knowles Machinery leaves (Knowles machine shop broken by two bad contracts)*. South side: 59 Thomas Loney, Margaret Loney and Terrence Loney [1930-1981]. (Knowles interview, March 1991; London Room, Potter interview July 1991; RCWL)

Oct. 13, 1952:
34 Weston Street, 4:15 pm, dump fire. (London Fire Department Watch Ledger, RCWL)

1952:
City directory: Weston Street north side: ♥ *38 Advance Heating (R.D.Palser/ B.G.Guest) and Physical Enterprises (W. L. Oliver scientific equipment) move in.* (London Room; RCWL)

Aug. 29, 1953:
Arthur Knowles, 4th son of Thomas Knowles senior, dies aged 80. (Woodland Cemetery)

1953:
City directory: Weston Street north side: ♥ *38 Advance Heating leaves. Physical Enterprises stays.* 48 Edwin Harman and Viola Harman leave, J. A. Arnott moves in. South side: 41 Henry Wong [chemical technician] moves

in to new house. (London Room; RCWL)

Oct. 30, 1953:
Albert Edward Knowles [1905-1991] to Violet Mary Knowles [1904-1971], sub lot 7 except E. 57', lot 25, R.P. #312, $1. Grant #61794 [34 Weston Street]. (Middlesex County Registry Office)

April 26, 1954:
Joseph Knowles, 3rd son of Thomas Knowles senior dies, aged 86. (Woodland cemetery)

1954:
City directory: Weston Street north side: ♥ *38 Weston Street Physical Enterprises leaves.* (London Room, UWO Regional Collection)

1955/56:
City directory: Weston Street north side: 34 Albert Knowles and Violet Knowles leave (they eventually move to 1 Wellington Road where she opens V.K. Antiques in the 1960's), Kenneth Pease moves in. ♥ *38 London/Vancouver Express [Kenneth Pease proprietor] moves in.* 48 J. A. Arnott leaves, William Hynds moves in. South side: 59 Thomas Loney and Margaret Loney leave, H. Clapham [contractor] moves in. [Claphams run a boarding house.] (London Room; RCWL)

1957:
City directory: Weston Street north side: 48 Mastex Limited Plastic Products. (London Room; RCWL)

♥ Hans and Monica Hoelzl move into 57 Weston Street. Hans Hoelzl recalls that 'The London Vancouver Express parked on half of the field. It was all gravel and there was no grass. Neubauer also parked there. There was no fence on the west side in 1957, only on the east side. 38 Weston had a flat roof in 1956. There was a side door and some partitions. The office was on the west side. The city put up a fence around the field in 1964 because they didn't want it used for dumping fill.' (Hans and Monica Hoelzl interview, May 1991)

1958:

♥ Eddie Pranskus, 'there was no parking on the south side of Weston so the workers at 38 used to park in the field. When we played ball on the parking lot the workers would chase us off.' (Pranskus interview, March 1991)

City directory: Weston Street north side: 34 Kenneth Pease leaves. ♥ *38 London Vancouver Express leaves, Nu-Built Mattress Company (F. Griffin manager) Moves in.* 48 Paul Hill [salesman Boyle Midway]. South side: 39 Eliza Henson leaves. 41 Henry Wong and Myrtle Wong. 59 Steve Urbaniak [works Kayser & Co.]/Kresenz Urbaniak/Hans Hertsa/Monica Hertsa. (London Room, RCWL)

1959:

City directory: Weston Street north side: 34 vacant. ♥ *38 Nu Built Mattress Company replaces London Vancouver Express.* 48 Mastex Limited leaves, D. Rombough [contractor] moves in. South side: 39 Amedio Borg [Malta, Excello]/Pauline Borg [Malta] move in. 41 Henry Wong and Myrtle Wong. 59 H. Clapham leaves, Steve Urbaniak, Hans Hertsa [Austria] and Monica Hertsa [Austria] move in. (London Room; RCWL)

1960:

The London phone book lists: ♥ NU-Built Mattress Co. 38 Weston....GE 9-3331. (London Room)

Apr. 7, 1960:

♥ Lamon & Macnab, Barristers and Solicitors to Holstead & Orendorff, Land Surveyors: 'The Royal Bank of Canada has agreed to sell the Westerly 83'6' more or less, of the above mentioned lot on which is located the house known as No. 34 Weston Street. The offer provides also, that the Easterly line of the property to be conveyed shall be 2' from the existing garages [at 38 Weston St.] on the East side of the property and we, of course, are not sure that this coincides exactly with the frontage of 83'6'". 'We would be obliged if you could attend at the property and advise us what frontage should go with the sale of 34 Weston Street in order to have the Eastern boundary of the land to be conveyed clear the garages on the property adjoining to the East by 2'.' (Redmond letter, 1985)

Apr. 25, 1960:
The Royal Bank to Angelo Pepe, west 86.54′ of sub-lot 7, RP #312, lot 25, broken front, Township of Westminster now in the City of London, 34 Weston Street, $9500. Grant #93387. (Middlesex County Registry Office abstract)

Apr. 29, 1960:
♥ Plan No. 60-124 by Holstead & Orendorff severs lot 7, Registered Plan 312. The Easterly portion has a frontage of 86.54′, and the Westerly portion has a frontage of 65.96′. The front of the garages at 38 Weston Street are 2′ from the property line. The back of the garages is 3.61′ from the property line. (Redmond letter, 1985)

May 20, 1960:
♥ Albert Edward Knowles [1905-1991] to the Royal Bank of Canada, sub lot 7, RP #312 [34 and 38 Weston Street]. Final order of foreclosure #93456. (Middlesex County Registry Office)

Sept. 6, 1960:
♥ 38 Weston St. 12:59 to 3:05 pm, fire. 'Someone had dumped a load of scrap here and set it on fire' – fire records ledger, London Fire Department. (RCWL)

1960:
City directory: Weston Street north side: 4 T. M. Knowles, Amelia L. M. Knowles and Annie Knowles. 6 Knowles Lithograph Company. 34 Knowles. (London Room)

c.1961:
The Watson Street sewage disposal plant is demolished. (Walter Abrams interview, July 17, 1991.

Feb. 23, 1961:
'Mrs. T. Milton Knowles [Amelia Short] 65, of 4 Weston St., died today at Victoria Hospital. She was a life-long resident of London and a member of Calvary United Church and Omar Temple No. 111, Daughters of the Nile. Surviving besides her husband are a brother, Albert Short of Lakeworth

Fla., a sister Mrs. Newman (Kate) Pidd of London. Funeral service will be conducted at A. Millard George funeral home by Rev. E. G. Turnbull of Calvary United Church, Saturday at 3:30 p.m. Burial will be in Woodland Cemetery.' (*London Evening Free Press*)

June 15, 1961:
Premier Trust Co. to Vincenzo Ornato, West 75 feet of sub lot 5, Registered Plan #206 [48 Weston Street], $1. Grant #151618. (Middlesex County Registry Office)

1961:
City directory: Weston Street north side: 34 Angelo Pepe [Italy, Carl Miller Construction] and Carmela Pepe [Italy] move in. South side: 41 Henry Wong and Myrtle Wong leave, Robert Chapman [instructor Bell Canada] and Frances E. Chapman move in. 59 W. J. Sexsmith [printer] boards with Hoelzls? (London Room; RCWL)

1962:
City directory: Weston Street north side: 48 D. Rombough leaves, Vincenzo Ornato [Italy, works B & D Insulation] and Antonia Ornato [Italy] move in. South side: 39 Amedio Borg and Pauline borg leave, Frank Cassel [Malta, works at Excello] and Josephine Cassel [Malta] move in. 59 Hans Hoelzl [sand blaster E.H. Munro Co.] and Monica Hoelzl. (London Room; RCWL)

Greg Curnoe purchases old objects (including a rubber stamp set) from Violet Knowles, proprietor of V.K. Antiques at 1 Wellington Road, for collages and constructions around this time.

July 4, 1963:
The Reverend Leonard Bartlett dies in Thamesville at the age of 91. (United Church Archives)

1963:
City directory: Weston Street north side: 34 Joseph Vella moves in with Angelo and Carmela Pepe. South side: 37 Frank Henson and Dorothy Henson leave, Heinrich Kinting [Köln, barber] and Marthe Kinting [Köln, nurse] move in. They rent for $40 a month with a 2-year option to buy.

Most of the houses from 19 to 39 are covered with Insulbrick. Number 39 has fancy woodwork under the Insulbrick including clapboard with decorative slots, and ginger bread trim. (Heinrich [Henry] Kinting interview, July 17, 1991; London Room)

Sept. 23, 1963:
♥ The Royal Bank of Canada to Rosmarie [Rosie] Neubauer [Berlin], sub lot 7, RP #312, except the westerly 86.54 feet (66.84 feet), $6750 [38 Weston Street]. Herb Neubauer has had business losses at an earlier location connected with large contractors who went bankrupt. He starts his cabinet making business again at 38 Weston Street with very little money. Grant #111338. (Cole; Kinting interview; Moore)

Fall 1963:
♥ Herbert [Neubur] Neubauer [Berlin, cabinetmaker] builds a 3-bedroom apartment at the front of 38 Weston Street in which he lives with Rosmarie Neubauer. He also builds an office in the double garages on the west side. The north-west corner of the shop at the rear is partitioned off for a sanding room. He and his partner make stereo cabinets for Mates TV on Adelaide Street. (Kinting interview, July 17, 1991)

Oct. 28, 1963:
'T. Milton Knowles, 71, of 4 Weston St., well known in many London lodges died yesterday in Victoria Hospital. Born in London, Mr. Knowles had been a lithographer, operating his own business, Knowles Lithographing Company for many years. He was a member of Calvary United Church. He was a member of Union Lodge No. 380, AF and AM Centennial Lodge No. 688, AF and AM London Lodge of Perfection, London Sovereign Chapter of Rose Croix, Moore Sovereign Consistory, Mocha Temple of London, Xella Grotto of London, the London Chamber of Commerce and the Past Master's, Masters' and Warden's Association. His wife, the former Amelia Louise Short, died in 1961. He is survived by his mother Mrs. Annie Knowles of London. Service will be held at the A. Millard George funeral home, Wednesday at 3 p.m. Rev. E. G. Turnbull will officiate. Burial will be in Woodland Cemetery. A Masonic memorial service will be held at the funeral home at 7:30 p.m. under the auspices of Union Lodge No. 380, AF and AM.' (*The London Evening Free Press*)

1964:
City directory: Weston Street north side: 34 Carman Farrugia moves in with Angelo Pepe and Carmela Pepe. ♥ *38 Nu Built Mattress Company leaves, Forest City Wood Products [Herbert Neubauer proprietor] moves in.* (London Room.)

c. 1965:
Weston Street from Wellington Street to 38 is graded. The street had been higher than the lots. The Weston Street hill is graded as well, making it much less steep. (Kinting interview, July 17, 1991)

Dec. 15, 1966:
♥ Rosmarie Neubauer and Herbert Neubauer [cabinetmaker] to John Verkley [cabinetmaker] and Wilhemina Joanne Verkley, sub lot 7, RP #312, except the westerly 86.54 feet [38 Weston Street]. Verkley lets the front apartment for $100 a month. He finds that the electrical service isn't heavy enough to run his woodworking machinery. Grant #130253. (Cole, Moore)

Dec. 9, 1967:
♥ Agreement to purchase between Gregory Richard Curnoe and George Messing of Paiement Realty for 38 Weston Street. The Purchaser agrees to accept present tenants at $100 per month [number 38]. (Curnoe)

early 1968:
Don and Benice Vincent visit 38 Weston Street in early 1968. Don Vincent takes his first photographs of the building at around the same time.

March 1968:
♥ Dick Kirkpatrick, Ontario Land Surveyor, surveys the easterly portion of sub lot 7. for Greg and Sheila Curnoe. He bases his survey on Farncomb & Kirkpatrick surveys of Weston Street. The Farncomb & Kirkpatrick surveys use measurements from Wellington Street at Weston Street. He determines that the garages on the west side of 38 Weston Street encroach on the line, between 34 Weston Street and 38 Weston Street, approximately 8 inches, at the front. Archibald/Gray & McKay, Holstead/Orendorff & Redmond and Murray Frazer all disagree with Farncomb & Kirkpatrick's surveys of the area. Holstead/Orendorff & Redmond base their surveys on

the extension of Wellington Road south along Beverly Street to Weston Street. (Archibald phone conversation, Apr. 1991; Frazer conversation, July 1991; Holstead phone conversation, April 1991; Kirkpatrick phone conversations, 1968 to present; Redmond letter, 1985)

May 15, 1968:
♥ Gregory Richard Curnoe [Nov. 19. 1936-], Sheila Curnoe, and Owen Thomas Curnoe [Apr.30. 1966-] move into 38 Weston Street (Bob Manson [Ireland 1922-] & Jack Flynn [England 1917-] commence alterations in March 1968). There are two unglazed window openings and a broken door to the basement at the rear of the building. The roof at the rear west side and above the larger bedroom on the centre west side collapses slightly and begins to leak after the winter of 1967/68. Manson and Flynn splice the roof beams to repair it. They find the living room floor has a slope of 6 inches from one side to the other. Tin Ton carpeting is installed in the living room over a new plywood floor. They put in a new door through the west wall leading to the side yard. 'When we moved into 38 in 1968 there was a one story brick cottage that faced the river at number 64 [The Bartlett house]. It was set well back from the street and had a lot of bushes around it so that it was hardly visible. It had a window on each side of the front door. The front door had stained glass around it I think. There was a lane to the river flat from near the front door. Two hippies lived there, a young woman and a young man. They were very friendly to us. The house was torn down around 1970 and a generic fourplex was built in its place. The lane still exists.' It used to have a yellow brick barn in front right on Weston St. June 15. 1991. (Greg Curnoe)

June 1968:
♥ Carolyn Denny, Peter Denny, Hugh McIntyre paint the rear workshop with Greg & Sheila Curnoe.

June 22, 1968:
♥ Galen Richard Curnoe is born at Victoria Hospital. (Curnoe)

Aug. 26, 1968:
Annie [Foot] Knowles, widow of Thomas Knowles junior dies at the Dearness Home, at the age of 102. Her nick name at the Dearness home was Granny. (Glen Curnoe; Woodland Cemetery)

PART FIVE

Aug. 1968:
'Begins *View of Victoria Hospital, First Series* (completed Jan. 1969; purchased by the National Gallery of Canada that year).' (Théberge, *Greg Curnoe*, p. 60)

Sept.? 1968:
Richard Hamilton and Dennis Young visit and look at *Victoria Hospital, First Series*. Hamilton selects this work and awards it a prize in the Canadian Artists '68 exhibition.

Dec. 14, 1968:
♥ John Verkley and Wilhemina Joanne Verkley to John Henderson (Jake) Moore [executive 1915- , great great nephew of William McClary surveyor 1812-?, grandson of John Moore surveyor/civil engineer/architect 1857-1930, who subdivides Maryboro Place/McClary Avenue], Sub lot 7, RP #312, except the westerly 86.54 feet, $14700 [38 Weston Street]. Grant #137195. (Moore)

Winter 1968/1969:
After a particularly heavy snowfall, Ron Martin and Michael Ondaatje help shovel snow off the roof. Around this time Tony Urquhart works on a construction at 38 Weston Street.

February 1969:
'Begins *View of Victoria Hospital, Second Series* (completed March 1971; purchased by the National Gallery of Canada that year).' (Théberge, *Greg Curnoe*, p. 60) Jack Chambers photographs Victoria Hospital from the roof of 38 Weston Street, with a wide angle lense (approx. 35mm) his intention is to work on a painting of the hospital in the Weston Street studio but his leukemia is diagnosed and he is obliged to do the work in his own studio.

Sept. 9, 1969:
♥ *John Henderson Moore to Gregory Richard Curnoe and Sheila Curnoe, sub lot 7, RP #312, except the westerly 86.54 feet (66.84 feet), $14916 [38 Weston Street]. Grant #151736.* (Cole, Moore)

Fall 1970:
Murray Favro shows *Still Life* (The Table), his first successful projection,

using a projected slide of a table on a table, at 38 Weston Street in the studio. Films are shown by Royden Rabinowitch (driving around in a truck, shot by ?), Greg Curnoe (*Souwesto*), slides by David Rabinowitch (black cattle in a field), slides by Hugh McIntyre of his trip to Scotland, and a film by Kee Dewdney (?). The audience includes Sheila Curnoe, Paterson Ewen, Judy Favro, Bob Fones?, Dave Gordon, Jamelie Hassan, Ron Martin, Steve Parzybok, Christine Parzybok and so on.

♥ A computer terminal is installed in the office at 38 Weston Street, connected by a modem to the computer science department at the University of Western Ontario. Journals are typed directly into the computer, including descriptions of views out of the windows. '06-NOV-70 ABOUT I I AM THE LEAVES MOVING ON THE DRIVEWAY, I'M LOOKING SOUTH AT WESTON STREET FROM MY OFFICE WINDOW. WJ STEWART TRUCK DRIVES BY. THE HOUSE NEARLY OPPOSITE IS THE LEAST ALTERED OF THE ONES ON THE OTHER SIDE – THE SOUTH SIDE. IT HAS AN ALUMINUM STORM DOOR & THAT'S ALL THAT'S NEW ON IT.'

1970:
♥ Harry Fones, father of Robert Fones, builds cupboards in the front bathroom after the water heater is moved into the studio. (Greg Curnoe)

Nov. 17, 1971:
♥ Sarah Zoë Curnoe is born at Victoria Hospital. (Greg Curnoe)

Spring 1972:
♥ James Gagan converts the office in the garage on the west side of 38 Weston St. to a room and builds a hall from the house to the new room. (Greg Curnoe)

Mar. 11, 1974:
Angelo Pepe and Carmela Pepe to Daniel Mortier and Peter Hessel, west 86.54' of sub-lot 7, RP #312, 34 Weston Street, $1. Grant #186272. (Middlesex County Registry Office abstract)

Spring 1975:
♥ Karl Peter builds a second bedroom in the garage and removes a small bedroom to enlarge the kitchen. He removes a second bedroom to enlarge the living room to twice its size. (Greg Curnoe)

Dec. 24, 1975:
Christmas eve, 34 Weston Street is gutted by fire. Because of its construction the walls are left standing. Elliot Ekdahl's frozen doctoral thesis is rescued, placed in a freezer, and taken to Western where it is thawed and saved. The fire is caused by faulty wiring or an inadequate fuse box. A strong east wind saves 38 Weston Street from damage by the fire. (Greg Curnoe)

1976:
♥ The west driveway is replaced with an enclosed front garden.

The river valley below 38 Weston Street is called 'the flats' by long time residents. Owen, Galen and Zoë Curnoe and Mark Favro call it 'the dump,' 'down back,' 'down the back,' and 'the wasteland.'

Summer 1976:
♥ A skylight is built at the rear of 38 Weston Street by Karl Peter. It measures 14 feet 8 inches wide by 12 feet 10 1/2 deep. It is approximately 8 feet high at the main windows and 7 feet high at the back. A sample of lithography from one of the printing shops is found in the rafters. It is a model airplane cut out, printed on card. (Greg Curnoe)

1970's:
Around this time John Greer, Michael Fernandes, David Bolduc and Sandy Spencer visit several times. They usually drink a bottle or two of Lil Thompson's wine.

Oct. 21, 1976:
Daniel Mortier and Peter Hessel to David Marinigh and C.E. Investments, west 86.54′ of sub-lot 7, RP #312, 43 Weston Street. Grant #464788.

Summer 1978:
♥ Rufus is adopted from the London Humane Society animal shelter. (Sheila Curnoe)

1978:
♥ Paul Kershaw designs and Karl Peter builds a second floor on the front of 38 Weston Street and a sun room at the west side on the ground floor. The

gable faces east and west. The architect determines that the original roof is a floor and can carry the weight of the addition. (Greg Curnoe)

March 12, 1980:
♥ Registered Plan #33R 4297 shows 38 Weston Street measuring: north side 69.32', east side 285.41', south side 66.84', west side 162.31'. (Kirkpatrick)

July 1980:
♥ Property dispute develops between Greg and Sheila Curnoe and x-Trax Investments Ltd. (Tony Pavan, David Marinigh) over the location of the property line between 34 and 38 Weston Street.

Apr. 6, 1981:
♥ Brad Holstead of Holstead, Orendorff & Redmond, Land Surveyors states that he is 99/100 percent sure that the April 29. 1960 Holstead, Orendorff line would be ruled correct by a judge under the boundaries act. (Holstead phone conversation, 1981)

Summer 1981:
Galen Curnoe finds part of a litho stone, with labels and letterheads engraved on it, in the hillside below the fence at the rear of 38 Weston Street, west of a willow tree. 'It was sticking right out of the ground. There were tons of bricks there. Remember the sandstone we found that we used to carve in' [sand-like residue from metal casting]. (Galen Curnoe conversation, Aug. 20, 1991)

1981:
♥ Herbert Neubauer: His understanding was that the line passed somewhere west of the garage. Angelo Pepe never complained about his use of the garage area as a right of way from the front to the back. (Neubauer phone interview, spring 1981)

♥ Angelo Pepe: He says that the line was 2 feet west of the garage. Was aware of second survey (Farncomb & Kirkpatrick) showing different line, but he purchased property with original Holstead survey from Bank of Montreal. Lived at 34 Weston from May 1960 to October 1968. (Pepe phone interview, spring 1981)

Summer 1982:
Weston Street from Wellington Street to the east side of the original road allowance between lots 24 and 25 is paved to the edge of the sidewalk. Curbs and gutters are not put in. Up to this point it had been coated with stones and oiled each year. The eastern section, which was annexed in 1912, was paved much earlier and had concrete curbs, gutters, and separate sanitary and storm sewers. The sidewalk from the original road allowance to east of number 54 was paid for by Mrs. Daley (Abrams phone conversation July 1991; Kinting interview July 17, 1991)

Mar. 3. 1983:
David Marinigh and C.E. Investments to Sandra M. Pavan, west 86.54' of sub-lot 7, RP #312, 34 Weston Street. Grant #633894. (Middlesex County Registry Office abstract)

Fall 1983:
♥ A black, cast metal A. KNOWLES LONDON, ONT. sign with relief letters is obtained from a freight elevator in Jamelie Hassan's studio in the Beatty building at the south-west corner of William and York Streets (demolished 1985). (gift of Jamelie Hassan)

July 11, 1984:
♥ Gregory Curnoe and Sheila Curnoe to Sandra Marie Pavan, ' Part of Lot Number Seven, according to Registered Plan Number 312, being more particularly described as Parts 1, 2, and 3 on a reference plan deposited in the Land Registry Office for the Registry Division of Middlesex East (No. 33) as Number 33R 5340. TOGETHER with a right-of-way over Part 4, on said Reference Plan Number 33R 5340. – as part of lot 7, RP 312. AND SUBJECT to a right-of-way in favour of the vendors over Part 3 on said Reference Plan 33R 5340. – as part of lot 7, RP 312', $2.00. Grant #676109. (Judson)

July 11, 1984:
♥ Sandra Marie Pavan to Gregory Curnoe and Sheila Curnoe, the same as above except 'TOGETHER with a right-of-way over Part 3 on Reference Plan 33R 5340. – as part of lot 7, RP 312. AND SUBJECT to a right-of-way in favour of the Vendor over Part 4 of said Reference Plan 33R 5340. – as part of lot 7,

RP 312', $2.00. Grant #676108. (Judson)

1983-84:
Teach Map Directory, Map 65: Weston Street north side: 6/10 Royal Order of Moose, 12 Gary Hunt, 16 J. Lee, 18 M. Cassar, 20 N. Gileff, 30 T. Millson, 34 D. Marinigh/A. Pavan, ♥ 38 G. Curnoe, 48 V. Ornato, 50 W. Abrams, 54 W. Ruck, 60 R. Gregory, 62 W. Cousins/G. Dawkins, 78 K. Steeves. Weston Street south side: 39 D. McNab, 41 S. Kukuk, 59 J. Hoelzl.

1988:
bill bissett and Mike Snow meet and have dinner at 38 Weston Street.

Feb./June 1989:
♥ The studio at 38 Weston Street (rear) is insulated and drywalled by Derek Lancaster, Greg, Galen and Owen Curnoe. The north and east facing windows are replaced and a new north window is added (there are now 5 windows in the north wall and 2 in the east wall). The west window is blocked off. It is discovered that the old windows are storm windows nailed to the outside window sashes (probably after the fire of 1937). The original concrete stairway to the basement is opened up. It has been closed off since before 1968. (Greg Curnoe)

Spring 1989:
♥ Lulu, a 3 month old dalmatian, is purchased in Dorchester.

Nov. 1989:
♥ Rufus dies. (Sheila Curnoe)

June 7, 1990:
Vincenzo and Antonia Ornato to Kenneth Harper, west 75 feet of sub lot 5, Registered Plan #206 [48 Weston Street], $104,000. (Middlesex County Registry Office)

Sept. 1990:
Thomas Millsom owner of 30 Weston Street dies. 30 Weston Street is vacant. His wife, Dora Millsom, who died in around 1987 was a Webb. She

emigrated from England around 1915 with her parents. They lived at number 18. (Bill Webb phone conversation, Nov. 20, 1991)

Dec. 25, 1990:
♥ On Christmas night Owen Curnoe sees the Pup on Rectory Street near the CNR tracks. She is starving. The Pup is about 2 months old when brought back to 38 Weston Street. She is a great dane cross. No one calls in response to information given to Animal Control)

Feb. 24, 1991:
Nicole Jolicoeur visits for 2 days.

May 1991:
Walter and May Abrams leave 50 Weston Street.

May 28, 1991:
A phone call to Joanne Gumb of London reveals that her family lives in West Nissouri, and that William and Caroline are names that have been handed down over several generations.

During a second call from Joanne Gumb, she says that John Gumb married a woman named Knapton [executor of Steele's estate?]. (Gumb phone interview, May 28 1991)

June 1991:
Contract let for archaeological investigation of area at South end of Adelaide Street Bridge, south side (lot 23) and north side. This area is one of the last relatively undisturbed sections of the river flats. (Ferris interview June 1991)

June 15, 1991:
A garden party is held in for Goldie and Geoffrey Rans at 38 Weston Street and on the original road allowance.

June 19, 1991:
A Conversation at 38 Weston Street with Jake Moore reveals that he is a McClary and that he has some of William McClary's survey notes from around 1830 or 1840. (Moore interview, June 19, 1991)

June 26, 1991:
Albert Edward Knowles [the son of Arthur Knowles, the grandson of Thomas Knowles senior and Elizabeth Knowles] dies at the Dearness Home aged 86. (Woodland Cemetery)

July 1991:
An archaeological assessment is carried out at the Adelaide Street bridge by archaeologists from the Lawson Museum. No archaeological evidence is found. (Pearce interview, July 31, 1991)

July 11, 1991:
Jake Moore provides a photo copy of William McClary's revised plan of Westminster (with lot numbers added to Simon Zelotes Watson's original traverse of the Thames River and Broken Front, date unknown) from McClary's papers. (Moore interview, July 11, 1991)

July 16, 1991:
Peter Piazza from GOLDEN EAGLE INC. (CENTURY 21) makes a real estate appraisal of 38 Weston St.. He states that the lot is large but the portion at the back is of little use except for the view. He says that the electric base board heaters in the house are a drawback as is the lack of a basement. He notes that 38 Weston St. is different. The fact that the floors are on different levels is not desirable. He states that houses priced over $200,000 are not selling at all and that our lot alone would be desirable if an investor wished to put up a small apartment. In that case our building would be demolished. He also points out that our place is much better than its location: it is the most impressive building on our street. That is also not desirable. He recommends a price of about $165,000. Compare this estimate with $104,000 paid for 48 Weston St. (a one story frame cottage) last year. (Piazza appraisal, July 1991)

July 26, 1991:
Owen Curnoe rents an apartment from Murray Leff. When Leff sees Owen's current address he starts to talk about Ab Knowles. He calls him the black sheep of the family. (Murray Leff conversation, July 1991)

Aug. 2, 1991:
The ground is broken for the foundation of number 46? Weston Street, on the

west side of lot 24, on the north side of the street.

Aug. 6, 1991:
The hole for the foundation reveals that there are about 10 feet of fine dark sand over clay at the top of the old river bank at 48 Weston Street.

Aug. 20, 1991:
♥ Galen and Greg Curnoe dig in the hillside where the lithograph stones were found in 1981 [approx. 6 feet below the fence on the edge of the hill at the rear of 38 Weston Street, near the middle of the lot]. Galen pulls a fragment of a litho stone out of the ground. They both find 4 more pieces of limestone including: a large fragment with a floral frame and colour separations for a Union Jack, a small corner with a letter head for a share certificate, a fragment that contains a document that states 'pay to the order of..........192', a piece from the back of the latter, a small blank piece.

Sept. 12,13,14, 1991:
Marlene Creates stays in the studio.

Sept. 24,25,26, 1991:
Audrey Thomas stays in the studio.

Oct. 31, 1991 Walter Klepac comes from Toronto to select work for READING: PUBLIC SIGNS, PRIVATE ACTS.

Nov. 3, 1991:
Greg Curnoe is elected president of the London Centennial Wheelers bicycle club at the club's annual general meeting. The meeting is held at 38 Weston Street.

Nov. 5, 1991:
I find a part of a brick at the location of the old brick kiln on Brick Street, south side, east of Wharncliffe Road. I intend to have the brick analyzed along with a brick from 38 Weston Street.

Nov. 10/15, 1991:
Nellie Curnoe remembers the 'brickyard' with its two brick kilns on Brick

Street (Highland Road, now Commissioners' Road) just west of Eddie Howe's farm and east of Nuttal's house. They were round structures made from the yellow brick. The clay was excavated from Winery Hill at the rear of the kilns. There was another building where the bricks were formed but she doesn't remember it very well. The brickyard ceased operation sometime in the 1920's. (Nellie Curnoe conversation and phone conversation)

December 6, 1991; Neal Ferris says that he has talked to Bob Calvert, an elderly amateur archaeologist who found Iroquian artifacts at the junction of Foxbar Creek and the Thames River, at the foot of Weston Street hill, in the 1920's or 30's (on sub-lot 5, RP #312). This discovery proves Iroquoian occupation of lot 25 sometime before 1690, althought sub-lot 7 wasn't occupied in this way because it was higher up and didn't have a creek flowing through it.

December 12, 1991; Del Riley tells me that the man who was the horse shoe champion with the Weston Street Horseshoe Club is probably Sylvester Simon, who is in his 70's or 80's and still living on the Muncey Reserve. I obtain his phone number on January 28, 1992 from the girlfriend of his grandson Robert Simon.

Appendix One

The Weston Family

Some time in the 1820's William Weston arrived in Canada with His Majesty's Corps of Royal Artillery. He had been born in England in 1799. In 1837 he arrived in Upper Canada.

William Weston was married to Sarah Ann Weston who was probably born in Scotland in 1799. They had at least three children: Ann born in Upper Canada in 1830, George born in Upper Canada in 1835 and Eliza born in Canada West in 1839.

In 1841 William Weston, tanner, rented property on lot 45, concession 1, Westminster Township (now Byron) owned by the McMillen family. Archibald McMillen operated a tavern on the property. Weston lived on lot 45 with: his wife Sarah Ann, another married couple, 3 male children (one of whom, possibly George, was born in Canada between 1823 and 1827) and 1 female child.

On September 6, 1842 William Weston, who was by then a corporal in the Corps of Royal Artillery stationed at London, by trade a tanner and currier, bought part of lot 25 in the broken front concession of Westminster Township (Wellington Road to the north east corner of number 39 Weston Street) from Robert Thacker [born c.1825] (a plasterer who had arrived in Canada from Scotland in 1840) and Catherine Thacker [born c.1825] for £33. 15s. The deed was witnessed by his neighbours George King (a carpenter who arrived in London in 1831 where he bought property on the west side of Wellington Road opposite Weston Street) and William Horton [1818-1891] (a lawyer who lived on the south side of what is now McClary Avenue).

On January 31, 1848 William Weston, now called a yeoman, bought a part of lot 24 in the broken front concession of Westminster Township, adjoining his property (the north west corner of number 59 Weston Street to the north west corner of Weston and Trevethen Streets) from Albert Scriver Odell, a farmer [1793-1856] for £40. 12s. 6p. The deed was

witnessed by William McClary [1812-1893] (a land surveyor and civil engineer). This meant that William and Sarah Ann Weston owned a lot with a 214 foot frontage on Wellington Gravel Road and almost a quarter of a mile deep running east from the curve in Wellington Road, along the south side of Weston Street. The rear of the backyards on the south side of Weston Street was the southern limit of Weston's land. William Weston worked this land as a market garden. He and his family lived in a one storey log cabin somewhere on the property, probably on the high ground west of Foxbar Creek, facing Wellington Road. They had 3 acres in crops, 2 acres in pasture, 1 acre of orchards and 3 acres of woods.

On July 7, 1848 the *London Times* listed a number of letters 'remaining at the London Post Office, 1st July, 1848.' One was addressed to William Weston.

Sometime after 1850 Ann Weston married a merchant named John Walker (a J. A. Walker who was a commission merchant is listed in the 1864 directory at Horton and Simcoe Streets. He lived on Talbot Street) and George Weston married Anna Jane Adelaide Hayes who was born in Upper Canada in 1833.

On November 3, 1852 Sarah Ann Weston died at the age of 50. St. Paul's burial register lists her husband William as a pensioner. In the census of 1861 William Weston possessed 1 horse, 1 cow and 1 pig with a value of $44 and 2 carriages with a value of $40. He occupied 6 1/2 acres and Eliza Weston occupied 1/4 acre. In 1863 a family named Weston shared a pew at Christ Church with the Fellows family.

On Thursday, July 20, 1865 Eliza Weston married John Shopland in William Weston's log house on Wellington Gravel Road near Weston Street.

On July 16, 1867 Eliza Shopland died in Westminster Township at the age of 28.

On November 6, 1869, William Weston's granddaughter Lulu Mabel Hayes Weston was born to Anna Jane Adelaide Weston, the wife of George Weston who was a carpenter by this time. They lived on Hill Street. Their daughter was baptised at Christ Church. Their other children included: Georgia [a teacher from 1881 to 1884], Eliza [a tailoress in 1884], Katie, Addie and Charlotte (Lottie).

On May 7, 1871 William Weston died at the age of 71. His will appointed his son George and his daughter Anne Walker the executor and executrix of his estate. They were both living in London at that time. Sarah, Eliza and

William Weston were all buried in St. Paul's cemetery located near the Western Fair Grounds, east of Ontario Street and south of Dundas Street. Their remains were moved to Woodland cemetery when it opened in 1878.

On May 11 of 1871 John and Anne Walker sold their share of both portions of William Weston's land to George Weston. John Walker loaned George Weston the money to buy the property in the form of a mortgage on May 22, 1871. On the same date John Walker, who was living in the State of Illinois in the United States, acting on behalf of William Weston's estate and for George Weston and Anna Jane Adelaide Weston of Westminster and Anne Walker of Illinois, sold the eastern portion of Weston's land (the west side of Trevethen between Weston and Bond Streets) to Richard Frank [1799-Nov. 1, 1872] for $75. Richard Frank lived at Frank Mount, now Redeemer Lutheran Church on Frank Place at Wellington Road. The deed was witnessed by William Horton.

On June 20, 1872 George Weston took out a $750 mortgage on the western portion of his property (3 acres, 1 rood and 13 perches, Wellington Road to number 39 Weston Street) with the Huron and Erie Savings and Loan Society. On July 6, 1872 George Weston paid John Walker $500, discharging the mortgage held by Walker on the Weston Street property. On April 25, 1873 George Weston took out a second $250 mortgage on the western portion of his property with the Huron and Erie. On Nov. 22, 1873 George Weston sold all his land to James Dagg, an innkeeper, for $1. Dagg sold the same land to Anna Jane Adelaide Weston, the wife of George Weston, for $1.

On December 10, 1873 a plaintiff named Green won a court case against a man named Weston. Weston was obliged to pay for a kiln of bricks worth $59.75. Weston had claimed that the bricks were 'not good and merchantable'. It is possible that George Weston was building a brick house on the east side of Wellington Road around this time. It would have been a replacement for William Weston's log house. The house would have been completed in 1874 since the assessment on the Weston property increased substantially in 1875.

In 1874 George and Adelaide Weston lived on the east side of Wellington Gravel Road, south of Weston Street. They paid taxes on 5 1/4 acres of land with an assessed value of $600. They had 5 children living at home and a dog. In 1875 they paid taxes on 6 acres with an assessed value of $1,100. There were 4 children living at home.

On February 8, 1875 George Weston's Huron and Erie mortgages were

assigned to Leonard Ardiel, farmer [1828–December 11, 1890] who lived at the corner of Adelaide and Oxford Streets. Weston owed the Savings and Loan Society $1,230. On November 5, 1878, the Court of Chancery issued the final order of foreclosure to George and Anna Jane Adelaide Weston for William Weston's land east from 59 Weston Street to Trevethen Street. The land was awarded to Leonard Ardiel.

In 1879 George and Anna Weston paid taxes on 6 1/2 acres of land on the south side of Weston Street at Wellington Road with an assessed value of $1,100. There were 5 children living at home.

In 1880 Georgia Weston boarded with George and Anna Weston on Wellington Road. Anna ran a grocery store at 340 Clarence Street.

On December 25, 1880, Katie Margaret Isabella Weston, a daughter of George and Anna Weston, died. They were living at 129 Clarence Street. In the same year George Weston disappeared from the Westminster Township assessment roll. He is listed in the 1880-1881 directory on Wellington Road south of Mill Street (Watson Street). Anna lived at 129 Clarence Street in 1881 and 1882. Georgia boarded with her there.

On October 22, 1881 Eliza Georgina Jane Weston (a daughter of Anna Jane Adelaide Weston and George Weston) married W. B. Longworth of the State of Michigan in the United States at Christ Church on Wellington Street.

On February 14, 1882 John Edward Weston of Glencoe (possibly a son of George and Anna Weston) married Annie McPhail of London at Christ Church.

In 1883 Georgia Weston, a teacher, lived in the Weston house on Wellington Road 10 houses south of Mill Street (Watson Street). Anna Weston lived at 524 Hill Street (4 doors west of William Street) in that year.

The 1884 and 1885 Westminster Township assessment rolls list Mrs. Weston with 3 children occupying 6 1/2 acres of land jointly with Leonard Ardiel. The property was now assessed at $1,700. This would suggest that George Weston died some time between 1881 and 1883 when he was between 46 and 48 years old.

The 1886 City directory lists Anna on lot 25 in Westminster and at 567 Richmond Street where she ran a confectionery. In 1887 Annie Weston, widow of George, was living at 341 Clarence Street. Addie, Charlotte and Lulu Weston boarded with her. In 1888 and 1889 she was living at 116 Carling Street with Lottie (Charlotte) and Lulu. In 1890 she was living at 255

Horton Street with Lulu who worked as a clerk at T. G. Whiskard. Around that time Anna moved to Detroit where she lived at 151 Perry Street.

Anna Jane Adelaide Weston died in Detroit on May 29, 1895 at the age of 62. She was buried in Woodland cemetery. There is no marker on her grave. She was survived by Charlotte, Lulu and Addie Weston and Eliza Longworth.

The Weston family lived beside Weston Street for 46 years (c.1840 to c.1886). Weston Street is named after William Weston. It is called Weston Street roadway on Samuel Peters' registered plan #312 of June 28, 1873. It was called Providence from 1877 to 1878. William Weston had lived south of what is now Weston Street for 6 years when John Gumb bought the land to the north of his property. William would have been a neighbour of Leonard Bartlett Senior as well. George and Adelaide Weston would have been neighbours of Thomas Knowles Senior and Elizabeth Knowles.

Appendix Two

The Gumb Family

John Gumb, born 1793, brickmaker and blacksmith, emigrated from England around 1845 with his children: William, born 1825, Thomas (a blacksmith), born 1828, twins Daniel and Richard (a brickmaker), born 1829, and Caroline, born on August 15, 1834. They were all members of the Church of England.

On December 14, 1848 John Gumb bought part of the north half of lot 25 in the broken front concession of Westminster Township from James Brakurridge Strathy [born in Scotland 1813 - died in Kingston 1896], (customs officer in the Town of London) from about number 90 Wellington Road to Weston Street then along Weston Street to the south east corner of number 38 Weston Street for £200. Thomas Gumb loaned him £500 to buy the land. On October 1, 1849 he bought part of lot 24 in the broken front concession of Westminster Township from Albert Scriver Odell [farmer 1793-1856] (from the south west corner of 48 Weston Street to the south west corner of Weston and Trevethen Streets) for £100. Thomas Gumb loaned him £150 to buy that land. The two loans from Thomas were paid off on August 19, 1850.

By 1849 John Gumb owned all the land along the south bank of the Thames River from Wellington Road to Trevethen St., and along the east side of Wellington Road from 2 houses south of Watson Street to Weston Street.

The Gumb family settled on what is now the north side of Weston Street, and what was then at the end of a long lane, off the east side of Wellington Road. The lane crossed Foxbar Creek which ran through a steep valley (Weston Street hill just east of Wellington Road). They lived in a one storey frame house overlooking the Thames River. They owned 17 acres of which 12 were in pasture.

In the census of 1851 John Gumb is listed as a widower and a brickmaker. William and Daniel are listed as labourers, and Caroline is listed as a housekeeper.

DEEDS/ABSTRACTS

On August 28, 1851 John Gumb sold all of his land in Westminster township to George W. Strathy of Toronto, possibly the brother of James B. Strathy, for £200. On March 22, 1852 John Gumb bought back all of the land from George Strathy for £200.

The assessment roll for the Town of London in 1854 showed John Gumb owning 3 properties on lot 15, on the south side of King Street (midway between Ridout and Talbot Streets). Thomas Gumb was a tenant at one of these addresses.

On June 11, 1855 John Gumb hired Samuel Peters, Provincial Land Surveyor, to survey and sub-divide Gumb's portion of lot 24 into 5 sub-lots. The plan was registered in the Middlesex County Registry Office on October 14, 1865 by Samuel Peters of London and John Gumb of Nissouri.

On June 16, 1855 John Gumb sold sub-lot 3 (part of number 62 to part of number 72 Weston Street) to Henry Fairhall, a maltster, who had married Caroline Gumb. Fairhall was born in England on December 12, 1829. In June he also sold sub-lot 5 (number 48 to part of 54 Weston Street) to Thomas Gumb.

On August 27, 1855 John Gumb sold the northerly part of lot 25 to his sons William and Daniel, for 5 shillings. It seems that on December 5, 1855 John Gumb and his wife sold the same part of lot 25 to all their children, but the name of Mrs. Gumb never appears. The Middlesex County Registry Office abstract lists 'John Gumb and wife' as grantors of '6 acres more or less' to grantees 'William Gumb et al.'

On July 26, 1856 John Gumb sold sub-lot 4 (part of number 54 to part of number 62 Weston Street) to Richard Gumb. On December 24, 1856 he sold sub-lot 1 to Richard Gumb (numbers 80 and 82 Weston Street) and sub-lot 2 to Thomas Gumb (part of number 72 to number 78 Weston Street) for £500. Thomas Gumb is called a blacksmith on the deed.

The 1856 *Middlesex Gazetteer* lists: Daniel and William Gumb on Concession B, lot 25 and Richard Gumb and Henry Fairhall on lot 24, Concession B in Westminster Township.

Around 1859 John Gumb moved to West Nissouri with his sons William, Daniel and Thomas. In 1864 Daniel and Thomas A. Gumb occupied lot 23 on the 6th concession of Nissouri. Richard, who had married Catherine or Christina, born in Canada East in 1827 (she couldn't write), and their children: William born in 1850, Mary born in 1853 died in July 1855, Caroline born in August 1855 died in October 1855, Alfred born in 1856, Elizabeth

born in 1857, Emily F. born in 1858 and Richard Junior who died in 1862, continued to live on sub-lot 1 or 2 (part of 72 to number 82) on what is now Weston Street. Their family had become members of the Methodist Church by 1861 but the deaths of three of their children were registered at St. Paul's Cathedral (Anglican).

Caroline (Gumb) Fairhall, Henry Fairhall and their daughter Mary born 1856 also remained on Weston Street, where they lived in a one storey brick house on sub-lot 3 (part of 62 to part of 72 Weston). They were Anglicans and probably members of Christ Church (built 1862/1863) on Wellington Road at Grey Street.

In the 1861 census Robert Gumb, born in Canada West in 1827 and a member of the Church of England, is listed as an occupant of Westminster Township.

On February 11, 1863 Daniel Gumb sold his share of the northerly part of lot 25 to William Gumb. In July 1863 William Gumb died at the age of 48, leaving his estate to his brothers and sister. By this time Thomas Gumb had married a woman named Jane who was born in Upper Canada 1829 and Daniel had married a woman also named Jane who was born in Upper Canada.

On September 27, 1864 Daniel Gumb, Thomas Gumb, their father John and the Westminster Gumbs and Fairhalls sold their portion of lot 25 to George Mignon Innes [1826-1903], who later became the Dean of St. Paul's Cathedral, for $600. In 1863 he was the founding minister at Christ Church on Wellington Street. Mrs. Gumb must have died by this time since the wives of the Gumbs are all listed on the bargain and sale document to Innes except for her.

On December 9, 1863 Richard and Christina (Catherine) Gumb sold part of sub-lot 1 (number 82 Weston Street) to Volney McAlpine, who was a dentist living in Westminster, for $175.

On October 2, 1865 Henry and Caroline (Gumb) Fairhall sold sub-lots 3 and 4 (part of number 54 to part of number 62 Weston Street) to Leonard Bartlett, market gardener [1828-1904]. On November 7, 1866 their mortgage on sub-lots 3 and 4 was assigned to Lieutenant Colonel John Barton Taylor, the eventual owner of John Gumb's part of lot 25 (Taylor and his family were members of Christ Church). He and his wife would have had Irish accents. Caroline was 33 years old in 1866 and Henry was 37. The Fairhall family moved to West Nissouri Township around 1867. In 1868 they occupied lot 21

on the 5th concession in Nissouri Township (near St. Ives).

In 1867 Thomas and Jane Gumb sold sub-lot 5 (number 48 to part of number 54 Weston Street) to Leonard Bartlett for $110. Thomas was 39 years old and Jane was 38.

On October 31, 1868 Richard and Christina (Catherine) Gumb, who were now living in Desoto, Wisconsin, sold part of sub-lot 1 and all of sub-lot 2 (part of number 62 to number 80 Weston Street) to John Mellis of Westminster Township for $350. Richard was 39 years old and Catherine was 41.

John Gumb died sometime between 1863 and 1871 probably in West Nissouri Township.

The 1871 census lists Thomas Gumb, farmer 43, Jane Gumb 42, and their children: John [farmer 1851-1927], Caroline [1851-?], Thomas [farmer 1853-?], and Alice [1859-?], all living in West Nissouri.

John Gumb [1851-1927] married Emma Harris [1852-1927]. He died on May 28, 1927 at the age of 76. She died on March 16, 1927 at the age of 76. They had a son John Gordon Gumb [1888-1927]. He died on July 10, 1927 at the age of 39. He was the great grandson of John Gumb. In 1875 Thomas Gumb had moved to Concession 4, Lot 35 in West Nissouri. In 1880 Daniel Gumb occupied 1/4 of Lot 23 in the 4th Concession of West Nissouri. John Gumb [1851-1927] (the son of Thomas), Thomas [1828-?], Thomas Junior [1853-?] and Thomas Gumb III? each occupied 1/4 of Lot 34 in the 4th Concession. In 1881 Daniel Gumb occupied lot 23 in the 4th Concession, John Gumb occupied lot 31 on the 4th and Thomas Gumb occupied lot 34 on the 4th Concession. In 1884 John Gumb had moved to Lot 34 on the 4th. In 1886 another J. Gumb was on lot 34. In 1887 Thomas Gumb (the son of Thomas) also occupied lot 34 and in 1888/1889 James Gumb occupied lot 23 in the 4th Concession with Daniel Gumb.

The Fairhalls (now spelled Fairall) remained on Lot 21 in the 5th Concession. Henry Fairhall died on December 9, 1906 at the age of 77 and Caroline died on January 8, 1911 at the same age. They were both buried in the Vining Cemetery, lot 8, concession 5, in West Nissouri Township.

John [1851-1927], Emma [1852-1927] and John Gumb [1888-1927] were all buried in Mount Pleasant Cemetery. They may have moved to London after 1890. There are still members of the Gumb family living in West Nissouri in 1991. There is one Gumb, Joanne, in the London phone book in 1991. She is a descendent of the John Gumb who emigrated to Canada with his family around 1845.

The Gumb family lived on Weston Street for about 20 years (c.1848 to c.1868).

There is one Gumb descendant listed in the London section of the 1992 London telephone directory. Two Gumb descendants are in the Thorndale section of the phone book. One Fairhall descendant is listed in the Thorndale section.

Appendix Three

The Bartlett Family

Leonard Walter Burt Bartlett was born in 1827 to Mrs. Hunt. He emigrated from the Isle of Wight to London, Upper Canada in 1854 with his brother Samuel G. Bartlett, his sister-in-law Mary Bartlett, their children and the children of another brother, William Bartlett, who had died in Jersey in 1854.

In the London Directory of 1856 Leonard Bartlett was listed as a plasterer living on Simcoe Street at the corner of Waterloo. John Bartlett was listed as a bricklayer at the same address. Samuel Bartlett was listed as a tanner at Coyne's. His home was in Westminster Township.

In Upper Canada Leonard Bartlett married Rachel Dawson who was born in 1831 in Westminster Township. Her mother, who was born in United States, was of German descent and her father, who was of English descent, was born in New Brunswick. In 1864 they purchased sub-lots 3 and 4 of John Gumb's registered plan 206 (part of number 54 to part of number 72 Weston Street) from Henry Fairhall and Caroline (Gumb) Fairhall. It appears that John Barton Taylor [Ireland 1830-Winnipeg?] the owner of sub-lot 7, plan 312, held a mortgage on the Fairhall's property and that Leonard Bartlett acquired sub-lots 3 and 4 from Taylor. They may have lived in the Fairhall house which was a one storey brick structure on sub-lot 3 (part of number 62 to part of number 72 Weston Street). A brick barn was built on the north edge of Weston Street in front of their house. The side-walk on Weston Street still ends where their barn stood. The barn was torn down in the 1930's and the house was torn down in 1970.

On August 20, 1867 they purchased sub-lot 5 from Thomas Gumb for $110.

In the 1871/72 directory Leonard Bartlett was listed on lot 22 (?) in the broken front concession of Westminster.

In 1872 Leonard Bartlett worked as a bricklayer. He paid taxes on 3 3/4 acres of land with an assessed value of $400. There were 5 children living at

home and 1 dog. In 1876 their property was assessed at $650. In 1878 it increased in value to $800, perhaps because the brick barn was built then. In Polk's 1880-1881 London directory Leonard Bartlett is listed as a florist.

In the 1877-78 directory Samuel G. Bartlett was listed 'furniture and stoves, 239 Dundas, res[idence] the same.' and John H. Bartlett was listed 'builder, 217 Richmond, res[idence] the same.'

In 1881 the Weston Street Bartletts consisted of Leonard age 58, Rachel 56, Dora May born in Ontario 15, Oliver 14, Selina (Tot) 11, Leonard Junior 9, and Esther Victoria 10 months old [born May 1881]. Two other children, Charles and Mary, had died in infancy. On August 30, 1882 they purchased part of sub-lot 1 and all of sub-lot 2 (part of number 72 to number 80 Weston Street) from Alfred Robinson and his wife, except for the eastern half of sub-lot 1 (the west side of Trevethen Street) owned by George B. R. Frank (Eliza Bartlett paid taxes on 1/5 of an acre of sub-lot 2 in 1876). These lots were immediately west of the house at the north-west corner of Trevethen and Weston Streets. By this time Leonard and Rachel owned the north side of Weston Street from number 48 to the west side of Trevethen Street. The south bank of the Thames River was the north boundary of their property. They had 2 dogs.

On the 24th of May, Dora boarded the steam boat *Victoria* at Springbank Park but got off again before the boat sailed. The *Victoria* capsized near the coves and over 200 lives were lost. Leonard Bartlett went to the disaster and looked over the dead to try to find his daughter.

In 1884 the Bartletts paid taxes on 10 acres of land with an assessed value of $1,500.

In 1887 Oliver Bartlett was employed as a woodworker with John Campbell. From 1889 to 1893 Leonard Bartlett Junior worked as a pattern maker at the London Machine and Tool Company and Selina Bartlett worked as a grocery clerk, possibly at William Weatherhead's [Ireland 1829-London, Ontario, August 25, 1916] grocery store on the east side of Wellington Road, about 3 doors north of Weston Street, or at John Broomfield's [1847-August 30, 1906] grocery store near the north-east corner of Wellington and Weston. She had tuberculosis and died on December 29, 1897 at the age of 28. Oliver Bartlett, who was a carriage maker, died on August 28, 1898 at the age of 31.

Around this time Dora Bartlett married Marmaduke Steele. They lived at 7 Maryboro Place (now McClary Avenue) in 1898.

In 1893 Leonard Bartlett Junior became engaged to Sarah Jane Phillips

of Christ Church Anglican on Wellington Street at Hill. In the same year he became a candidate for the ministry of the Methodist Church, and the Sunday School secretary at the High Street Mission on Emery Street at High (this mission later became Calvary United Church). In 1896 he was appointed to Wesleyan Theological College in Montreal where he took prizes in Hebrew and other subjects.

On March 28, 1898 Leonard Bartlett Senior sold the western portion of sub-lot 1 and all of sub-lots 2, 3, 4, and 5 to Leonard Bartlett Junior, who was a student in Montréal, Québec (at Wesleyan Theological College), for $1. His mother and father were given life states to the property, that is, they could live there for the rest of their lives. Oliver was given half an acre to work for his own benefit and if his parents died he was to be given the whole of the property to work for the rest of his life. Oliver, who had tuberculosis like his sister, only lived for 5 months after this transaction.

Leonard Bartlett Junior assumed three mortgages held by the London Loan Company. Leonard Junior was then assigned to Chatham where he was ordained and where he asked to be left without a station so that he could refund his school debts and help pay off his father's debts.

Leonard Junior married Sarah Jane Phillips at Aylmer in August of 1898, the same year he was ordained. They had five children: Sheldon born in December 1899 at Ravenswood, O. Russel born in 1903 at Windsor, Wallace born in 1904 at Woodham, Vera born January 30, 1907 at Tupperville, Mary born in 1909 at Dungannon. Sheldon took his Bachelor of Divinity at Albert College, Belleville and Montreal. In 1924 he married Albina Quesnel. They moved to Saskatchewan in 1928. In 1964 Russel, who had married Frieda McClary sometime after 1917, was a doctor in Windsor. Wallace lived in Toronto (he had married Lillian Lowrie of Tillsonburg around 1929). Vera was married to F. W. Haight and living in London, Ontario. Mary had married George Simms in 1929 and was living in Chatham.

On January 20, 1900 Esther (Etta) Bartlett bought the westerly 12 feet of sub-lot 3 and all of sub-lots 4 and 5 (Number 48 to number 62 Weston Street) from Leonard Junior and Sarah Jane Bartlett for $620. Leonard Junior was by then a clergyman living at Ravenswood (near Ipperwash). Esther married Charles R. Ayars in 1900. She was 19 years old. In the same year 54 Weston Street was built for Charles and Esther, probably by Esther's brother-in-law Maramaduke Steele. They eventually had two daughters: Myrtle and Lena.

In 1901 Maramaduke Steele bought the south side of Weston Street from the west boundary of lot 24 to Trevethen Street; he built 59 Weston Street on the lot and he and Dora May Steele moved in shortly after. Both sisters' houses were made of yellow brick, two and a half storeys high, with ornate wooden verandahs. 59 Weston Street had stained decorative glass windows on the ground floor and in the double front doors.

In 1903 Leonard Bartlett Junior's biography of Uncle Joe Little (Reverend Joseph Russell Little) was published by the William Briggs Company of Toronto. Around this time he also took a correspondence course in architecture, as a result of which he planned and designed several churches.

Leonard Bartlett Senior died on November 21, 1904 at the age of 77 years. Rachel Bartlett died on June 29, 1906 at the age of 75.

In 1907 Leonard Bartlett Junior left 66 Weston Street. In 1913 Leonard Bartlett Junior sold sub-lots 1 and 2 (part of number 72 to number 80 Weston Street) to Lorenzo and Nova R. Proctor for $1200. In the same year Charles Ayars left 52 Weston Street.

On December 24, 1918 Leonard Bartlett Junior, who was then living in Arva, made a declaration regarding sub-lots 1, 2, 3, 4, and 5. He sold sub-lots 1, 2 and the remaining part of sub-lot 3 (number 64 to 80 Weston Street) to Francis Nichol on that date for $3500. Leonard Junior was 46 years old.

In 1927 Esther Ayars sold the easterly 12 feet of sub-lot 3 and sub-lots 4 and 5 (number 48 to part of number 62 Weston Street) to John Daley for $3000. She was then living in Toronto. Her occupation is given as a nurse on the deed. She was 47 years old.

Dora May (Bartlett) Steele died on December 9, 1934 at 59 Weston St. She was probably the last of the Bartlett family to live on Weston St.

Sarah Jane Bartlett died on April 9, 1936 on Briscoe Street in London. On Easter 1937 Leonard Bartlett Junior married Ida Elizabeth (Manning) Weldon [1877-1950]. She died on June 8, 1950 at Belmont, Ontario. She was 73 years old. In 1951 he married Rowena O. Owen (Mrs. W. Stanley Owen) [1889-1981] at Blenheim.

Leonard Bartlett Junior died at Thamesville on July 4, 1963. He was 91 years old. Rowena O. Bartlett died on November 2, 1981 at Chatham, Ontario. She was 92 years old.

The Bartlett family lived on Weston Street for about 70 years (c.1864 to 1934).

Appendix Four

The Knowles Family

Some time before 1864 Thomas Knowles Senior, a machinist who was born in 1841, and Elizabeth Knowles his wife, who was born in 1843, emigrated to Canada from England.

Joseph Squires Knowles, born 1839 and his wife Sarah Jane Knowles, born in 1841 to a Scottish father and an English mother, emigrated some time before 1879. He was possibly the brother of Thomas. He first appears in the London directory of 1881-1882 where he is listed as a 'laborer' living on Victoria Street west of George Street.

On July 3, 1873 Thomas Knowles Senior purchased sub-lot 5 on Weston Street from John Barton Taylor [Ireland 1830-Winnipeg?] (part of number 10, the present location of the Moose Lodge to number 16 Weston) for $150. On September 4, 1875 he purchased sub-lot 7 from Taylor (the present location of numbers 34 and 38 Weston Street) for $200. Some time around 1875, the Knowles homestead was built on the present site of the Moose Lodge at 10 Weston Street. It was a 1 1/2 storey red brick house. A small frame house may have been built before that, just east of the homestead. In 1887 Thomas Knowles is listed as living at Providence in Westminster Township. Leonard Bartlett's address is the same. In 1880 Thomas Knowles Senior worked as a machinist for E. Leonard and Sons. In 1886 he worked as a machinist for J. Elliot and Sons. In 1887 he was back with Leonard.

In 1876 Ann Foot emigrated to Stratford, Ontario with her parents. She had been born in London, England in 1866. In 1886 she moved to London, Ontario.

In 1881 the following members of the Knowles family lived on Weston Street: Thomas Senior born 1841, Elizabeth the wife of Thomas Senior born 1843, their children: John born 1864 in Upper Canada, Thomas Junior born 1866 in Upper Canada (from 1884 to 1887 he worked as an engraver at the *London Free Press*), Joseph born 1868 in Ontario (in 1886 and 1887 he worked as a lithographer for the *London Free Press*), Arthur born 1871 in

Ontario, Theodore born 1872 in Ontario, Elizabeth born 1873 in Québec (she married a man named Vernon and then a man named Beanom and was living in Vancouver, British Columbia in 1954), Sarah Jane born 1877 (in 1894 she was a lithographer, in 1897 a milliner, in 1898 a clerk at T. J. Whiskard Co.) and Frederick born in 1879 in Ontario. Another son Ernest E. was born in 1887.

On May 13, 1882 Joseph Squires Knowles died at the age of 43. Sarah J. Knowles, his widow, appeared in the 1883 directory on Victoria Street west of Talbot Street. In 1884 she had moved to Richmond Street one house north of Oxford Street. On February 19, 1885 their son Harry Knowles [1877-1885] died at the age of 8. In 1886 Sarah had moved to Wellington and Clarke Streets where she worked as a dressmaker until 1887. In 1890 Sarah Jane Knowles opened a grocery store at the south-east corner of Wellington Road and Clarke Street (Grand Avenue East, near the present location of a large billboard). She lived at the same location.

From 1879 to 1907 her son Robert Knowles [1879-?], a machinist, lived with her. He worked for Arthur Knowles on High Street, who was possibly his first cousin, from 1897 to 1899. In 1900 he worked for the London Foundry. He worked as a machinist from 1901 to 1907 at which time he disappeared from London directories until 1915 when he worked as a painter at the Signery until 1917. He then lived at 6 Euclid Avenue. In 1918 he worked at Hyman's Tannery.

From 1881 to 1903 Margaret (Maggie) Knowles [1881-?], the daughter of Sarah Jane Knowles, a student in 1898 and then a book keeper at the Wray Corset Company in 1903, also lived with her. On October 22, 1903, Robert Knowles purchased lot 13 (the present location of Dobbin Printing) from Jane Wright of Luton, England for $1000. In 1906 Sarah Jane Knowles moved across the street to lot 13 at the north-east corner of Grand Avenue and Wellington Road. The grocery store no longer appears. In 1907 she disappeared from the City directory. On February 20, 1915 Robert Knowles and his wife, Ida Muriel Knowles, sold the same lot to Richard Cullis for $1,400.

A John Knowles lived with Sarah Jane Knowles ,the grocer, in 1890. He was a stoker at Knowles & Co. lithographers. In 1893 he worked as a farmhand. He may have been the oldest son of Thomas Senior and Elizabeth Knowles. John died sometime before 1926.

In 1888 and 1889 Thomas Knowles Junior operated Knowles &

Company Lithographers with Herbert A. Sabine at 215 Dundas Street. The Company employed Joseph and Theodore as lithographers.

In 1890 Thomas Knowles Junior married Ann Foot. On June 17, 1890 Thomas Knowles Senior sold sub-lot 7 (numbers 34 and 38 Weston Street) to Thomas Knowles Junior, lithographer, his 2nd oldest son, for $400.

Around 1890 Thomas Knowles Junior and Joseph Knowles were members of the Forest City Bicycle Club of London. There were 6 bicycle clubs in London at that time. The Forest City Bicycle Club was the first ranked club of the Canadian Wheelmen's Association. It had 32 members in 1897. In a group photograph from around this time, both Thomas and Joseph Junior are described as lithographers. They are both wearing medals. Thomas is about the same height as Joseph. They appear to be about 5′ 8″. Joseph has a moustache and Thomas Junior has a brush cut. Other members in the photograph include: Emma Saunders, her husband William Saunders, Arthur Stringer, the author, and Corbin Weld of the Farmer's Advocate. The membership shown in the photograph is notable for the number of prominent London families represented.

The photograph includes an ordinary and a safety bicycle as well as a safety tandem. All three bicycles have solid tires. Pneumatic tires were introduced in 1888 and solid tires had disappeared by 1895. The safety bicycle in the photograph resembles the Singer cross frame safety bicycle which was introduced in England in 1888. It has a curved frame tube which follows the shape of the rear wheel, the seat post fits into a sleeve in the top tube (it isn't an extension of the seat tube as in modern bicycles). Both wheels on this machine are radially spoked. This style of spoking gradually disappeared during the 1890's in favour of tangential spoking. In 1891 Thomas Knowles Junior lived at 341 Simcoe Street. In 1892 he lived beside George Watson on the east side of Wellington Road, two doors south of Watson Street. He worked as an engraver for Lawson and Jones.

In 1891/1892 the Knowles Lithography shop was built at 38 Weston Street for Thomas Knowles Junior and Joseph Knowles. In 1893 Litho Villa was built at 34 Weston Street for Thomas Knowles Junior and his wife Annie Foot. Thomas Knowles Junior was the proprietor of Knowles and Company lithographers and Thomas Knowles lived on sub-lot 5 on the site of the Moose Lodge. In 1904 the phone number for Knowles and Co. was 825. This property would stay in the Knowles family until May 3, 1930 when Thomas Milton Knowles, the grandson of Thomas Knowles

Senior, sold it to Muriel Featherston for $25.

On September 1, 1891 Arthur Knowles, the 4th oldest son of Thomas Knowles Senior and Elizabeth Knowles, purchased sub-lot 4 from Elizabeth Flower (the present location of: Cliff Parkin Flowers, Tak Sun, Curry's and the Moose Lodge parking lot) for $650. In 1893 Henry Payne acquired sub-lot 4 from Arthur Knowles when the mortgage he held wasn't repaid. Arthur married Sarah Amelia Greason [1861-1948] some time before 1897. He lived at 495 Bathurst Street in 1891, on Wellington Road in 1893 and at 1 door east of Wellington on Weston Street in 1894. In 1893 Arthur Knowles was a finisher for Essex Brass. From 1894 to 1895 he was a partner in the Knowles and Nipher Machine shop at 184 Bathurst Street. They manufactured laundry machinery, lithograph machinery, electric elevators and so on. Their phone number was 1046.

On August 28, 1897 Thomas Knowles Senior purchased sub-lot 4 from Henry Payne for $405.

In 1894 Ellen Knowles, the wife of Joseph Knowles, lithographer, purchased sub-lot 6 (the present location of numbers 18, 20 and 30 Weston Street) from William Weatherhead and Eliza Jane Weatherhead for $1,300. Joseph was the 3rd oldest son of Thomas and Elizabeth Knowles. He was born in 1868 in Ontario. The 1895 directory shows The Ontario Litho Co. on or near Thomas Senior and Elizabeth Knowles' location (The Moose Lodge). Joseph Knowles was the proprietor of this company. It appears to have existed for one year. Joseph Knowles disappears from the directories in 1895. In 1894 Ellen Knowles, the wife of Joseph Knowles and daughter-in-law of Thomas Knowles Senior, sold sub-lot 6 back to William Weatherhead. In 1926 Joseph Knowles was living in Birmingham, England. He was still living in England in 1933. He moved back to Canada some time after that and lived at 1 High Street. Joseph Knowles died at St. Mary's Hospital in London, Ontario on April 26, 1954 at the age of 86. His second wife Nellie Fields had pre-deceased him. He is buried with the family of Arthur Knowles. His stone reads 'Uncle Joe.'

By 1894 members of the Knowles family owned the north side of Weston Street from Wellington Road west to the original road allowance between lots 24 and 25 (the east side of 38 Weston Street).

The 1894 City directory showed Weston Street as follows: 'NORTH SIDE Knowles, Arthur. Knowles, Thomas. Knowles, Joseph. Knowles, Thomas. Jr. Knowles & Co, lithogrs. Vacant lots.' Thomas Senior, Robert and Arthur

were all listed as machinists, Thomas Junior, Frederick, Lilly and Joseph were all listed as lithographers. Sarah Jane, youngest daughter of Thomas and Elizabeth, was listed as a milliner.

Elizabeth Knowles, the wife of Thomas Knowles Senior, died on December 27, 1896. She was 54 years old.

By 1900 only Thomas Knowles Senior (at number 10), his daughter Elizabeth [age 19], and Thomas Knowles Junior, Annie Knowles and their children: Thomas Milton Knowles [age 8] and Ann E. [1898-August 19, 1902] (at number 34) lived on Weston Street. By 1914 Thomas Milton Knowles was the manager of the Fine Art Company at 34 Weston Street.

By 1897 Arthur and Sarah Amelia had moved to an eccentric house surrounded by a wrought iron chain fence with a frog motif at number 1 High Street on the west side at Clarke's Bridge. His machine shop was located one door south, at the corner of Front Street west. They lived in a brick building beside the bridge with their children: Pearl [1891-December 28, 1892], Mabel Kirby: clerk London Crockery 1909, saleslady London Crockery 1915, book keeper London Newspaper Subscription Service 1922, book keeper *London Advertiser* 1923 (lived in Detroit 1953), Mary: timekeeper 1910, Adeline (Addie) McManus: clerk 1910 (lived in Lake North, Florida in 1953), Sara V. (Sadie) Sceli: forelady Shuttleworth Co. 1915 (lived in St. Paul, Minnesota in 1953), Theodore E. (machinist 1917) [killed in plane crash in the US in 1936?], Edna V. Lichtle (lived in South Orange, New Jersey in 1953), Arthur [March 1900-April 28, 1900], Leola or Leaola Graae: timekeeper in 1921, [1902-1984 London, Ontario], Albert Edward [machinist, April 12, 1905-1991], Gordon N. [1908-June 2, 1909], Lily May [August 29, 1909-November 11, 1917], and Verna Rosaland [October 21, 1911-August 31, 1919]. Their phone number in 1905 was 1917.

Arthur appears to have rented 1 High Street from the executors of the estate of John B. Elliot until Sarah Amelia Knowles purchased the property on November 23, 1906 for $1200.

Sarah Amelia Knowles died on September 27, 1948 at the age of 77. Arthur Knowles retired in 1948 and he died on August 29, 1953 at the age of 80. He and his wife were both Anglicans. They attended Christ Church where Albert, Lily May and Verna Rosalind were baptised. Leola, Mabel and Edna were the executrices of Arthur Knowles' estate. They sold 1 High Street to Violet Knowles on September 30, 1954 for $8,000.

Theodore Knowles, a fashion artist, born in 1880 (5th oldest son of

Thomas Knowles Senior and the late Elizabeth Knowles) granted a mortgage on sub-lot 5 to his father, Thomas Knowles Senior, in 1922. Theodore lived at 12 Weston Street from 1921 to 1923. He worked in pastels and did some commercial design as well as fashion illustration. He became a Christian Scientist.

On October 5, 1925 Thomas Knowles Senior sold sub-lot 5 to 'Theodore Knowles, of the Town of Bogota, in the State of New Jersey, One of the United States of America, Artist, (formerly of the City of New York, in the State of New York)', for $450.

On March 2, 1928 Theodore sold the west 7 feet of sub-lot 5 to Annie Knowles, his sister-in-law, for $1. Annie sold the same part to Thomas Milton Knowles in 1953. The Moose Lodge bought the west 7 feet from Milton's estate on January 4, 1966.

In 1917 Thomas Knowles Junior moved out of 34 Weston Street and his son Thomas Milton Knowles moved in. Thomas Milton Knowles went into partnership with his father in the lithography shop at 38 Weston Street. Around 1920 the shop name changed to T. M. Knowles Lithographers and Printers. The phone number of T. M. Knowles Printers in 1921 was 1865J.

In the 1920's Thomas Milton Knowles married Amelia Louise Mary Short who had lived across the street at number 25 Weston Street. In 1922 T. Kenyon Knowles, a student, lived with T. Milton Knowles at 34 Weston Street. From 1923 to 1925 Thomas Milton Knowles lived at 489 Tecumseh Avenue. On August 1, 1927 Thomas Milton Knowles bought the east 57 feet of sub-lot 7 (number 38) from Emma Lee Saunders for $1,400. She had held various mortgages and ended up owning the property for a time. She bought back 38 Weston Street in 1930. In November 1933 she sold 38 Weston Street to the proprietors of the Triangle Printing Company, Metcalfe 8671, for $1,750.

Thomas Knowles Senior died in Victoria Hospital on Sunday, April 25, 1926 at the age of 85.

Thomas Knowles Junior died in Victoria Hospital on Friday, February 3, 1933 at the age of 67. At the time of his death his brothers Theodore and Ernest were living in New York City, Joseph was living in England, Ernest was living in Hartford, Conn., US, Arthur was living in the city and his sister Elizabeth Vernon was living in Vancouver.

In 1934 Thomas Milton Knowles, a dark, heavy-set man, moved into a brick building on sub-lot 4 at the rear of 6 Weston Street, just west of a small

frame house covered with tar paper, on the present site of the Moose Lodge. The Knowles homestead was torn down and the Knowles Lithography Company moved to number 6 Weston Street on sub-lot 5 beside Foxbar Creek. In the same year the City of London obtained all of sub-lot 4 by tax deed. The phone number of Knowles Litho in 1935 was Metcalfe 1266. In 1944 Thomas Milton Knowles and Amelia L. M. Knowles purchased the east 33 feet of sub-lot 4 from the City of London for $300. On January 4, 1966 The London Moose Lodge #1205 bought the Knowles property from the executors of Thomas Milton Knowles' estate.

On August 18, 1927 Duchess Maxine was born to Violet Mary Knowles (Gardner), the wife of Albert Edward Knowles. They lived at 8 Weston Street, near the present location of the Moose Lodge. Albert was the son of Arthur Knowles and the first cousin of Thomas Milton Knowles. On June 19, 1929 Gardner Knowles was born to Violet Knowles. They then lived at 1 High Street.

On February 26, 1944 Albert Knowles bought 38 Weston Street from Frank E. Wilson on October 29, 1943 for $2,000. Wilson had bought it from John Bayne, proprietor of the Triangle Lithographing Co. on October 29, 1943. Bayne's shop had been devastated by fire on Saturday, August 14, 1937. Albert bought the west half (number 34) on March 26, 1944 from Muriel Robinson Saunders Fetherston [1890-1943] for $2,100. Muriel Fetherston was the daughter of Emma Saunders (a member of the Forest City Bicycle Club in 1890). Albert Knowles operated the Knowles Machinery Co. at 38 Weston Street. He obtained defense contracts, and after the war he built freight elevators. The phone number of Knowles Machinery Co. in 1944 was Fairmont 3565. From 1941 to 1944 he and his wife Violet (Vi) lived at 117 Wortley Road, Metcalfe 4922. Albert Knowles moved into 34 Weston Street in 1945 and lived there with his wife and their son Gardner Knowles [1928-July 25, 1986] and daughters: Maxine (Johnson) [1927 - lived in El Paso, Texas, US in 1991], Joy (Tally) [lived Virginia Beach, Virginia, US in 1971] and Beverly (Smith) [died c.1980 in London, Ontario]. Gardner worked in the machine shop in the 1940's and early 1950's. In 1948 Albert took over his father's business.

In 1960 Albert Knowles' business failed. He left 38 and 34 Weston Street and moved to his father's machine shop at 1 High Street. The Royal Bank foreclosed on his mortgages, took possession of 34 and 38 Weston Street, and severed sub-lot 7 into 2 properties. His wife opened V.K. Antiques

around that time at the front of the machine shop on High Street. Vi Knowles was a formidable, practical, stout woman with grey hair. She seemed realistic, unsentimental and shrewd. She sold antiques, used furniture, appliances and junk. Her husband, a small man, was quietly in the background and her stock was stored in part of his machine shop. The antique store occupied the east side of the machine shop. It had a narrow store front with the entrance on the left. The front door was an aluminum storm door. The machine shop had skylights running from east to west. It seemed to be made out of a combination of wood, concrete and steel girders. Much of it was run down and unused in 1962. Violet Knowles died on October 7, 1971 at the age of 67.

In February 1991 I located Albert Knowles after phoning all the London and Lambeth Knowles' listings in the phone book. When he answered his phone he gave me an address on Adelaide Street. The person at that address had never heard of him. When Linda Davey and I checked out his old address on Dundas Street (an apartment block built on the site of James Strathy's home), we were told that he had moved to the Dearness Home. It was there that we met and interviewed him. In March 1991 Albert Knowles was a small, grey-haired man, about 5 1/2 feet tall with a slight frame. His head was rather narrow with a prominent forehead. His conversation contained periods of lucidity followed by periods of confusion or incomprehension. Albert died at the Dearness Home on June 26, 1991 at the age of 86.

Thomas Milton Knowles operated the Knowles Lithography Company at 6 Weston Street until his death on October 28, 1963 at the age of 71. His wife Amelia had died on February 23, 1961 at the age of 65. His mother Annie moved to the Dearness Home in 1963 where she was known as 'Granny.' She died there on August 26, 1968 at the age of 102. They were all members of Calvary United Church.

The Knowles family lived on Weston Street for about 91 years (c.1873 to c.1964). Thomas Knowles Senior was a neighbour of George Weston for about 5 years.

There are descendants of Thomas and Elizabeth Knowles living in London in 1992, but none of the Knowles listed in the London phone book are related to them. Albert Knowles was listed in the phone book until his death in June 1991.

Bibliography

Armstrong, F.H., H.A. Stevenson, and J.D. Wilson, ed.
1974 *Aspects of Nineteenth-Century Ontario*. Toronto. University of Toronto Press.

Armstrong, F.H., and D.J. Brock.
1974 The Rise of London: A Study of Urban Evolution in Nineteenth-Century Southwestern Ontario. In Armstrong, Stevenson, and Wilson, 80-100.

Avis, Walter S., et al.
1967 *A Dictionary of Canadianisms on Historical Principles*. Toronto. W.J. Gage.

BHC = Burton Historical Collection, Detroit Public Library, Detroit, MI.

Bremner, Archie.
1900 *Illustrated London, Ontario, Canada*. London. London Printing and Lithographing.

Canada
1891 *Indian Treaties and Land Surrenders (1680-1906)*. 3 vol. Queen's Printer. Ottawa (Reprinted by Coles Publishing Company, Canadiana Reprints, 1971).

The Canadian World Almanac.
1991 Toronto. Global Press.

Canniff, William
1971 *The Settlement of Upper Canada*. Belleville, Ont. Mika Silk Screening.

Carr, Lucien.
1884 On the Social-Political Position of Women among the Huron-Iroquois Tribes. *Peabody Museum of American Archaeology and Ethnology Report*, no. 3: 207-232.

Chapman, L.J., and D.F. Putnam.
1984 *The Physiography of Southern Ontario*. Toronto. Ontario Ministry of Natural Resources.

Clifton, James A.
1983 The Re-emergent Wyandot: A Study in Ethnogenesis on the Detroit River Borderland, 1747. In: *The Western District: Papers from the Western District Conference* (edited by K.G. Pryke and L.L. Kulisek), pp. 1-17. Essex County Historical Society. Windsor, Ont.

Crinklaw, Raymond.
1988 *Westminster Township*. Lambeth, Ont. The Crinklaw Press.

Crowfoot, Alfred H.
1957 *Benjamin Cronyn, First Bishop of Huron*. London, Ont. Synod of the Diocese of Huron.

Curnoe, W. Glen.
1976 *The London and Port Stanley Railway 1915-1965, a Picture History*. [London, Ont.].

DCB = Brown, George W., et al., eds.
1964 *Dictionary of Canadian Biography*. - vols. Toronto. University of Toronto Press.

Daillon, Joseph de la Roche
1981 Letter to a friend, 18 July, 1627. KEWA 81(4), pp. 2-7.

Dean, William P.
1984 *Economic Atlas of Ontario*. Toronto. University of Toronto Press.

Denke, Christian
1990 The Diaries of Christian Denke on the Sydenham River, 1804-
 1805. KEWA 90(5): 2-21.
1991 The Diaries of Christian Denke on the Sydenham River, 1805-
 1806. KEWA 91(7): 2-20.

Dodd, Christine F., et al.
1990 The Middle Ontario Iroquoian Stage. In Ellis and Ferris, 321-360.

Elliott, John K., and Terence W. Honey.
1979 *London Heritage*. London, Ontario. Phelps Publishing. Rpr.
 1991.

Ellis, Chris J., and Neal Ferris, ed.
1990 *The Archaeology of Southern Ontario to AD 1650*. London, Ont.
 London Chapter of the Ontario Archaeological Society.

Ellis, Chris J., and D. Brian Deller
1990 Paleo Indians. In Ellis and Ferris, 37-64.

Ellis, Chris J., Ian T. Kenyon, and Michael W. Spence.
1990 The Archaic. In Ellis and Ferris, 65-124.

Ferris, Neal
1989 *Continuity Within Change: Settlement-Subsistence Strategies and
 Artifact Patterns of the Southwestern Ontario Ojibwa AD 1780-1861*.
 Unpublished Master's Thesis, Department of Geography, York
 University. North York, ON.

Finos, P.L.
1991 The Surveyors General in Ontario. *The Ontario Land Surveyor*,
 Spring 1991: 32-36.

Fox, William A.
1990 The Middle Woodland to Late Woodland Transition. In Ellis and
 Ferris, 171-188.

Fraser, Alexander.
1906 *Third Report of the Bureau of Archives for the Province of Ontario*
 [1905]. Toronto. King's Printer.

Garland, M.A., and J.J. Talman
1974 Pioneer Drinking Habits and the Rise of the Temperance
 Agitation in Upper Canada prior to 1840. In Armstrong,
 Stevenson, and Wilson, 171-193. Geological Survey of Canada.
1864 *Report of Progress from its Commencement to 1863.* Montreal.

Goltz, Herbert C.W., Jr.
1983 The Indian Revival Religion and the Western District, 1805-
 1813. In Pryke and Kulisek, 18-32.

Goodspeed, W. (Publisher)
1889 *History of the County of Middlesex.* Toronto.

Gourlay, Robert Fleming.
1822 *Statistical Account of Upper Canada.* London.

Gray, Elma E.
1956 *Wilderness Christians: The Moravian Mission to the Delaware
 Indians.* Toronto. Macmillan.

Hamil, Fred Coyne
1939 Sally Ainse, Fur Trader. *Algonquin Club, Historical Bulletin* no. 3.
 Detroit.
1951 *The Valley of the Lower Thames.* Toronto. University of Toronto
 Press.

Heidenreich, Conrad E.
1990 History of the St. Lawrence-Great Lakes Area to AD 1650. In
 Ellis and Ferris, 475-492.

Hives, Christopher.
1981 *Flooding and Flood Control: Local Attitudes in London, Ontario.* MA
 Thesis, University of Western Ontario, London, Ont.

Hyatt, Alda
1967 *The Story of Dresden, 1825-1967*. Dresden, Ont. Dresden News.

Jacobs, Dean.
1983 Indian Land Surrenders. In Pryke and Kulisek, 61-67.

Johnson, Leo A.
1974 The Settlement of the Western District 1749-1850. In
 Armstrong, Stevenson, and Wilson, 19-35.

Jury, Elsie McLeod.
1974 *The Neutral Indians of Southwestern Ontario*. Museum of Indian
 Archaeology Bulletin no. 13. University of Western London, Ont.

Kah-ke-wa-quo-na-by [Peter Jones]
1860 *Life and Journals of Kah-ke-wa-quo-na-by (Rev. Peter Jones),
 Wesleyan Missionary*. Toronto. Anson Green.
1861 *History of the Ojebway Indians*. London. A.W. Bennett.

Keron, James
1981 A Lesson in History The Archaeologist as Detective. KEWA. April
 1981: 2-7.

Kjellberg, Erik G..
1985 *Seeking Shelter: Canadian Delaware Ethnohistory and Migration*.
 Unpublished Master's Thesis, Department of Anthropology,
 McMaster University. Hamilton.

Lafitau, Joseph François.
1724 *Moeurs des Sauvages Americains*. Paris.

Landon, Fred
1967 *Western Ontario and the American Frontier*. Toronto. M & S.

Lajeunesse, E.
1960 *The Windsor Border Region*. The Champlain Society. Toronto.
 University of Toronto Press.

Leighton, Douglas.

1986 *The Historical Development of the Walpole Island Community.* Nin-Da-Waab-Jig. Occasional Papers of the Walpole Island Research Centre, no. 22.

Lennox, Paul A., and William R. Fitzgerald.

1990 The Culture History and Archaeology of the Neutral Iroquoians. In Ellis and Ferris, 405-456.

London Room = London Public Library historical collection, Central branch.

MacDonald, Robert

1978 *The Uncharted Nations.* Calgary. The Ballantrae Foundation.

McGarry, R.E, and H.W.R. Wade

1975 *The Law of Real Property.* London. Stevens & Sons.

McLean, John

1889 *The Indians: Their Manners and Customs.* Toronto. William Briggs.

Marsh, James A., ed.

1985 *The Canadian Encyclopedia,* 3 vols. Edmonton. Hurtig.

Mayer, R., ed.

1987 *Onoyota'a:ka: People of the Standing Stone: The 1985 Archaeological Survey of the Oneida Nation of the Thames Settlement.* London, Ont. London Chapter of the Ontario Archaeological Society Inc.

Morris, James

1943 *Indians of Ontario.* Toronto. Ontario Department of Lands and Forests.

Murphy, Carl, and Neal Ferris

1990 The Late Woodland Western Basin Tradition in Southwestern Ontario. In Ellis and Ferris, 189-278.

NYCD = Documents Relative to the Colonial History of the State of New York. 15 vols. 1853-87. Albany, NY Weed Parsons.

Nin.Da.Waab.Jig
1987 *Walpole Island: The Soul of Indian Territory.* Walpole Island, Ont. Nin.Da.Waab.Jig.

PAC = Public Archives of Canada

RG10 = Records Group 10 (Indian Affairs) series.

PAO = Public Archives of Ontario

 MS 296 = Letterbook of William Jones, Indian Agent Baldoon and Port Sarnia, Upper Canada 1831-39. Private Mansucript Section, Letterbooks Collection.

PSWJ = The Papers of Sir William Johnson. 28 vol. 1911-38. University of the State of New York. Albany.

Paddon, Wayne
1977 *Steam and Petticoats: The Early Railway Era in Southwestern Ontario.* St. Thomas. Paddon.

Poole, J.I.
1913 The Battle at Longwoods. *Transactions.* London and Middlesex Historical Society. IV: 7-61.

Priddis, Harriet
1909 The Naming of London Streets. *Transactions.* London and Middlesex Historical Society. I: 7-30.
1913 The Reminiscences of Mrs. Gilbert Porte. *Transactions.* London and Middlesex Historical Society. IV: 62-69.

Pryke, K.G., and L.L. Kulisek, ed.
1983 *The Western District.* Windsor, Ont. Essex County Historical Society and the Western District Council.

RCWL = Regional Collection, D.B. Weldon Library, University of Western Ontario. London ON.

Read, Colin.
1982 *The Rising in Western Upper Canada 1837-38.* Toronto. University of Toronto Press.

Read, Colin, and R. J. Stagg, ed.
1985 *The Rebellion of 1837 in Upper Canada: A Collection of Documents.* Ottawa. Carleton University Press.

Rhame, Grace
1990 *They Were Such Happy Days, a Memoir.* Toronto. Typhoon Press.

Schmalz, Peter S.
1991 *The Ojibwa of Southern Ontario.* Toronto. University of Toronto Press.

Smith, David G.
1990 Iroquoian Societies in Southern Ontario: Introduction and Historic Overview. In Ellis and Ferris, 279-290.

Smith, William Henry
1846 *Smith's Canadian Gazetteer.* Toronto. H & W Rowsell.

Spence, Michael W., Robert H. Pihl, and Carl Murphy.
1990 Cultural Complexes of the Early and Middle Woodland Periods. In Ellis and Ferris, 125-170.

St. Denis, Guy
1985 *Byron: Pioneer Days in Westminster.* Lambeth, Ont. The Crinklaw Press.

Stott, Glenn
1988 *Witness to History: Tales of Southwestern Ontario.* Arkona, ON.

Tausky, Nancy Z., and Lynne D. Di Stefano.
1986 *Victorian Architecture in London and Southwestern Ontario.* Toronto. University of Toronto Press.

Taylor, John L.

1983 *The Historical Foundation For the Walpole Island Reserve Boundary
 Question.* Nin-Da-Waab-Jig. Occasional Papers of the Walpole
 Island Research Centre, no. 21.

1984 *A Supplement to the Historical Foundation for the Walpole Island
 Reserve Boundary Question.* Nin-Da-Waab-Jig. Occasional Paper
 of the Walpole Island Research Centre, no. 21a.

Théberge, Pierre.

1982 *Greg Curnoe.* Ottawa. The National Gallery of Canada.

Timmins, Arthur

1990 *Southdale: A Multi-Component Historic and Prehistoric Site in
 London, Ontario.* London. Museum of Indian Archaeology.
 Research Report no. 20.

Tooker, Elizabeth

1878 Wyandot. In Bruce G. Trigger, ed., *Handbook of North American Indians,
 Northeast,* pp. 398-406. Washington. Smithsonian Institute.

Trigger, Bruce

1976 *The Children of Aataensic: A History of the Huron People to 1660,* 2
 volumes. Montreal. McGill-Queen's University Press.

1985 *Natives and Newcomers.* Montreal. McGill-Queen's University
 Press.

1978 William Wintemberg: Iroquoian Archaeologist. In *Papers in
 Northeastern Anthropology in Memory of Marian White,* ed. W.
 Engelbrecht and D.K. Grayson. Occasional Papers in
 Northeastern Archaeology 5: 5-21

Trigger, B.G, L. Yaffe, et al.

1984 Parker Festooned Pottery at the Lawson Site: Trace-element
 Analysis. *Ontario Archaeology* 42: 3-11

Warren, William W.

1957 *History of the Ojebway Nation* [1885]. Ross and Haines.

Minneapolis. (First published in *Collections of the Minnesota Historical Society* 5: 29-394 as History of the Ojebways, Based upon Traditions and Oral Statements.)

Williamson, Ronald F.
1990 The Early Iroquoian Period of Southern Ontario. In Ellis and Ferris, 291-320.

Wilson, Edward F.
1886 *Missionary Work Among the Ojebway Indians.* London. Society for Promoting Christian Knowledge.

Wintemberg, W.J.
1939 *Lawson Prehistoric Village Site: Middlesex County, Ontario.* National Museum of Canada Bulletin 94.

About the Book and the Author

Before his tragic death in 1992, GREG CURNOE had submitted to Brick Books a manuscript based on extraordinarily detailed research into the history of 38 Weston, his address in London, Ontario. The result is a journal/collage that traces the occupancy of that one small plot of land hundreds of years back into aboriginal times when land in this country was not plotted according to the laws of geometry.

Deeds/Abstracts is an intensely concentrated and particular cross-section of Canadian history, layer upon layer upon layer. This book is a confirmation of Greg Curnoe's devotion to the city in which he was born and brought up, an expression of local pride that was so deep and polemical and activist that it made him one of the most solid cores of a local visual arts community that, paradoxically, placed London firmly on national and international cultural maps. Curnoe's own highly original work – some of it displayed within the covers of this book – reached across the country and outside its borders to such centres as Sao Paulo, Venice, Havana and the other London. Brick Books is proud to offer this exemplary work-in-progress (a 500-year diary can never be complete) assembled by a much-loved and keenly-lamented Canadian artist of the first importance.

GREG CURNOE was born in London in 1936. He studied art at Beal Technical School in London, at Doon School of Fine Arts in Kitchener, and at the Ontario College of Art in Toronto (where he achieved the distinction of failing in his final year) and for the rest of his life as a perpetual autodidact. He was a founder of the Nihilist Spasm Band, the Forest City Gallery, and *Region* magazine.

DATE DUE	RETURNED
7/11/2017	